LIFE
Carries On

From the Editors
of LIFE Magazine

A Fireside Book
Published by Simon & Schuster
New York London Toronto
Sydney Tokyo Singapore

FIRESIDE
Simon & Schuster Building
Rockefeller Center
1230 Avenue of the Americas
New York, New York, 10020

Photo Editor: Nancy Jo Johnson

Manufactured in the United States of
America

10 9 8 7 6 5 4 3 2 1

Picture sources listed on page 192.

ISBN: 0-671-86852-7

Contents

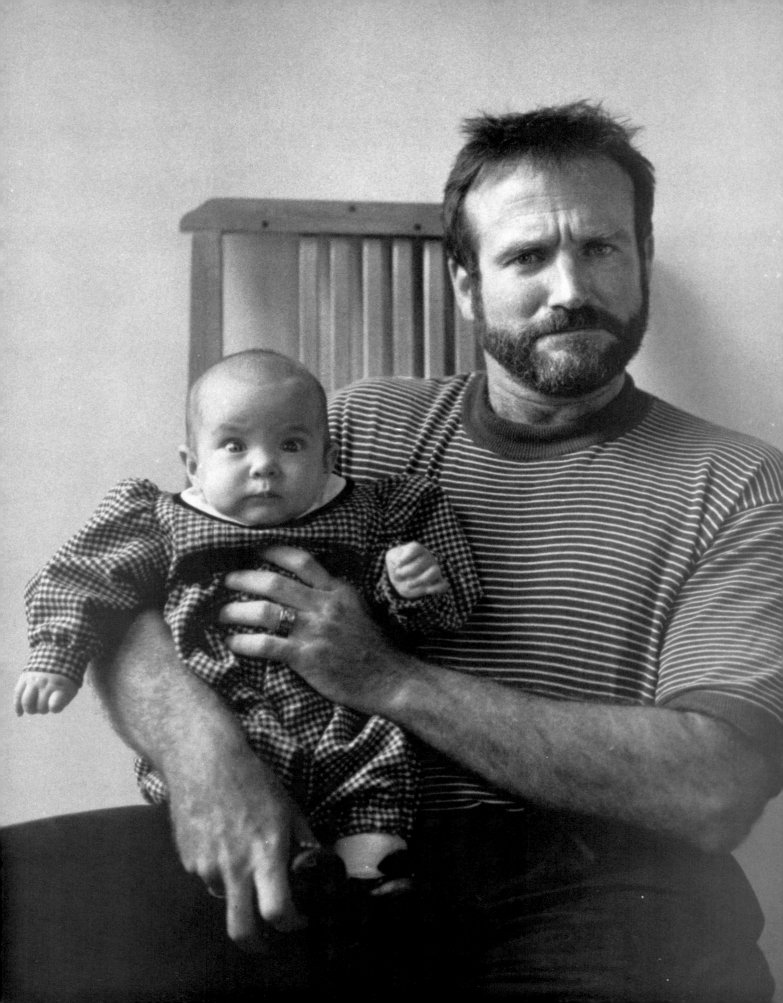

Introduction

This is the third book—and we certainly hope not the last—in a series that LIFE magazine has published with Simon & Schuster. The first one, *LIFE Smiles Back,* came out in 1987. Consisting of more than 200 photographs that had appeared on the last page of our magazine, it featured oddball images—many of which had been taken by amateurs—of equally oddball moments. You had to laugh at the soldier carrying a donkey on his back, at the dog playing a piano, at the baby/food critic who had dumped her spaghetti dinner on her head. A large number of the photographs were of children or animals, but whatever the subject, humor was the glue that held the book together.

Then two years later *LIFE Laughs Last* was published. The idea was similar: Let's give people a book of kooky photographs of hard-to-believe moments—again taken from that famous last page of LIFE. (In this volume it helped if you were an animal acting like a person, or vice versa.)

Both of these books were hugely successful; they are still in print and still, we think, very funny. They allow us to laugh at ourselves—always a healthy activity. But humor, like so much else in life (and in LIFE), is subjective. (If you could be a fly on the wall at one of the sessions when we decide what to publish on our last page, now called Just One More, you would see what we mean.) All of us, and we're not just talking about editors of picture magazines here, have become more sophisticated in our tastes. We expect more from our humor.

And that's why you may find *LIFE Carries On* just a little bit different from the two previous books. These days, most of the pictures that appear in LIFE as a Just One More are taken by professional photographers. Even so, these images still frequently feature animals or children—who

● *Left*

Is that a family resemblance? Robin Williams calmed down for a minute—well, sort of—to pose with his daughter Zelda in 1989.

Photographer:
Arthur Grace

can resist our favorite subjects?—but they are, we believe, more amazing, in either their theme or composition, than those LIFE published in its youth.

The other thing we're aware of, and this will explain another big difference between this book and its predecessors, is that many of the pictures we publish in the body of our magazine are likewise humorous. So we've included many of them, too. Some of these photographs will probably make you laugh aloud—let's face it, sight gags *are* funny. Other pictures will make you smile: Have you ever seen sumo wrestlers in tutus before? Or groan: Can you help but share the pain of a mother looking at a room that her three human tornadoes, all under the age of four, have destroyed? Or make you wonder at the things people do: Would you parachute with *your* dog?

But some of the pictures simply let us see something in a way that's totally new. Did we know that the shapes created by the veils on a crowd of praying Muslim women could be so beautiful? Did we know that there are monkeys born perfectly formed and yet smaller than a man's finger? Did we know that a child whose only swimming pool is a fire hydrant could be so happy? Maybe the pictures will seem, to your eye, not always uproariously comical. But they are, we promise, pictures that will stick so securely in your mind that you will want to go back to them, time and time again, to see if you really saw what you thought you saw.

The Editors of LIFE

LIFE
Carries
On

Chapter 1

How Did You Say You Do That?

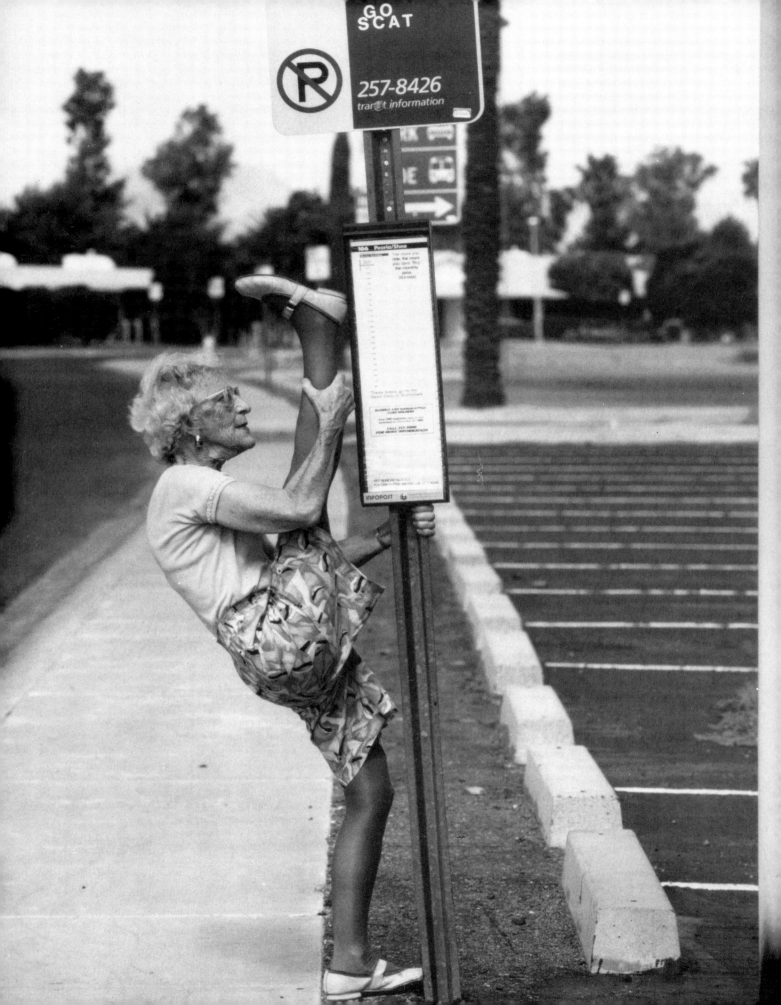

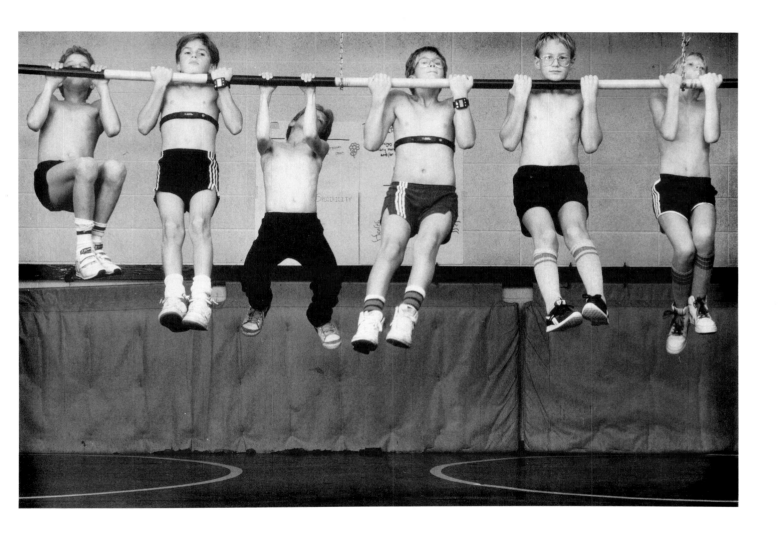

● *Previous page*

Auditioning for a Broadway show is scary, particularly when the dance steps get tricky.
Photographer:
Maggie Steeber

● *Left*

A part-time cheerleader and full-time great-grandmother of four, this retired postal clerk would fit two exercise classes into her weekly schedule, stopping for a warm-up or two along the homestretch.
Photographer:
Frank Fournier

● *Above*

When a Vinton, Iowa, middle school instituted a physical fitness program, some students found it easier than others. But chin up, kids: Sweat equity pays handsome dividends.
Photographer:
Tobey Sanford

How Did You Say You Do That?

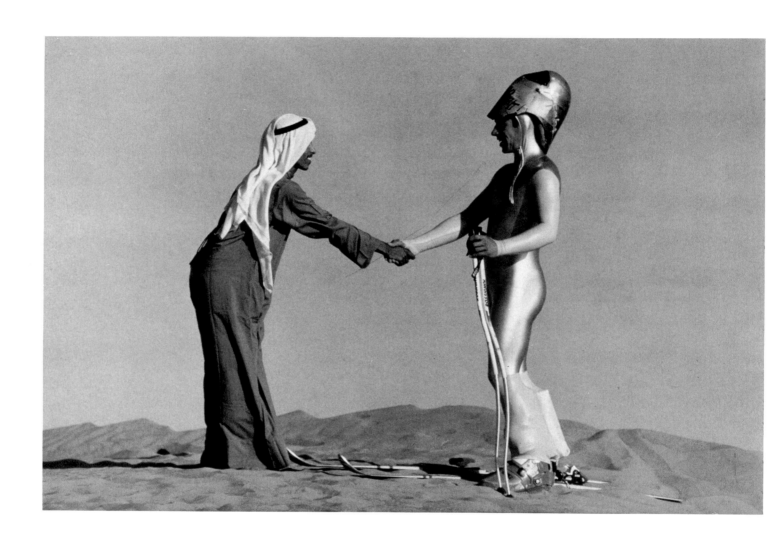

● *Above*

It was sheikh meets chic when
a puzzled native of Abu
Dhabi greeted a sand skier.
Photographer:
Gerard Vandystadt

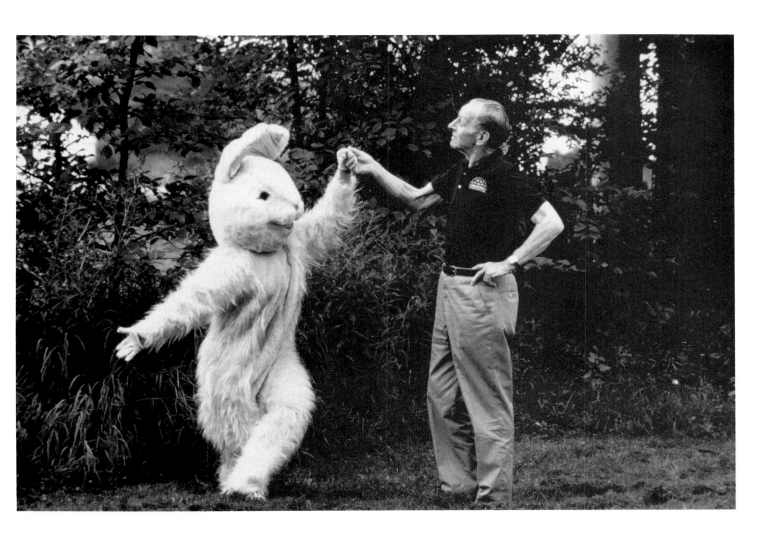

When Francis Grover
Cleveland (Grover
Cleveland's son) rehearsed
for *Harvey*, the classic
comedy about an alcoholic
and his imaginary rabbit, he
apparently learned a thing
or two from the hare.
Photographer:
Harry Benson

How Did You Say You Do That?

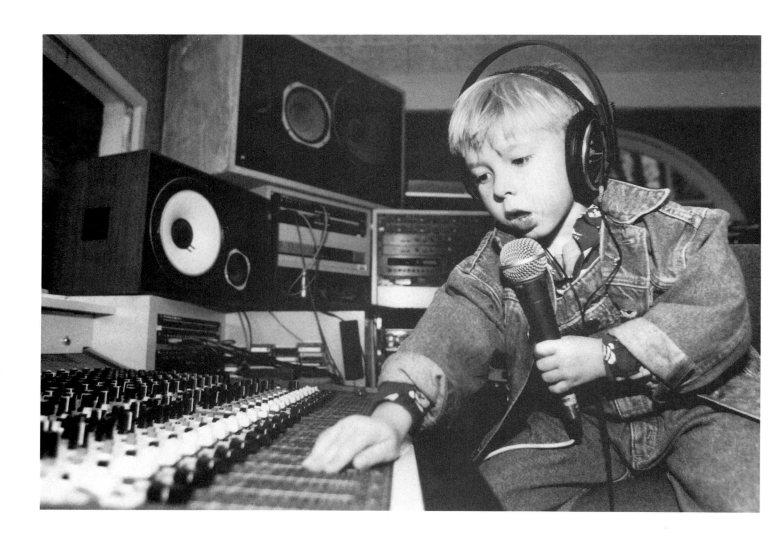

● *Above*

Meet a top rocker who's also a preschooler—a five-year-old French boy who sold millions of copies of a rap tune called "It's Hard to Be a Baby."
Photographer:
Lionel Cironneau

● *Right*

In the mid-'60s—look how small the skateboards were then—a couple of Denver teachers decided to find out what their students were up to. The verdict? A "heavenly feeling."
Photographer:
Carl Iwasaki

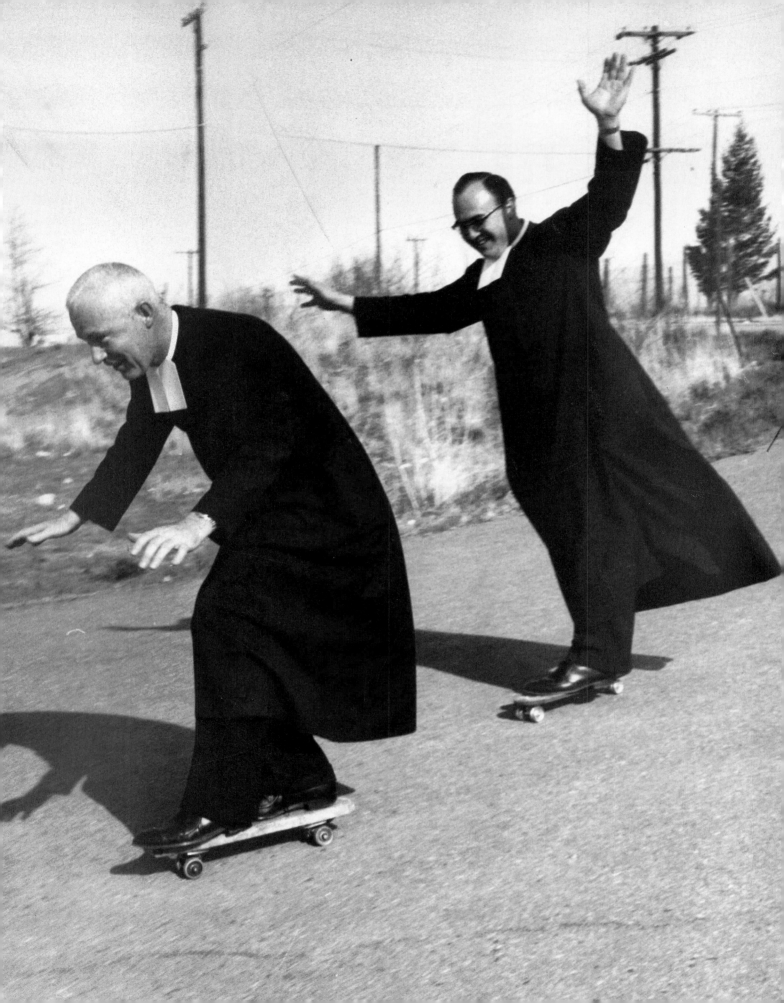

How Did You Say You Do That?

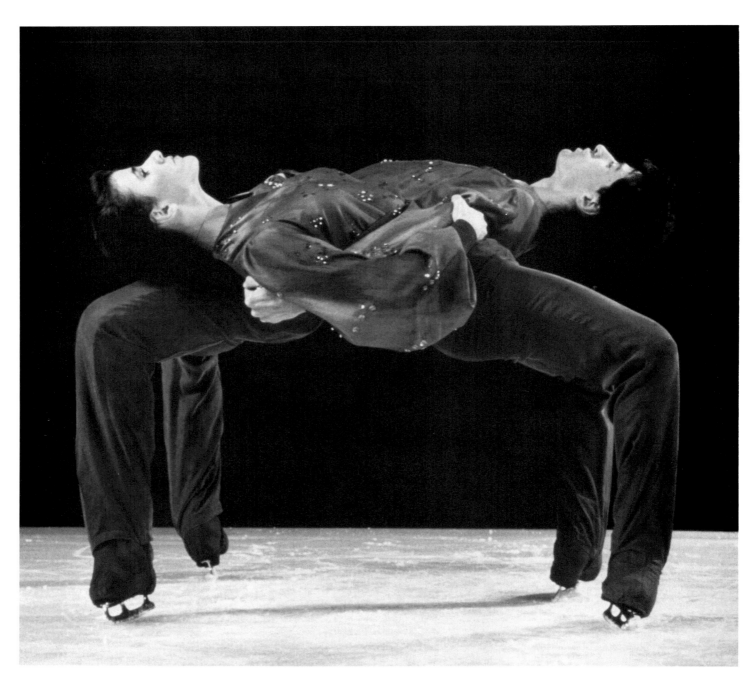

● *Above*

It may look like a two-headed, four-legged spider after a visit to Wayne Newton's tailor, but it's actually two ice dancers practicing.
Photographer:
G. Planchenault,
T. Deketelaere, G. Vandystadt

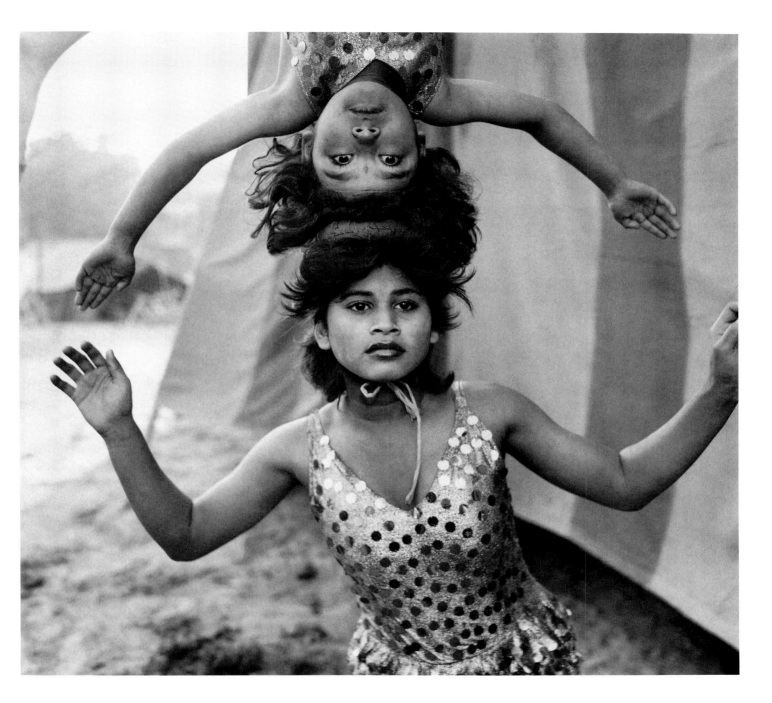

● *Above*

Indian circus performers, like these two young girls doing what many of us might find unbelievable at any age, often start perfecting their acts by the time they are six.

Photographer:

Mary Ellen Mark

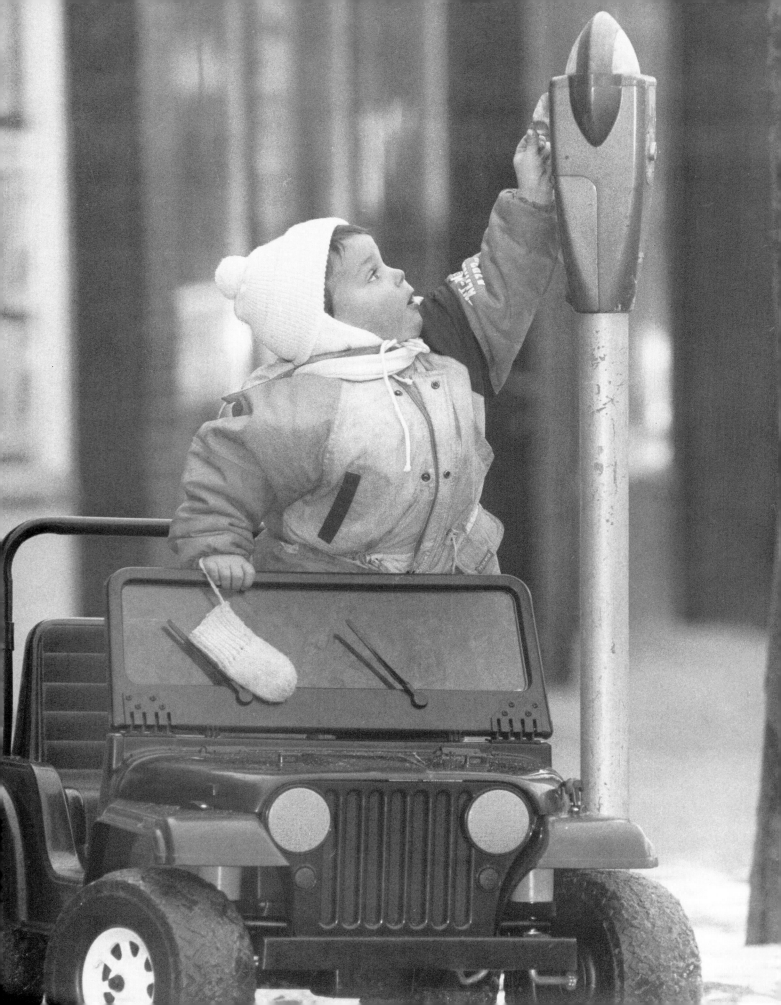

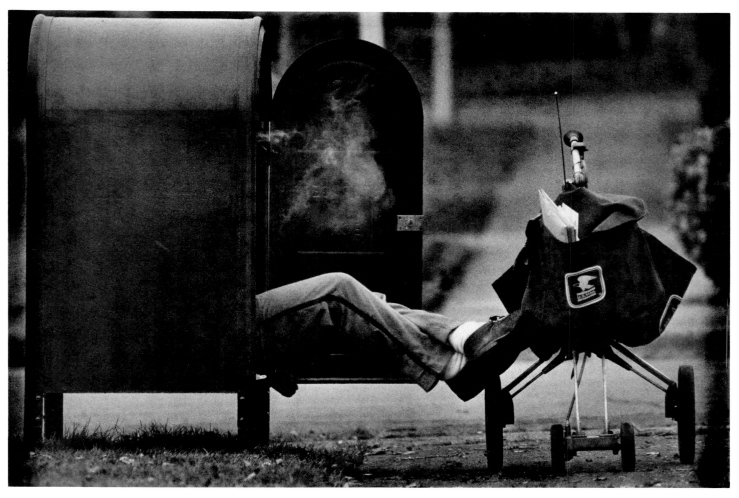

● *Left*

As his parents window-shopped, this little fellow pedaled the sidewalks in search of a place to park. Traffic was terrible.
The meters were too tall. Still, he drove on until he found a spot. After all, a $10 fine can take a mighty big bite out of a two-year-old's allowance.

Photographer:
Greig Reekie

● *Above*

Has the U.S. Postal Service finally come up with a surefire way to get a message across? Actually, the man here was not sending smoke signals. He's a letter carrier, taking a cigarette break from his daily rounds.

How Did You Say You Do That?

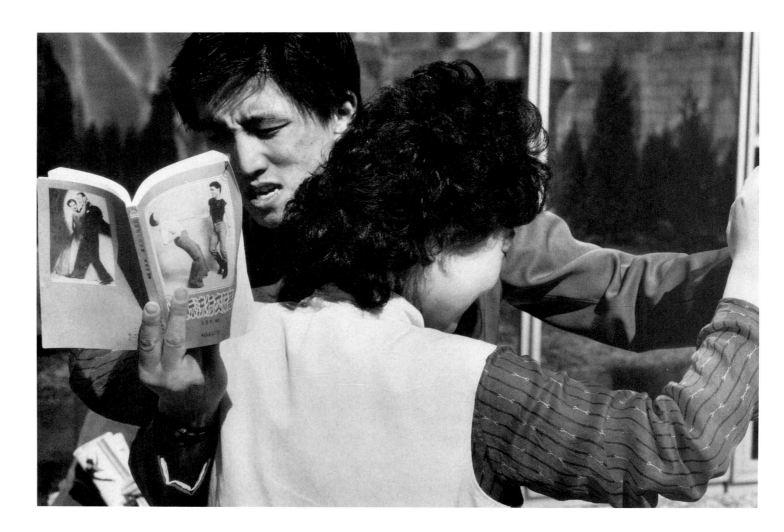

● *Above*

When the Chinese government lifted its ban on dancing, one young couple had to turn to an instruction manual for a little guidance.

Photographer:

J. Ross Baughman

● *Right*

It was tutu much when two sumo champions performed a pas de deux from *Hippo Lake*.

Photographer:

Sankei Shimbun

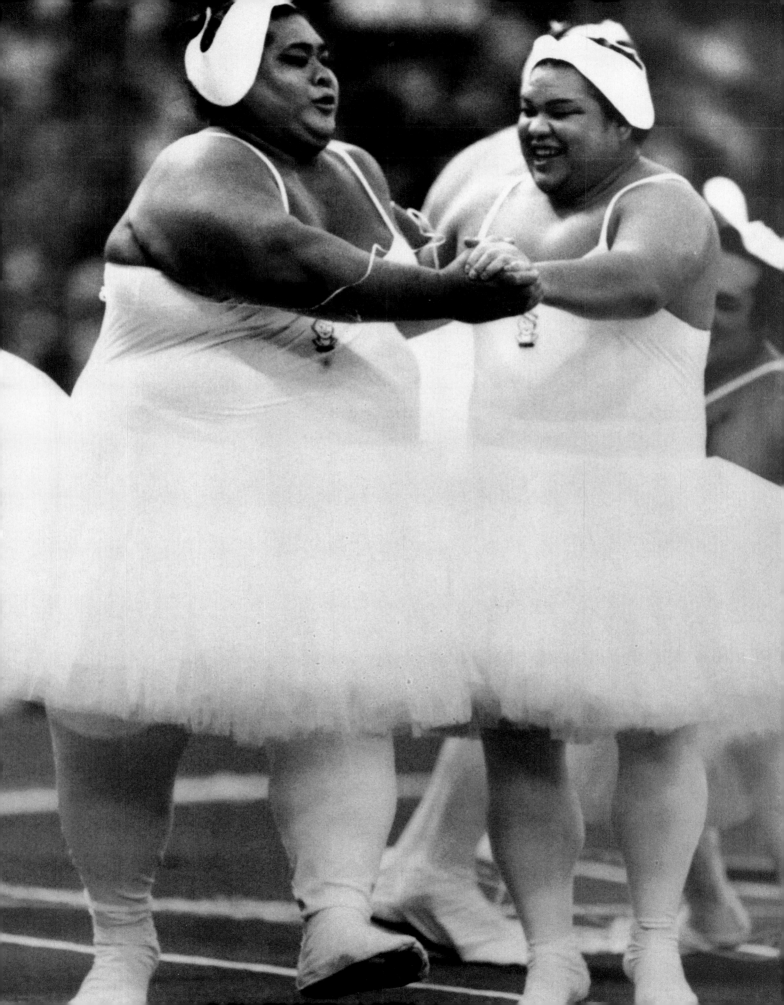

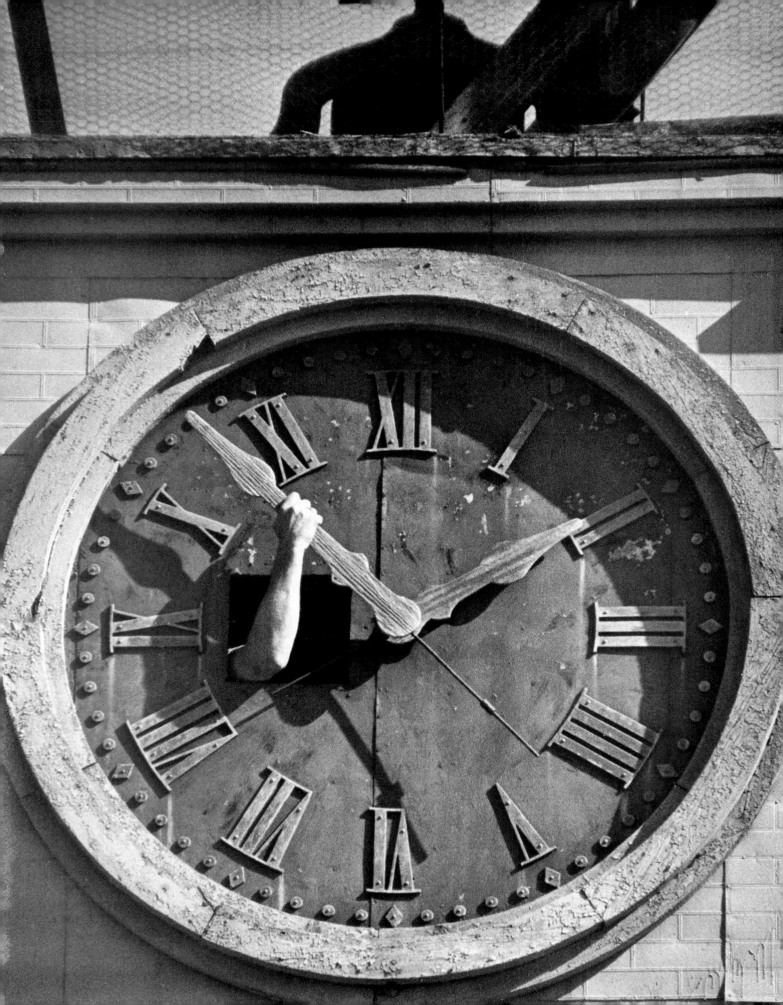

How Did You Say You Do That?

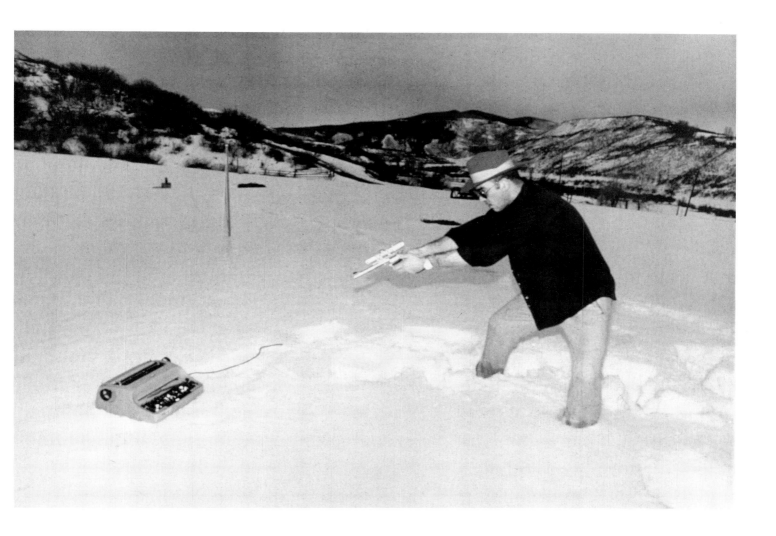

● *Left*

What mortal man dare tamper with the hands of Time? Never mind the hubris—it's just a guy doing his job, setting back an old clock to add a little daylight on winter mornings.

Photographer:
Jim Koepnick

● *Above*

They shoot typewriters, don't they? Well, they do if "they" are iconoclastic journalist Hunter Thompson, having a little writer's-block fun in the Aspen snow.

Photographer:
Paul Chesley

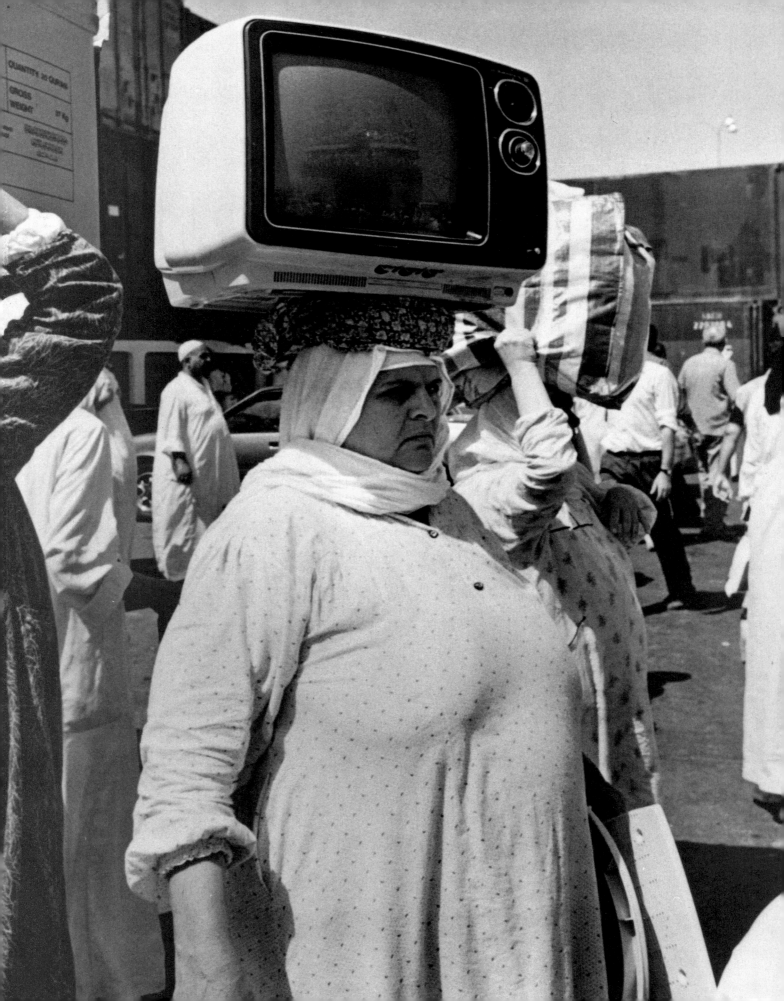

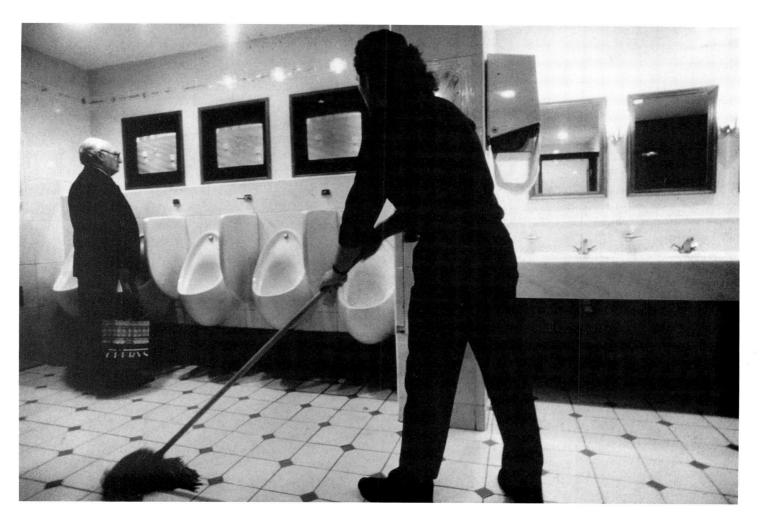

● *Left*

This Egyptian woman, on a pilgrimage to Mecca, let a Saudi Arabian bargain go to her head.

Photographer:

Manoocher

● *Above*

The 1990 World Cup mesmerized the world—or at least the millions of people who sat (or stood) transfixed before the blue light of their TV screens. Soccer may be the planet's obsession, but in Ireland's Jurys Dublin Hotel, boosting the green was a man's job.

Photographer:

James Meehan

How Did You Say You Do That?

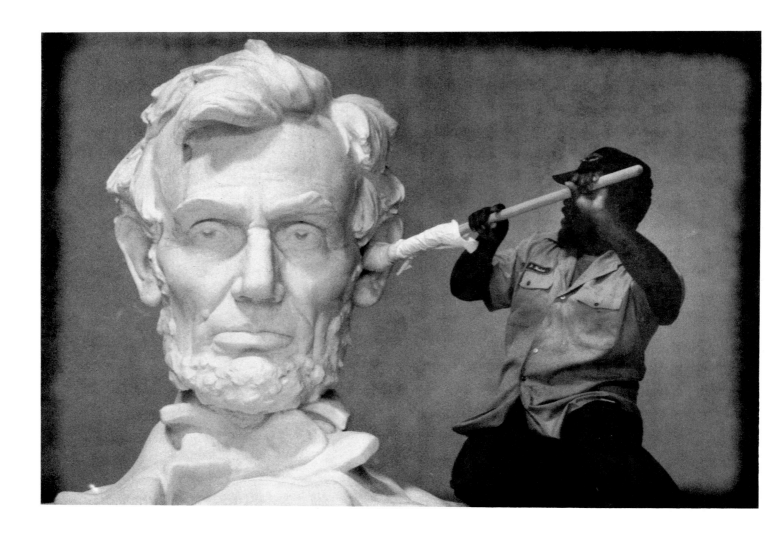

●*Above*

It's an ugly job but someone's got to do it, particularly when it's time for the Lincoln Memorial's annual cleaning.
Photographer:
Vince Mannino

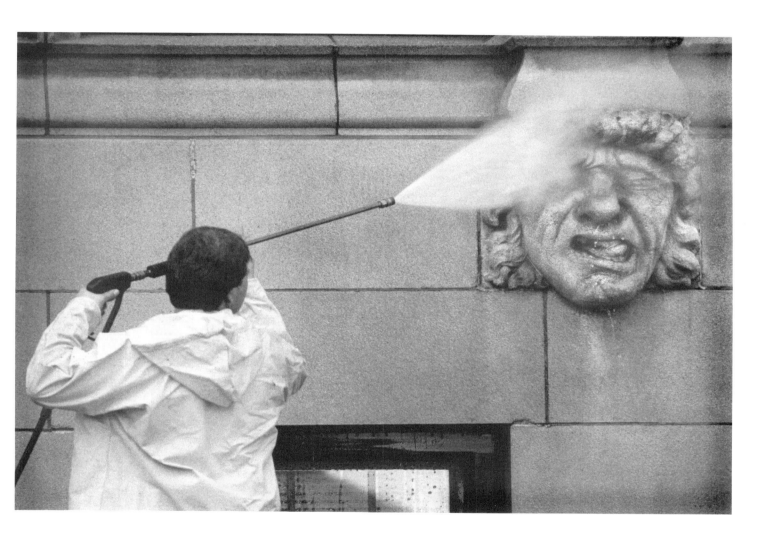

● *Above*

A shower every five years (whether he needs it or not) does little to cheer this stone-faced sourpuss. Fixed in a granite grimace on a Seattle apartment building since 1928, he serves as proof that mothers are right: Your face *will* get stuck that way.

Photographer:

Dan Schlatter

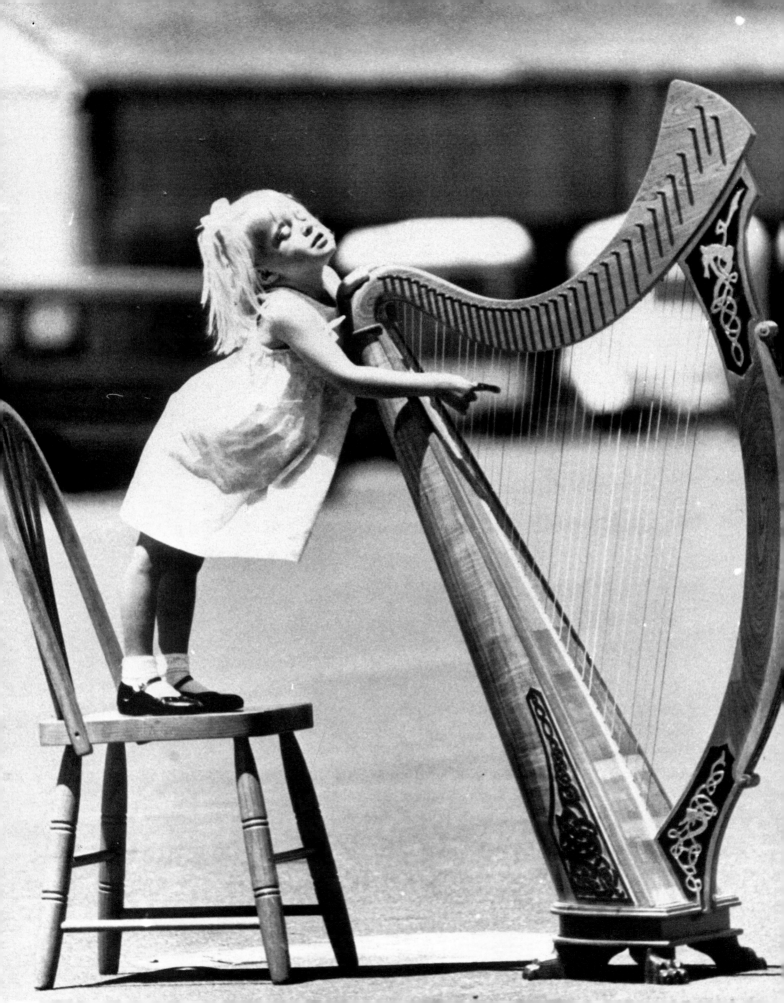

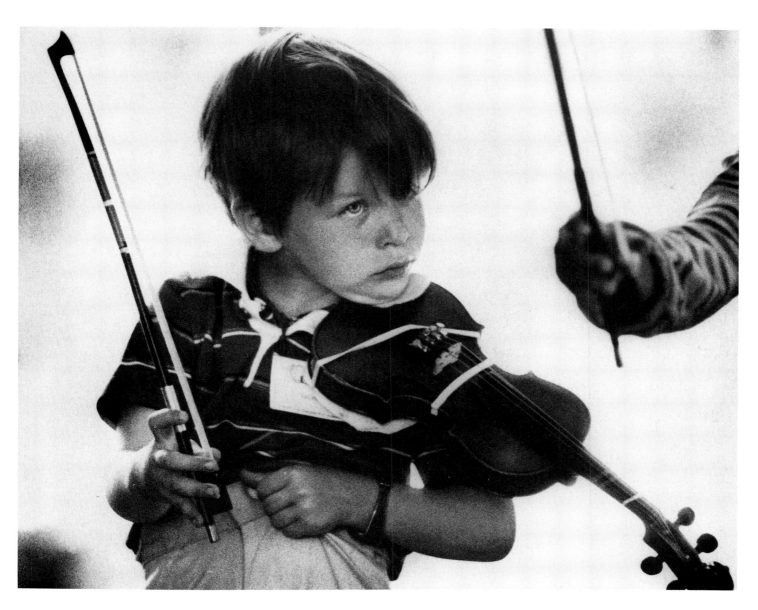

● *Left*

Undaunted by the harp's size, a high-strung three-year-old showed that she had plenty of pluck.

Photographer:
News Ltd., Sydney

● *Above*

This four-year-old pupil was making beautiful music at his Suzuki class when his trousers began an impromptu divertissement. Without coming unstrung, the plucky violinist followed the maestro's upswept bow and yanked them waistward *con brio*—dropping nothing but a few grace notes.

Photographer:
Wes Wilson

How Did You Say You Do That?

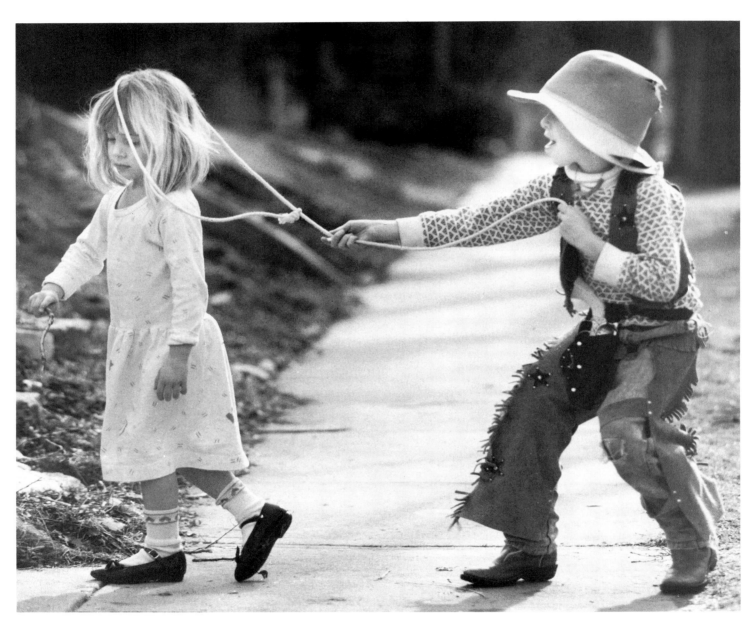

● *Above and right*

Sibling rivalry may tie some families up in knots, but even an ambush at high noon didn't give this cowgirl the blues. She just rounded up the varmint and showed him the ropes.

Photographer:

Glenn J. Asakawa

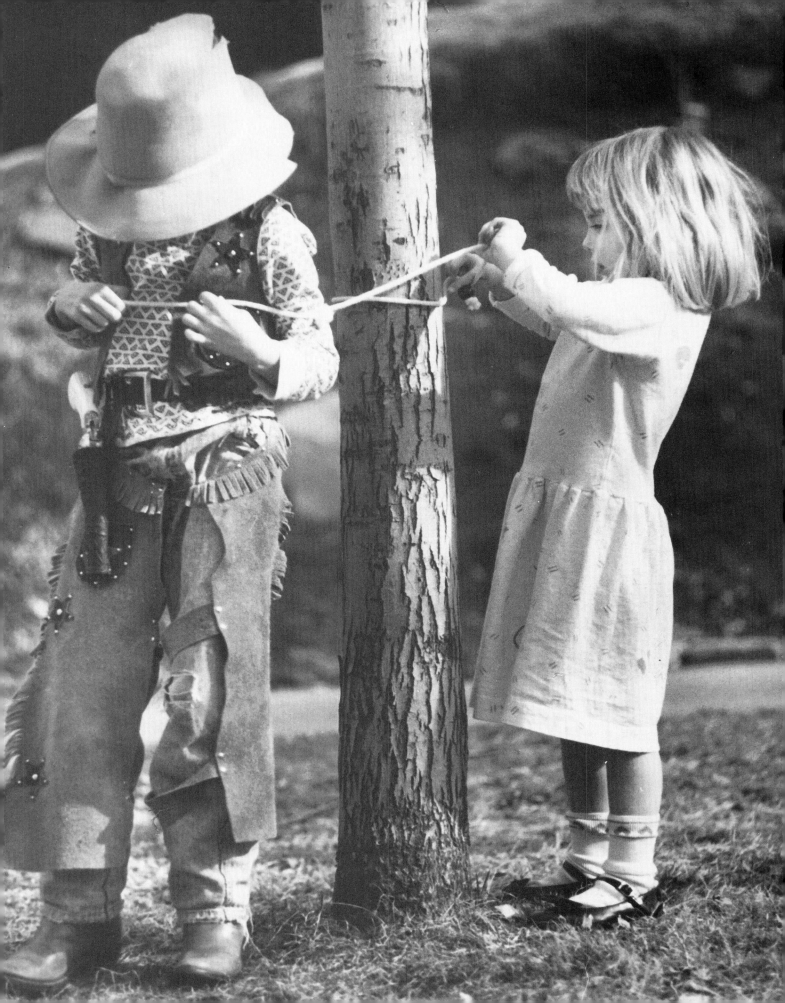

How Did You Say You Do That?

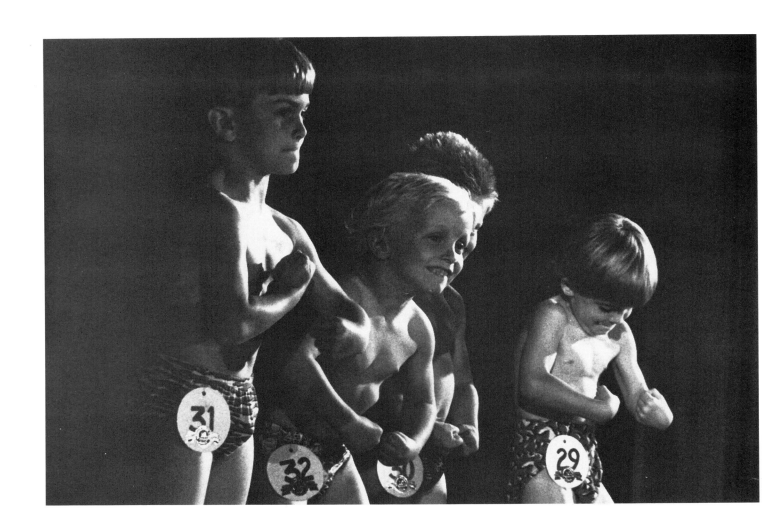

● *Above*

At a Marshville, N.C.,
bodybuilding meet, four
mighty mites won prizes
along with the big guys.

Photographer:

Jessica Norwood

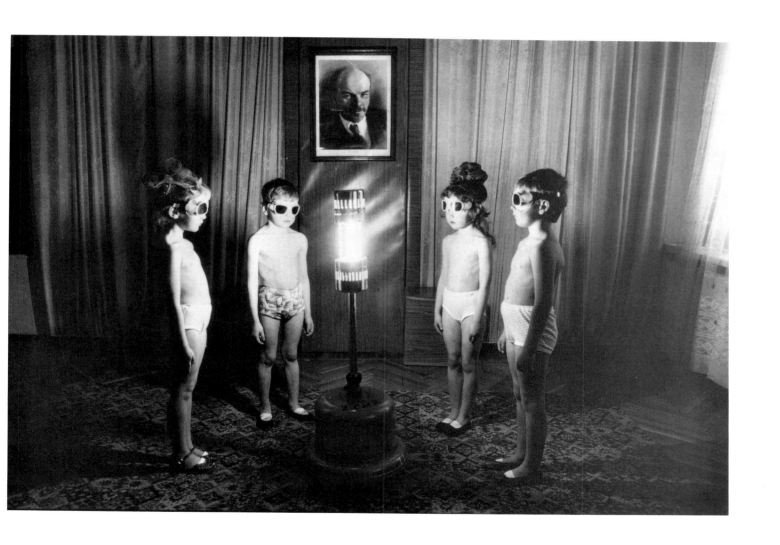

● *Above*

What would you do if you
lived in Siberia? Actually,
the practice of exposing
children to ultraviolet light
during the long, dark winters
is disappearing—which may,
or may not, meet with
Lenin's approval.

Photographer:

Mark S. Wexler

How Did You Say You Do That?

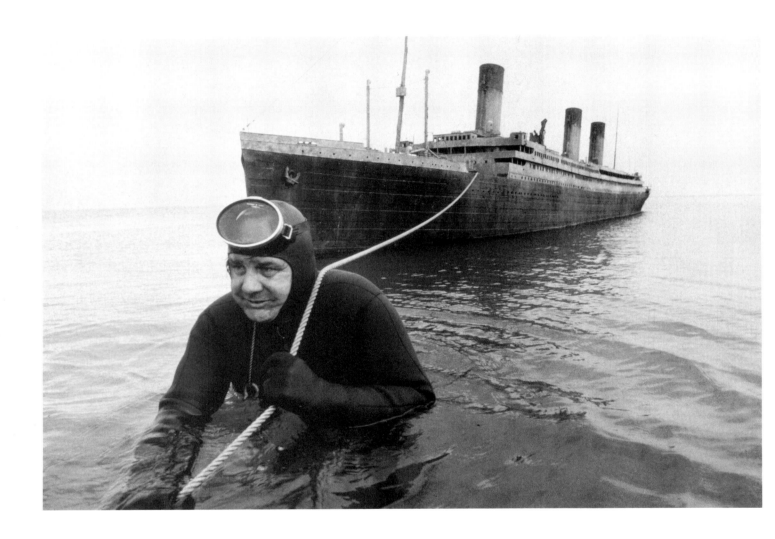

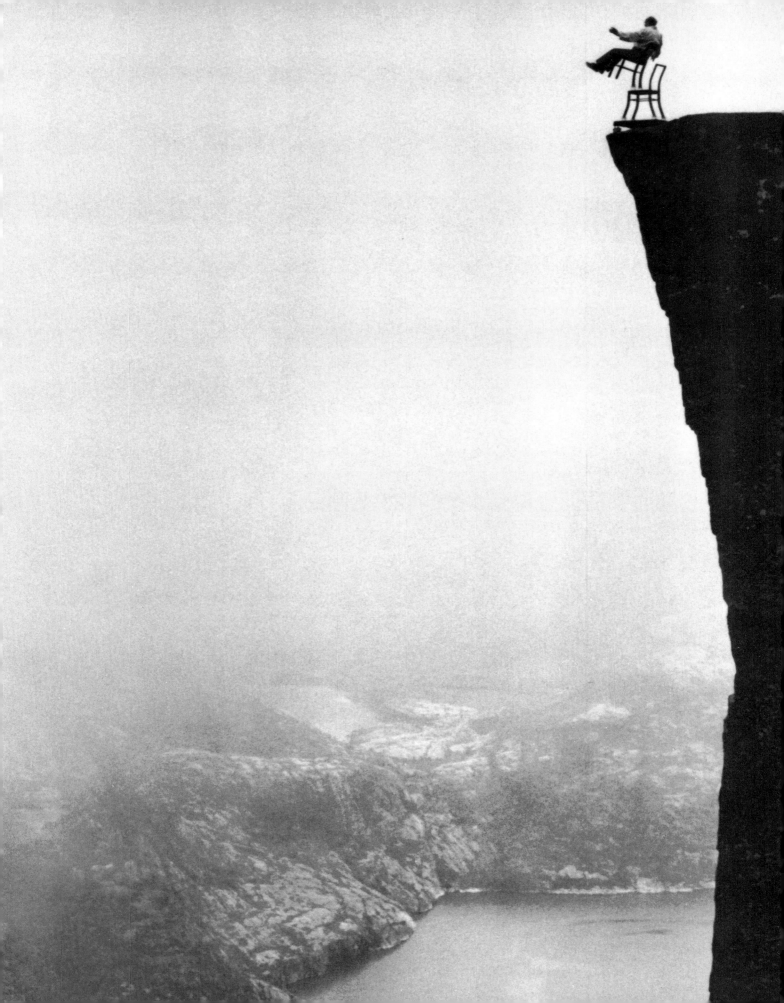

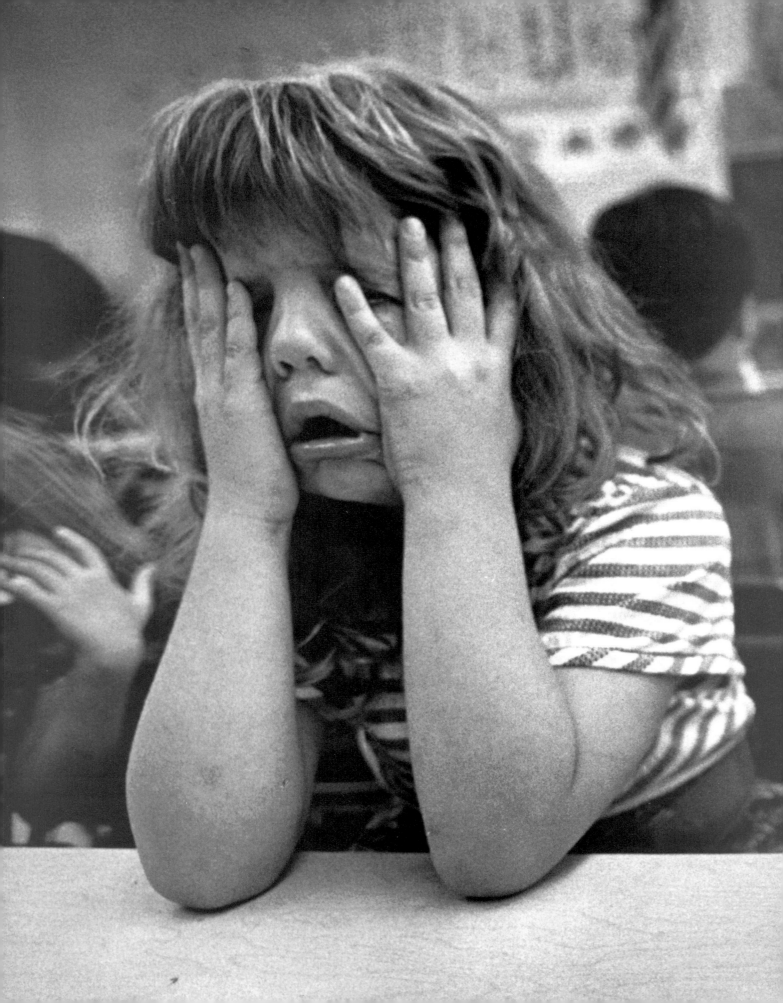

I Can't Believe This Is Happening to Me

I Can't Believe This Is Happening to Me

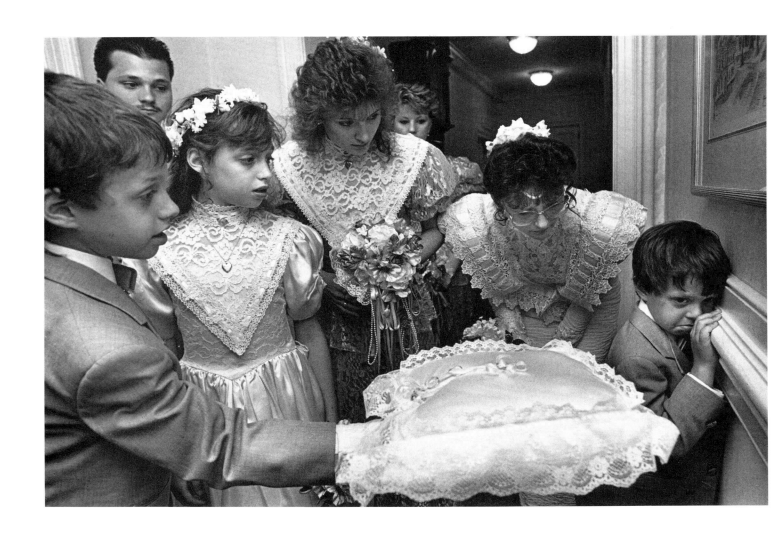

● *Previous page*

When you're only five and it's the first day of kindergarten, it's sometimes hard to keep an optimistic outlook.

Photographer:

April Saul

● *Above*

Then again, when you're only five and your father is remarrying, it's sometimes *very* hard to want to be a ring bearer.

Photographer:

April Saul

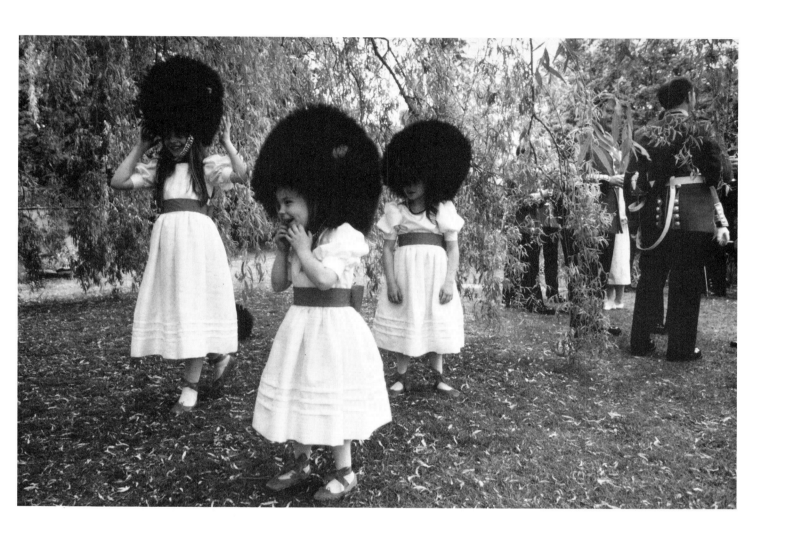

● *Above*

With their rear flank exposed, some British Grenadiers were caught off guard by a bunch of Somerset bridesmaids.

Photographer:
Roger Scruton

I Can't Believe This Is Happening to Me

● *Above*

And we thought it was only
spaghetti and meatballs!
Photographer:
Suzie Fitzhugh

● *Right*

Robert Penn Warren was
named America's first poet
laureate at just about the time
the rose became the national
flower. But no "roses are red"
stuff for him!
Photographer:
Alen MacWeeney

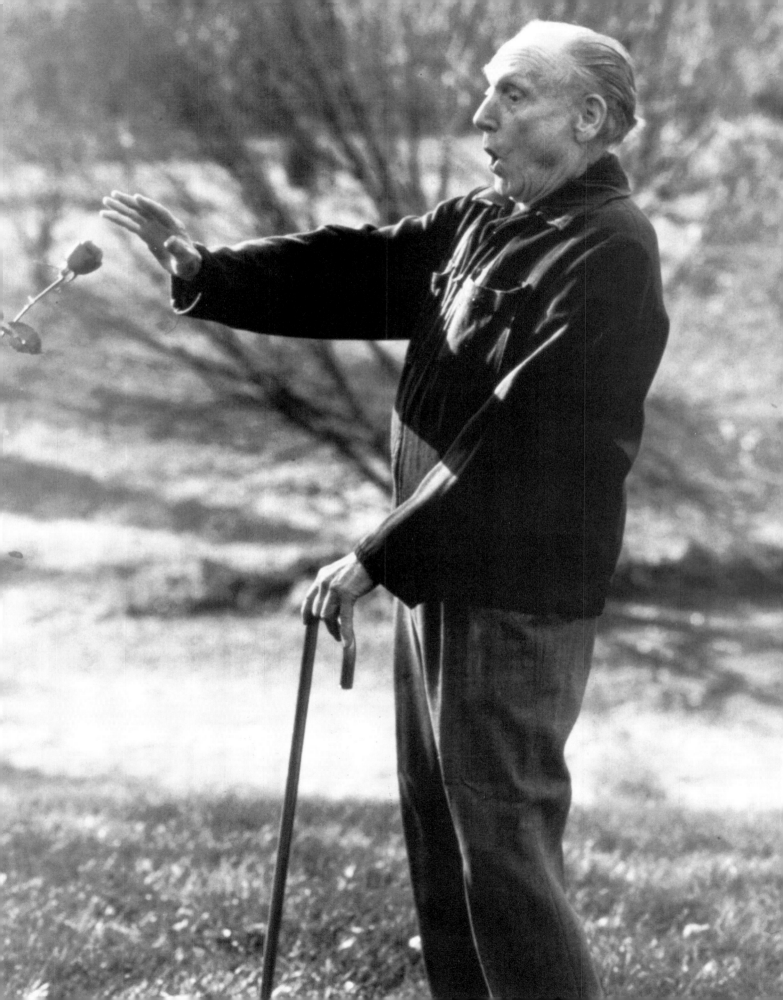

I Can't Believe This Is Happening to Me

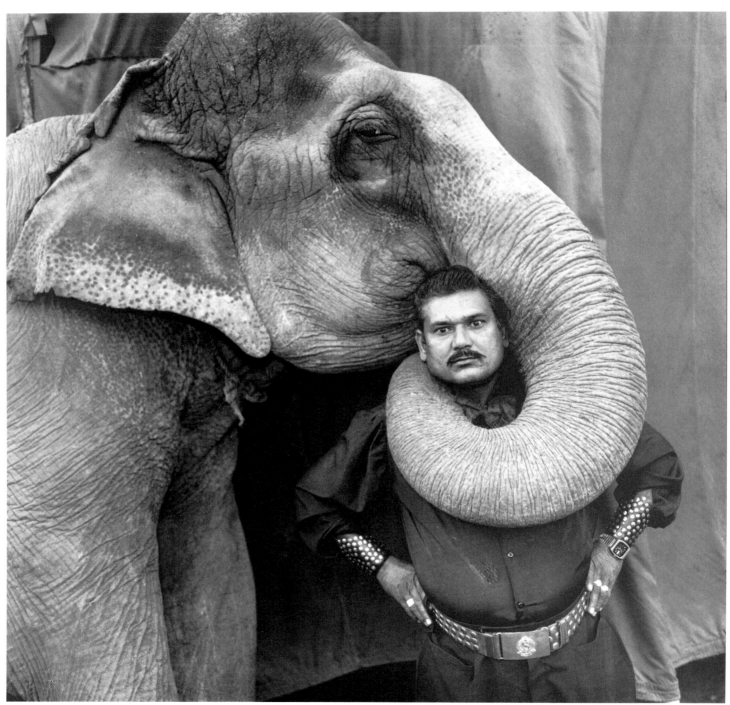

● *Above*

Ram Prakash Singh and his elephant Shyama are much more than casual acquaintances.

Photographer:

Mary Ellen Mark

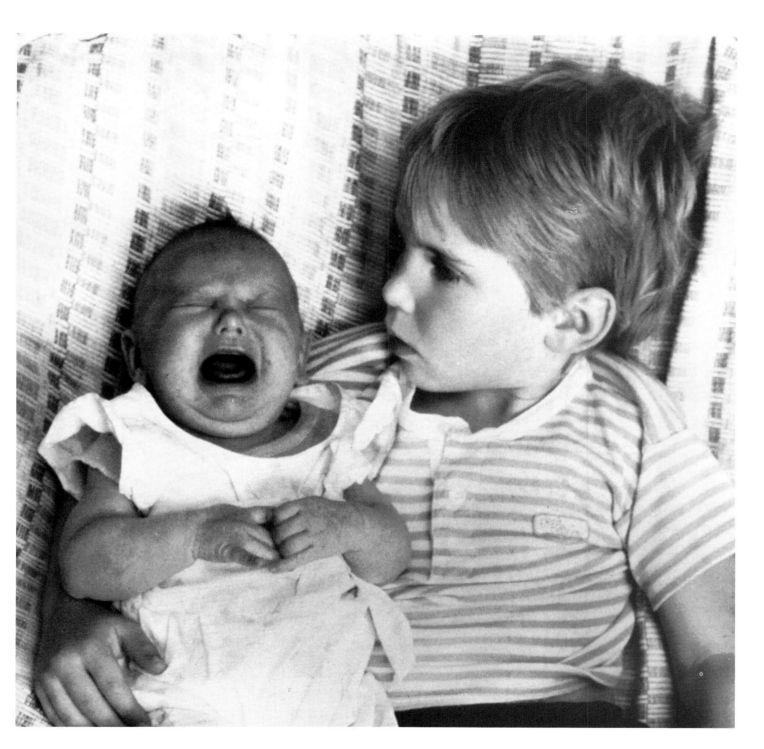

●*Above*

"Sure, you're going to love
the baby. It's just going to
take a little time."
Photographer:
N. Durrell McKenna

I Can't Believe This Is Happening to Me

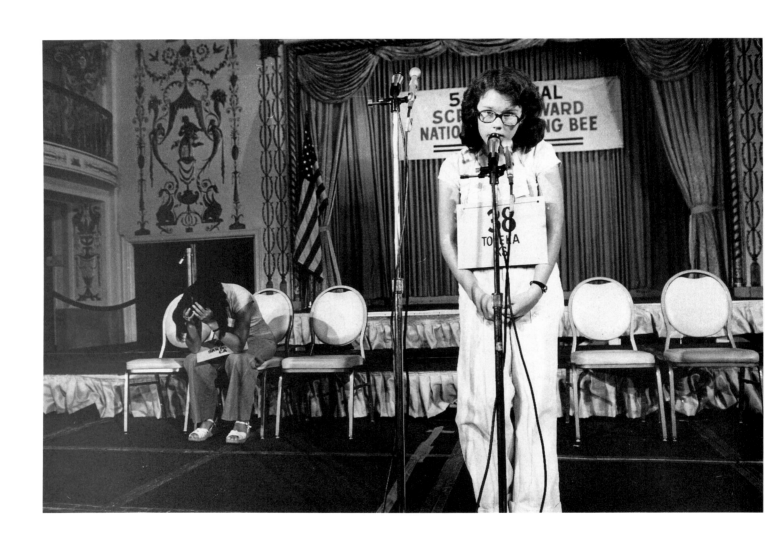

And the winning word (in
1978) was . . . "deification."
Photographer:
Daugherty

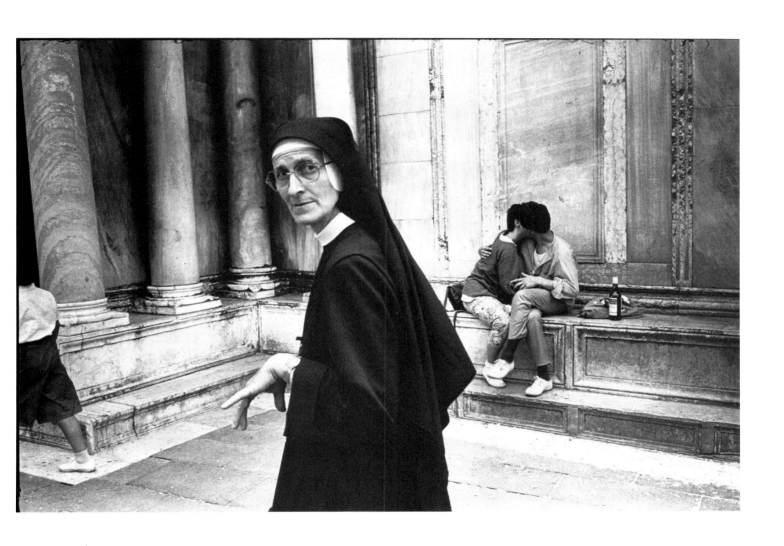

● *Above*

When you're not so young and not in love, sometimes it's best just to look the other way.

Photographer:

Donna Ferrato

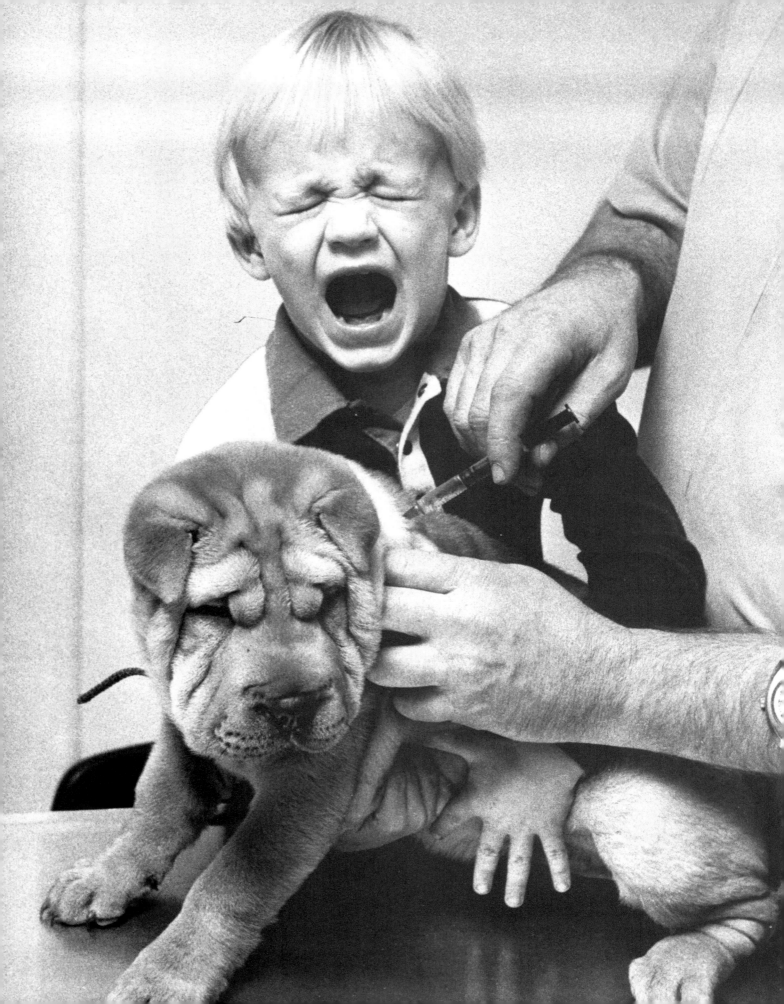

I Can't Believe This Is Happening to Me

I Can't Believe This Is Happening to Me

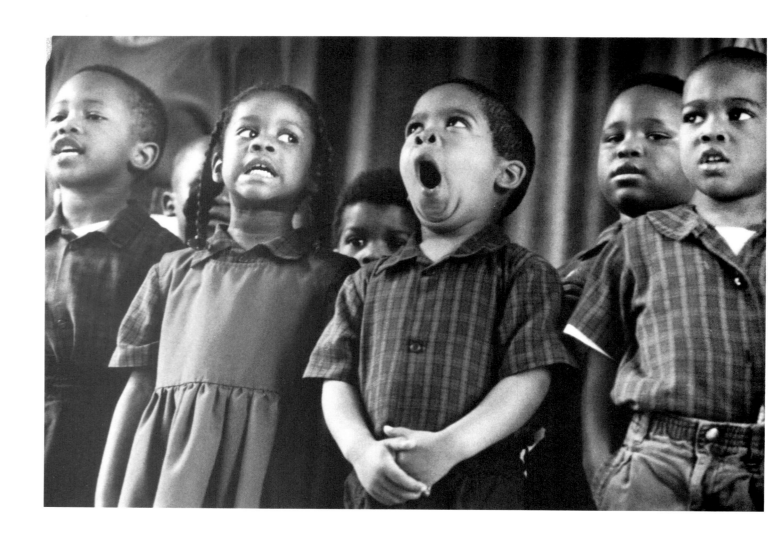

● *Above*

These preschool serenaders were trying their best to give a heavenly performance, but the lateness of the hour got to one sleepy songster.

Photographer:

Stormi Greener

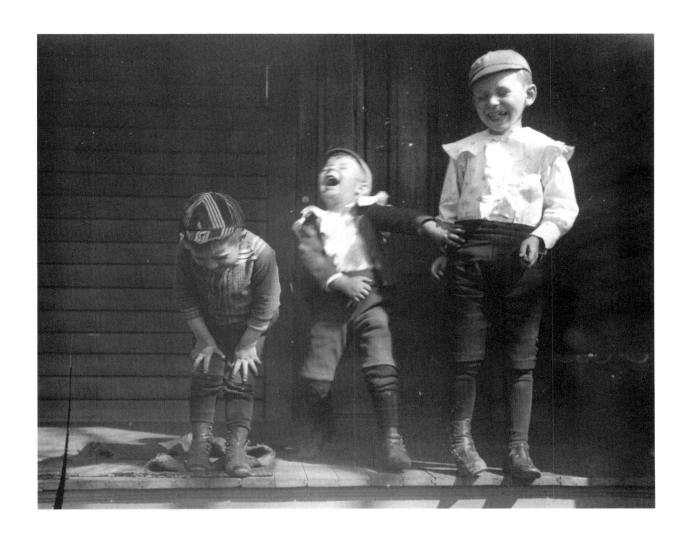

● *Above*

"Do you remember the one about the chicken crossing the road?"

Photographer:

Nebraska State Historical Society

51

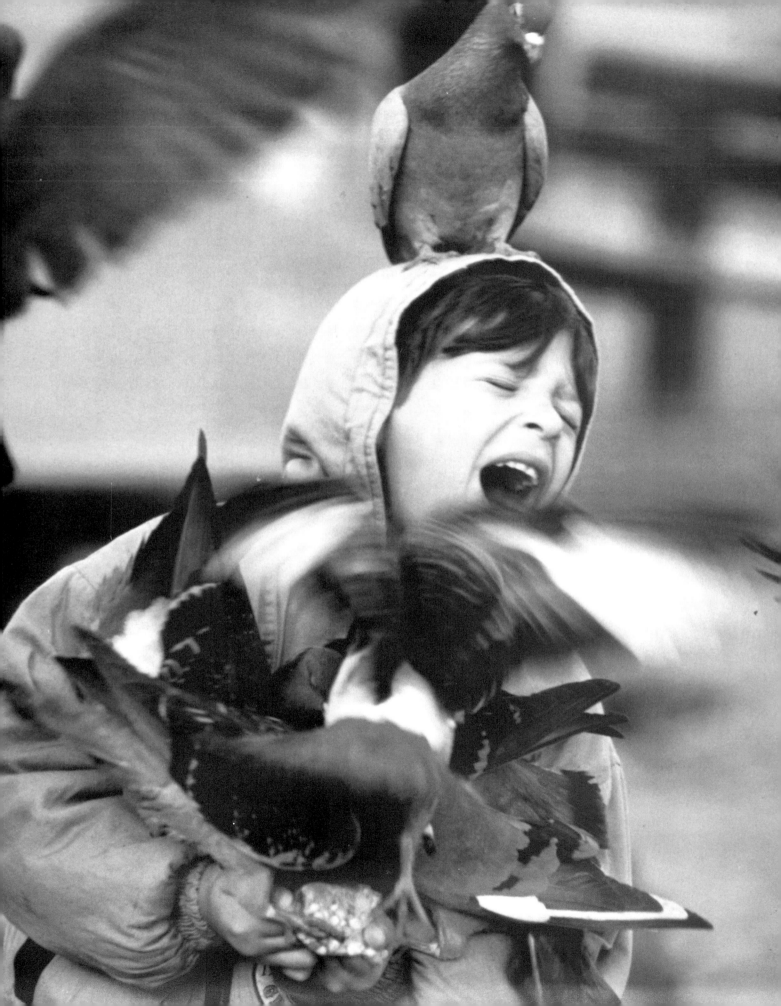

I Can't Believe This Is Happening to Me

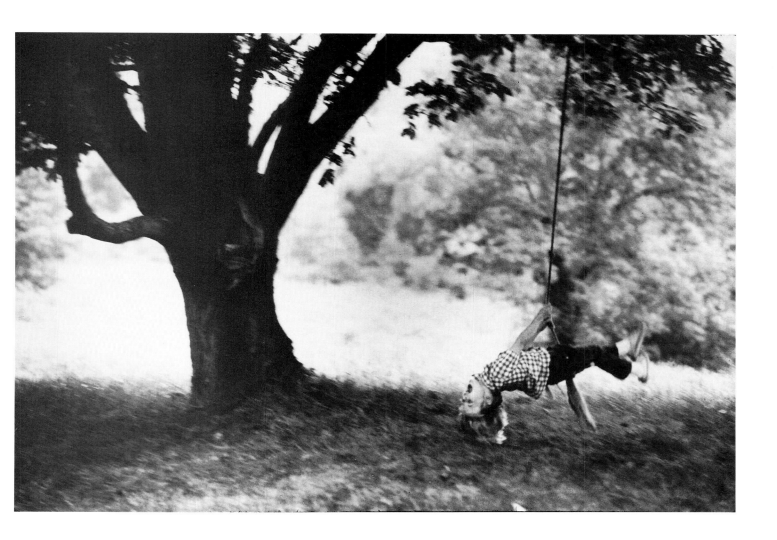

● *Left*

No sooner had this little boy started spreading bread crumbs than bird-word got around. Who said there's no such thing as a free lunch?

Photographer:

Michael Kienitz

● *Above*

Oh, to be young and free on a summer day!

Photographer:

Roger Malloch

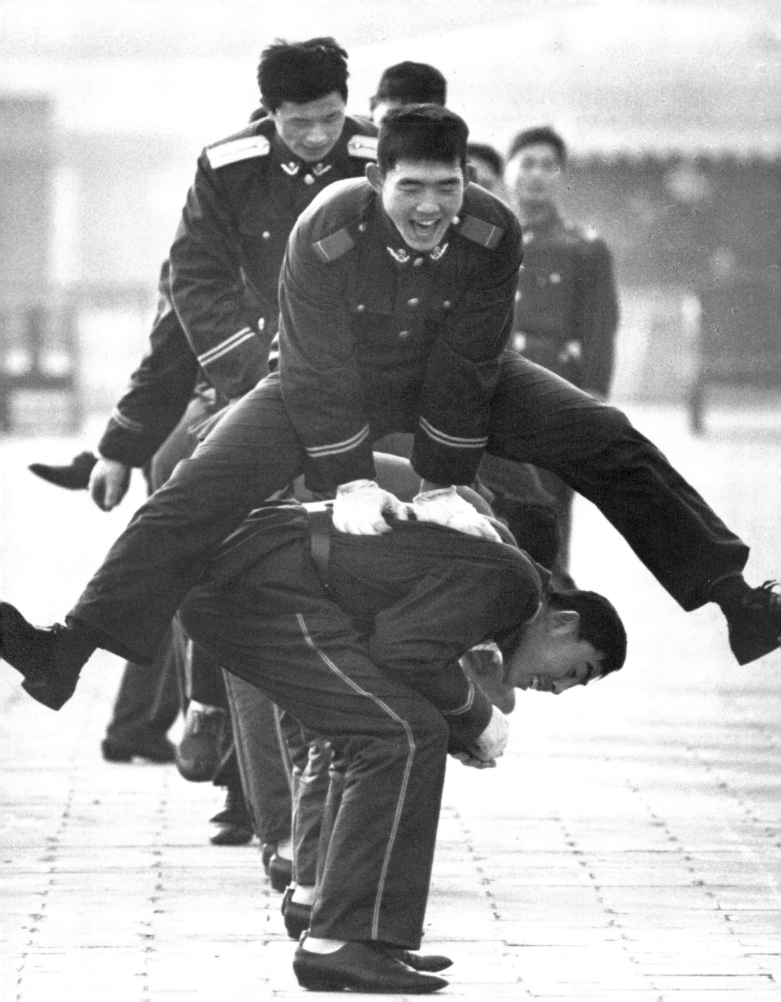

I Can't Believe This Is Happening to Me

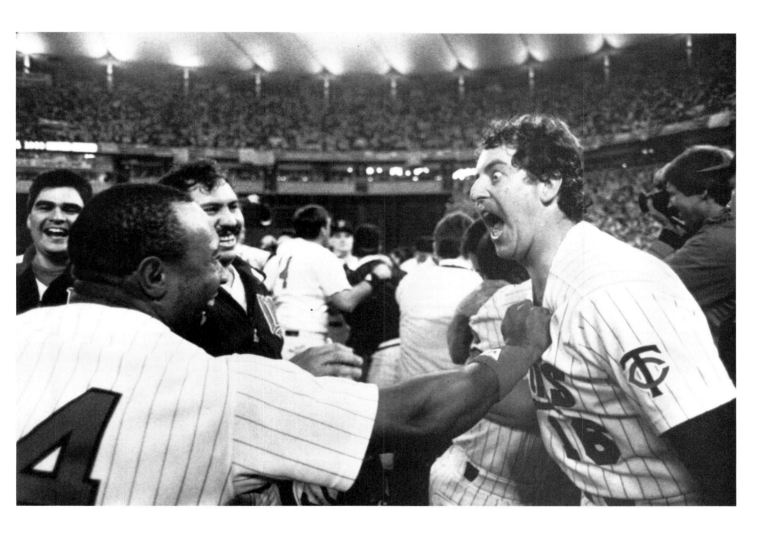

● *Left*

Even Beijing authorities
would probably condone this
display of gaiety from
members of the Chinese
People's Armed Police: In
these ranks leapfrog is
no game, but a rigorous
warm-up exercise.

Photographer:

Dennis Owen

● *Above*

When the Minnesota Twins
beat the St. Louis Cardinals in
the seventh game of the '87
World Series, Twins pitcher
(and most valuable player)
Frank Viola *(right)* looked as
if he wanted to catch a few
more flies.

Photographer:

Reuters/Bettmann

Newsphotos

I Can't Believe This Is Happening to Me

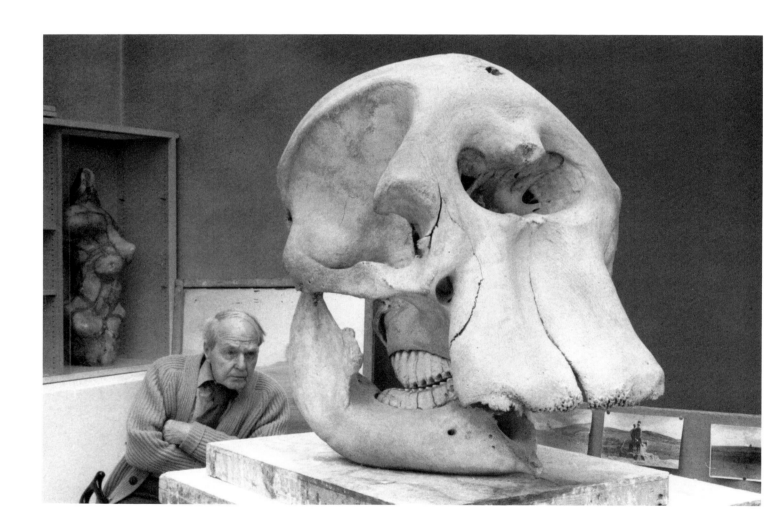

● *Above*

It takes a friend to know a friend: British biologist Julian Huxley gave sculptor Henry Moore this three-foot-tall elephant skull in 1968. Moore did 33 etchings based upon its shape and cavities.

Photographer:

John Loengard

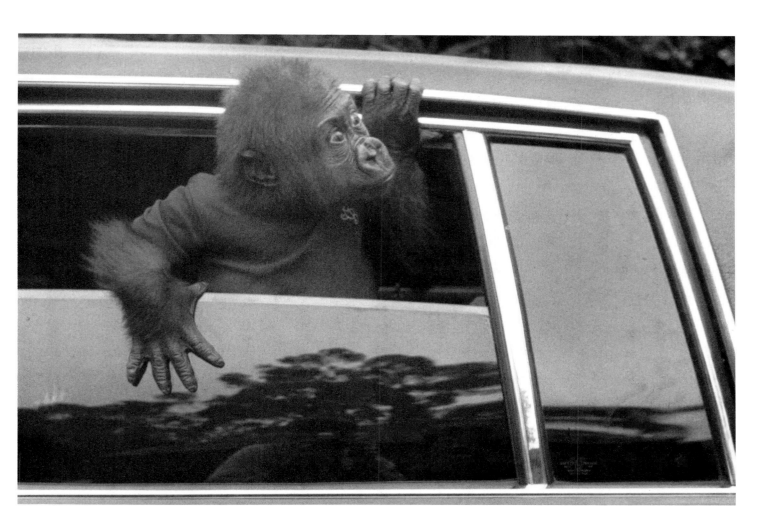

● *Above*

Stop tailgating, ya big ape: It takes gorilla tactics to negotiate those West Coast freeways. That's what Gordon, one and a half, found out while traveling by limo from the San Diego Zoo to a nearby animal park.

Photographer:

Don Kohlbauer

I Can't Believe This Is Happening to Me

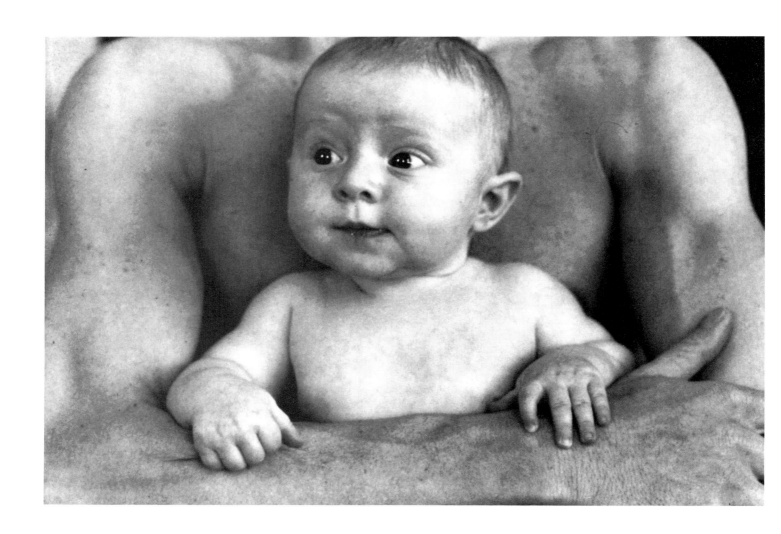

● *Above*

More than a few things can be
chalked up to genetics. . . .

Photographer:

Nicholas Devore III

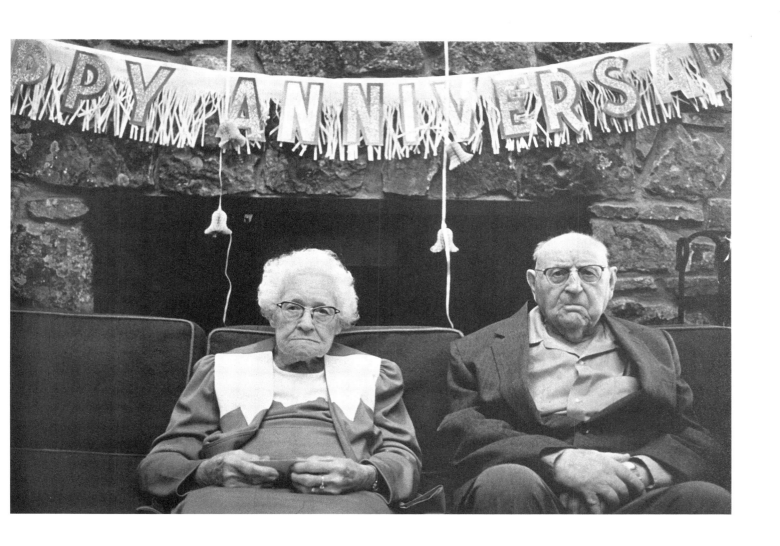

● *Above*

If you had been married to the same person for 74 years, you might look tired too.

Photographer:

Mary Kelley

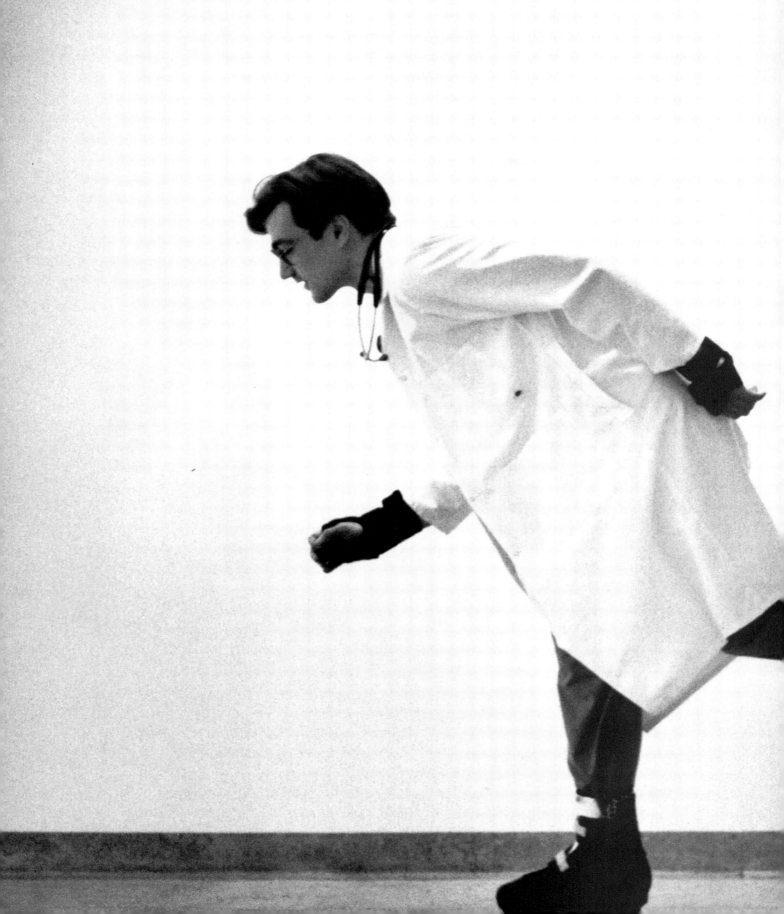

 ← Childrens hospital

 ← Wards 28 - 31

Accidents and
emergencies →

Blood test →

Fracture clinic →

Pharmacy →

X-ray →

Chapter 3

What's Going on Here?

What's Going on Here?

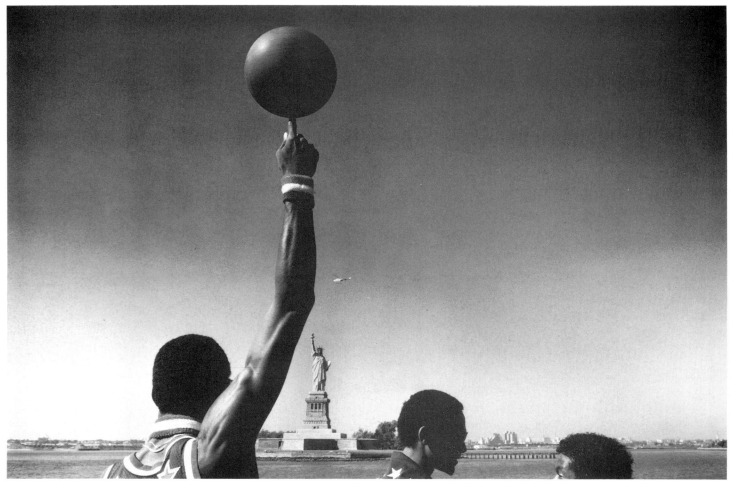

● *Previous page*

Physician, wheel thyself:
Bone-tired from running
three quarters of a mile
between two operating rooms
as many as 30 times a night,
this anesthesiologist decided
to risk his neck to save his
legs.

Photographer:

Tim Smith

● *Above*

The lady with the lamp and
the guy with the globe
(actually a Harlem
Globetrotter) took time to
hail each other across New
York Harbor.

Photographer:

Richard Vogel

● *Right*

Gloomy Saturday. There he
was with his sneakers on and
his favorite laces tied up tight,
but there wasn't anybody to
play one-on-one with. On top
of that, it was drizzling. Oh,
well. Keeping his chin up, this
nine-year-old trudged over to
the schoolyard to shoot
baskets by himself. And look
what happened.

Photographer:

Lloyd Fox

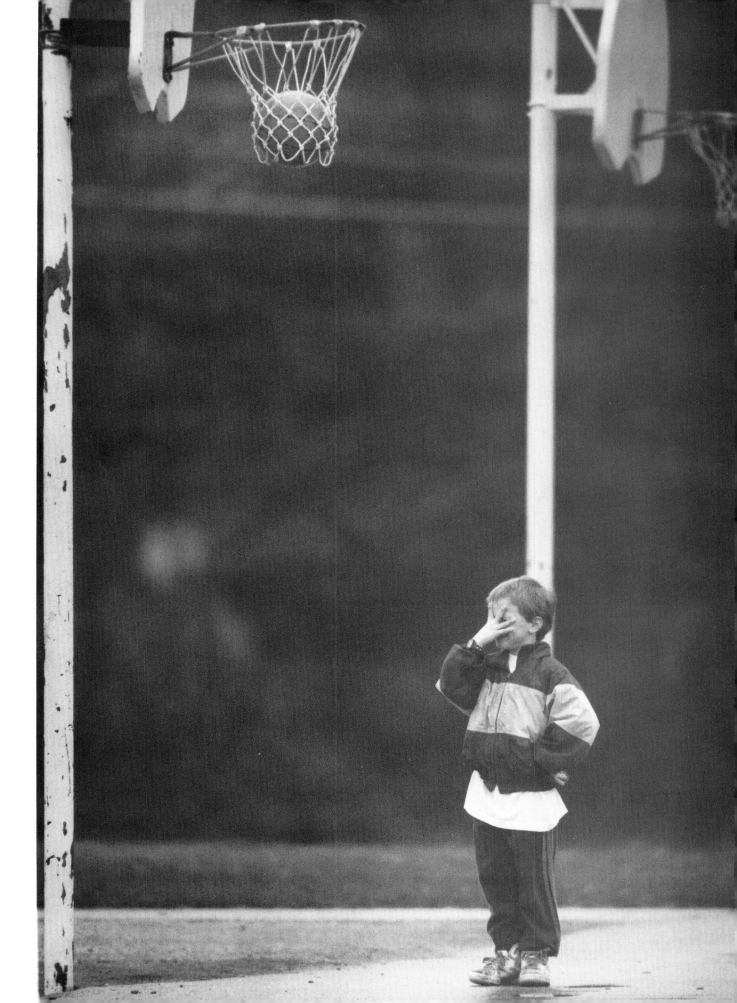

What's Going on Here?

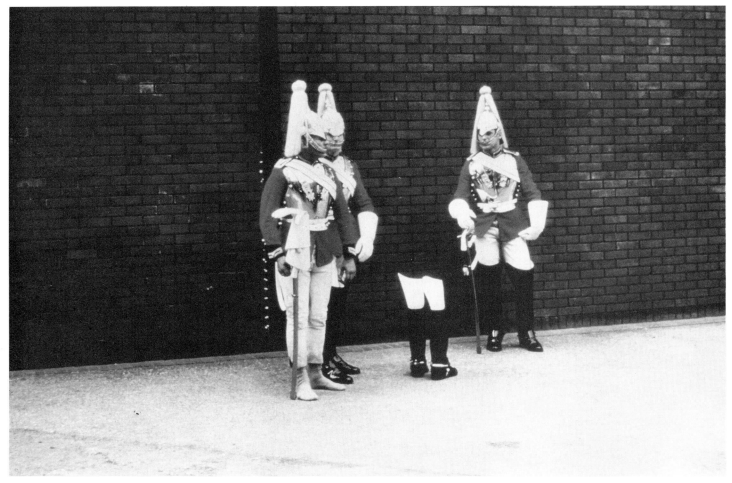

● *Above*

You may have seen the
changing of the guard,
but have you ever seen a
guard changing? Only
Britannia's best-dressed
troopers get picked for palace
duty, so having shined his
jackboots, the footloose chap
left them unscuffed
till the last moment. A
prudent sole.

Photographer:

Carlo Chinca

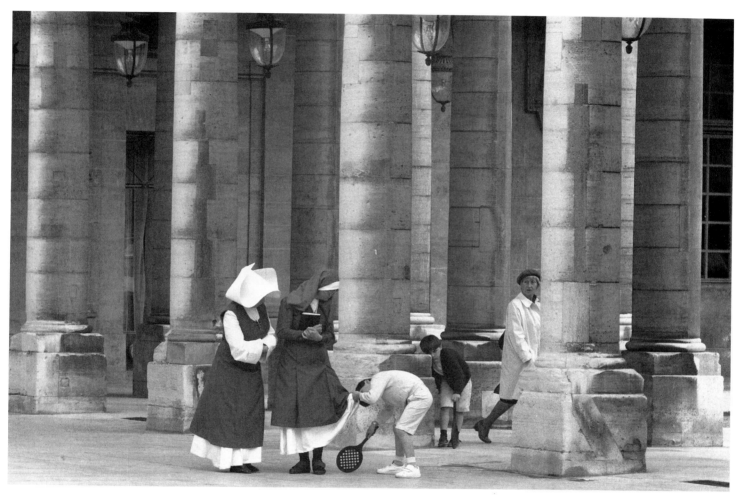

● *Above*

This is not a picture of good and bad but of goodwill and badminton. In Paris a nun in a long skirt benevolently allowed a young player in short pants to have a little innocent fun while seeking a stray shuttlecock. Whether her raised hemline caused her companion a raised eyebrow we'll never know.

Photographer:

Tom Jacobi

What's Going on Here?

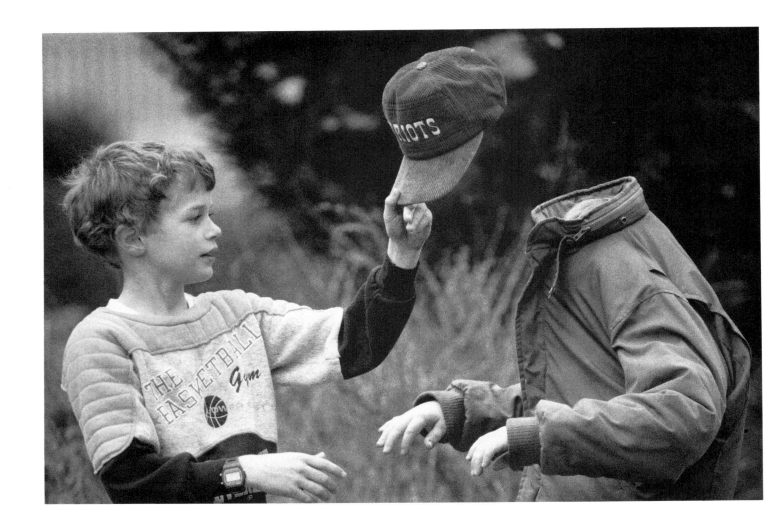

● *Above*

Both nine, these fellows had been wrestling. Then, when one went to grab his friend's favorite baseball hat, things got out of hand—and someone lost his head.

Photographer:

David Molnar

● *Right*

From the way the fella in Portland, Oreg., was gawking, you'd think he'd never seen a topless woman before. Debby—as she is called—also has a great pair of gams, but not one passerby gave them a glance.

Photographer:

Jack Smith

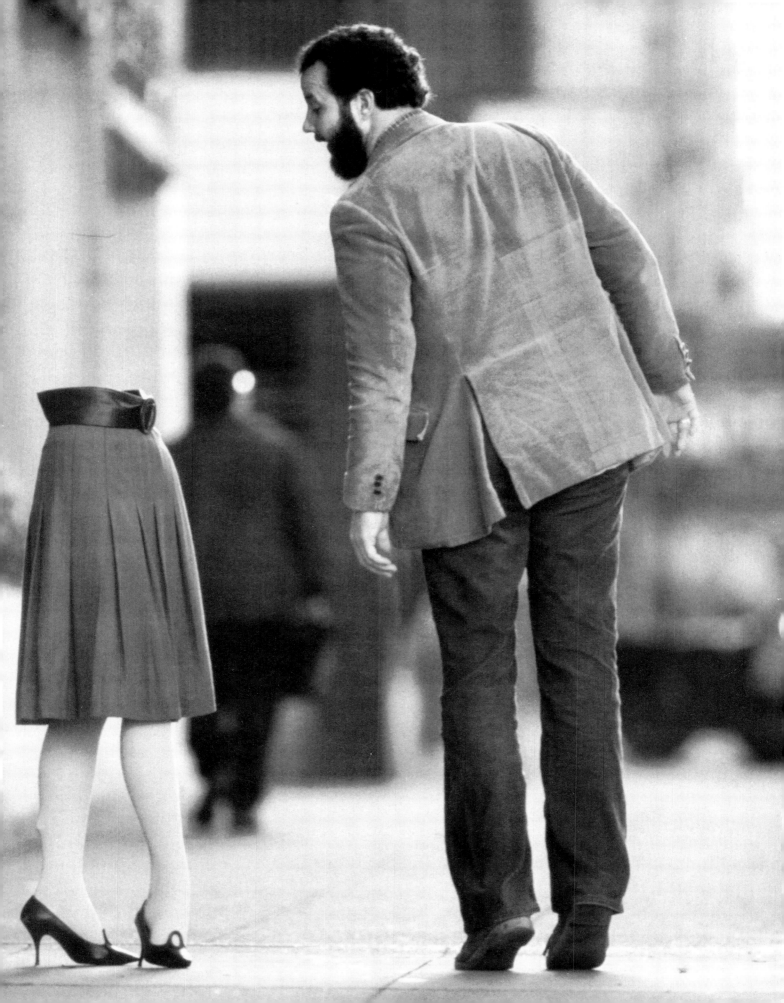

What's Going on Here?

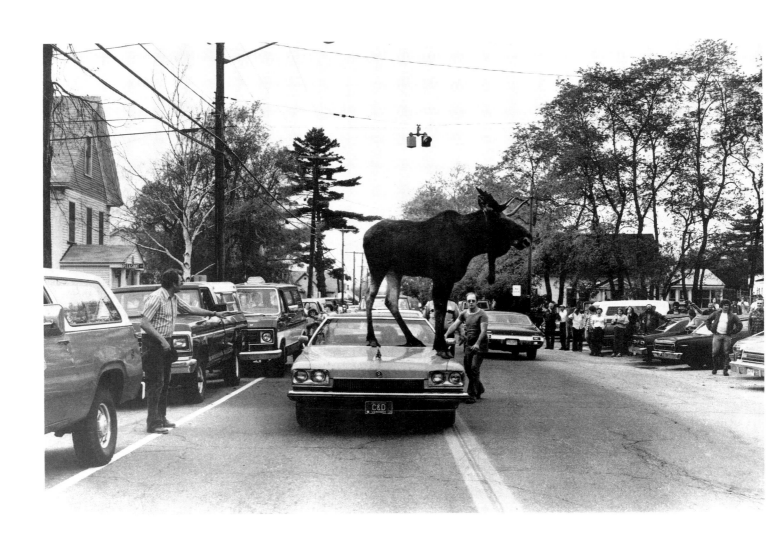

● *Above*

Residents of Groveton, N.H., are used to stray wildlife. But when an 800-pound moose, blinded by a careless hunter's birdshot, clambered onto a car right on the main street, even they took note.

Photographer:

Barbara Tetreault

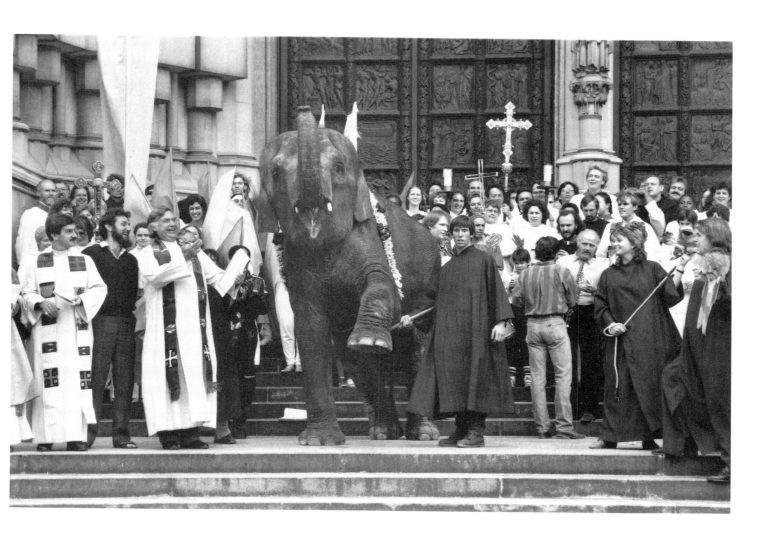

● *Above*

It was a mammoth mass when Minon, a retired circus animal, was trucked in to lead a beastly procession up the center aisle of New York City's Cathedral of St. John the Divine.

Photographer:
Andy Levin

What's Going on Here?

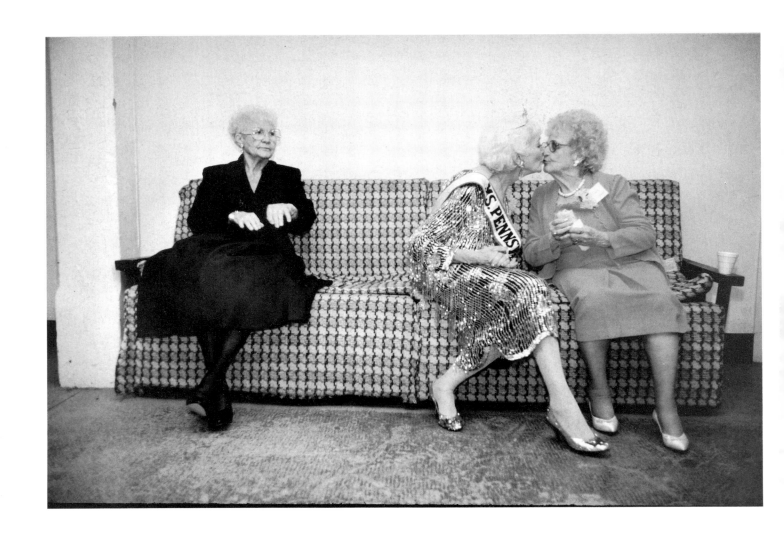

What's Going on Here?

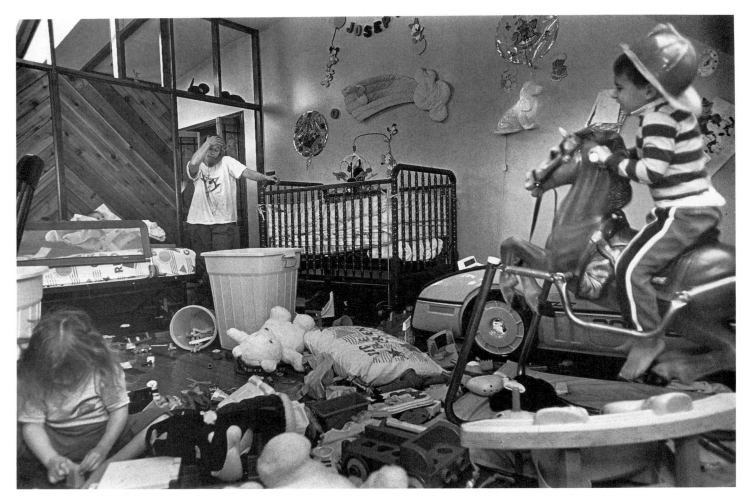

●*Above*

It took 10 minutes for three tiny tornadoes—ages four, three and three months— to wreak this wreckage. Their mother used to think that cleanliness was next to godliness; she soon learned it's next to impossible.

Photographer:

April Saul

●*Right*

United they sat, but not for long. The Joyce quints of Sea Girt, N.J., were posing for a group portrait when suddenly Christopher demonstrated the downside of having to share his third birthday with Megan, Ryan, Kevin and Lauren. Asked to comment, the other four took the Fifth.

Photographer:

Nancy Richmond

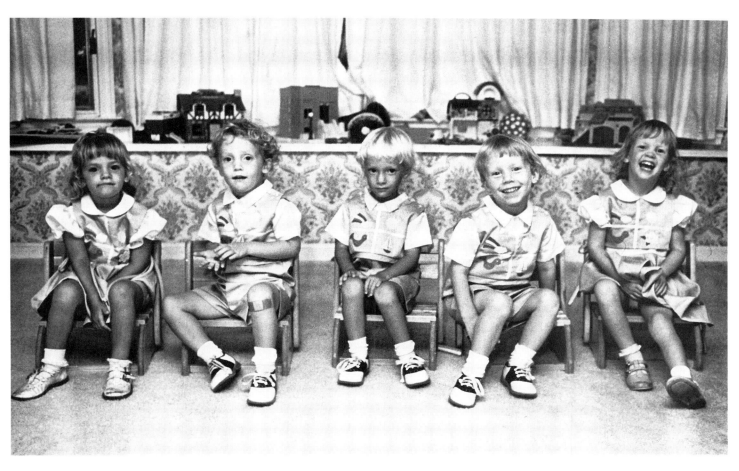

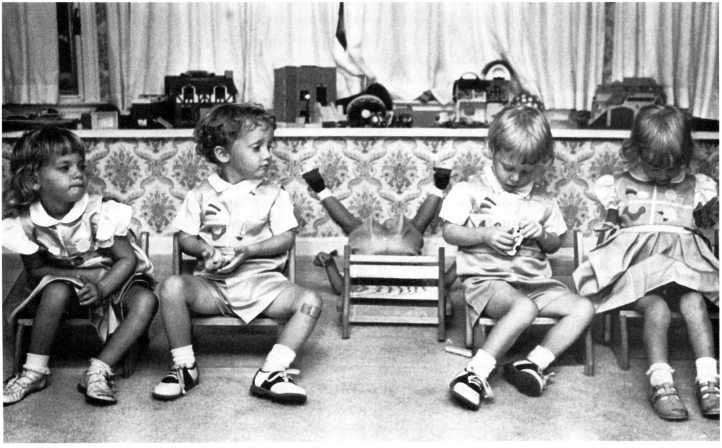

Chapter 4
A Special Kind of Love

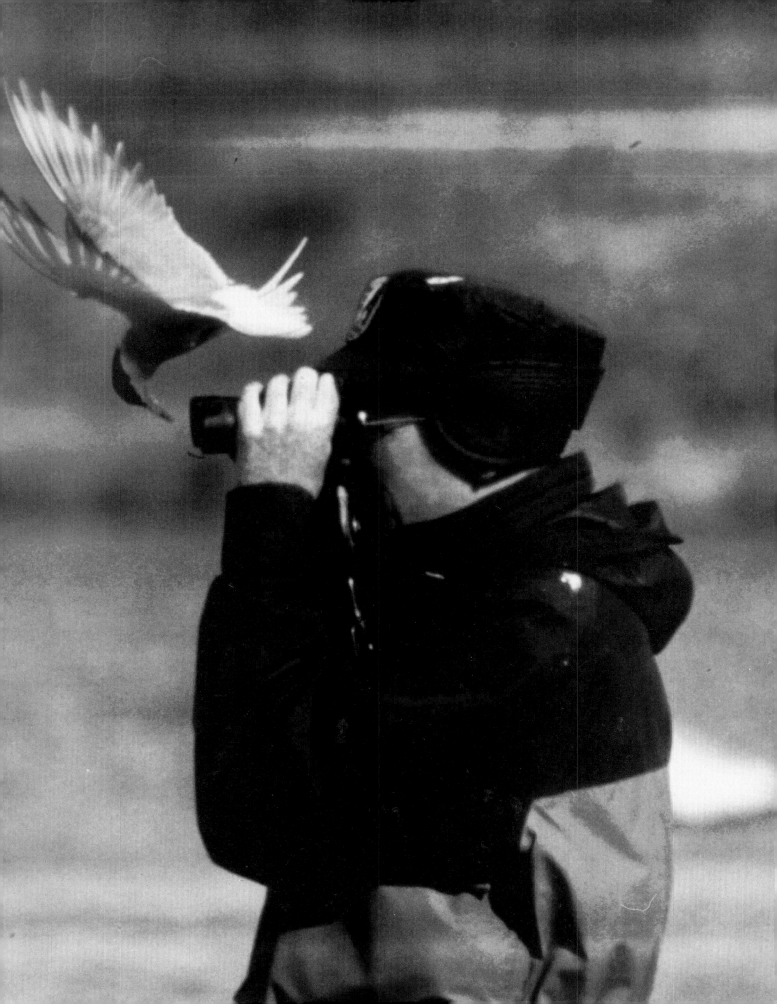

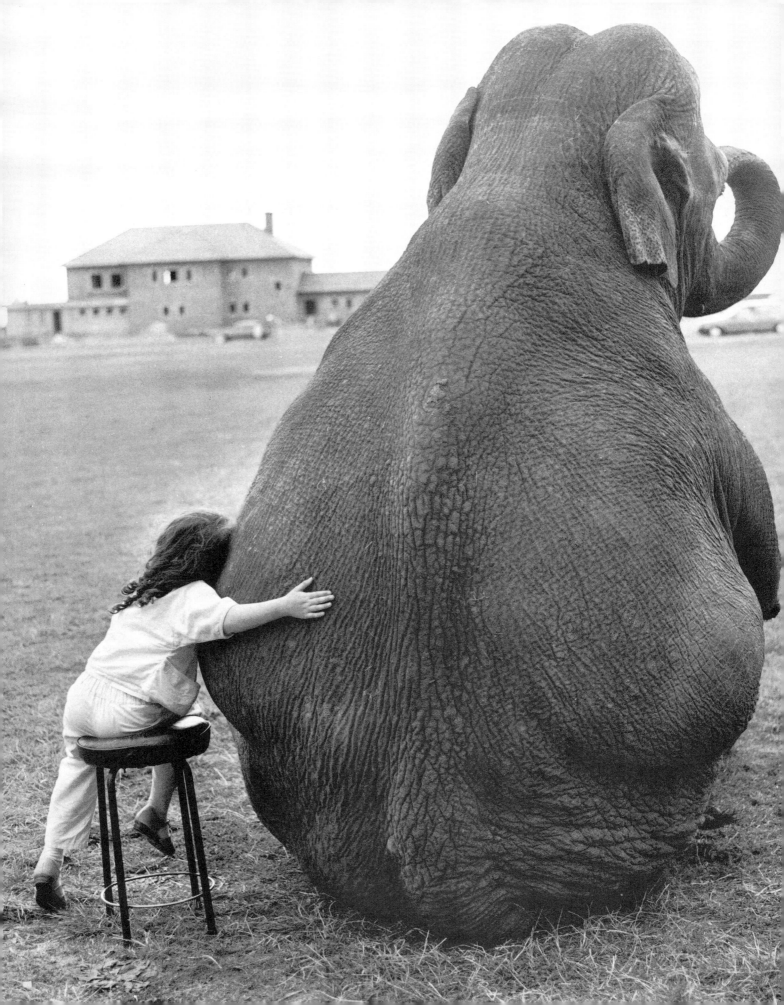

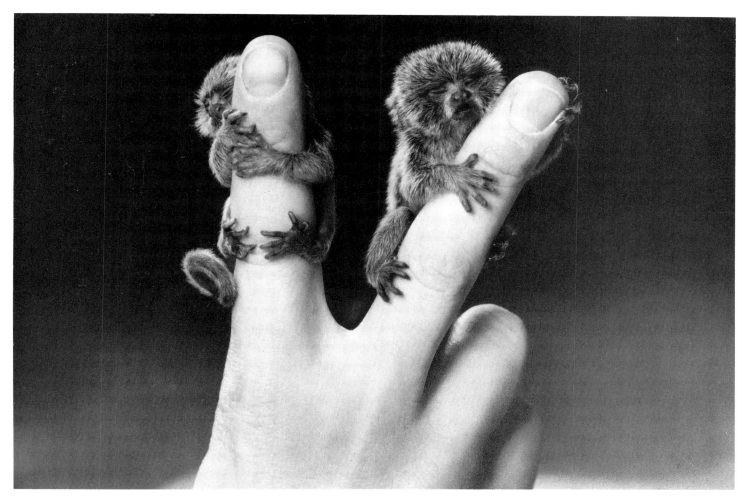

● *Previous page*

Birds seldom make passes at men who wear glasses, but this pesky Arctic bird decided that, sometimes, ternabout is fair play.

Photographer:

Norbert Rosing

● *Left*

Who says a girl and an elephant can't be best friends? One offers rides and a trunk to swing on; the other reciprocates as a child can.

Photographer:

John Drysdale

● *Above*

Most of the occupants of the monkey house at Sweden's Stockholm zoo are hell-raisers, but just this once the keeper had a couple of tenants wrapped around his fingers. These newborn pygmy marmosets, the world's tiniest monkeys, are twins. Adults are about six inches long.

Photographer:

Jan Du Sing

A Special Kind of Love

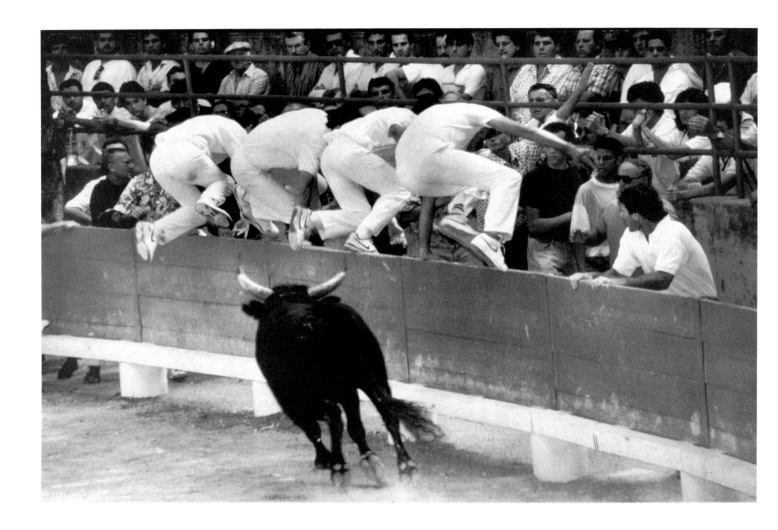

● *Above*

When it became illegal in France to kill the bull in a bullfight, toreadors turned into floreadors. The aim of the Gallic game is to snatch a paper flower off the bull's horns, then run like hell.

Photographer:

Christian Petit

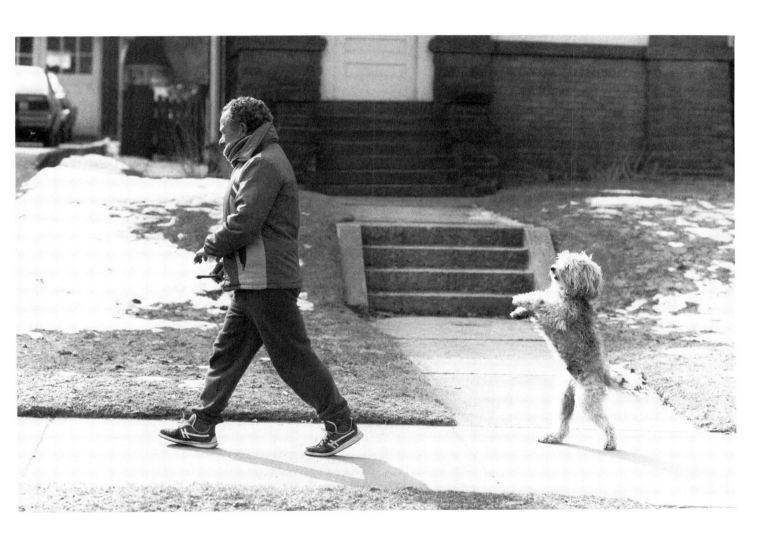

● *Above*

When these two would go for a walk, the biped on the right liked to dog his best friend's footsteps. Left, right, left, right, they marched single file to the corner. Then the shorter one quickened his stride so that the two could cross the street hand-in-paw.

Photographer:

Veronica Henri

A Special Kind of Love

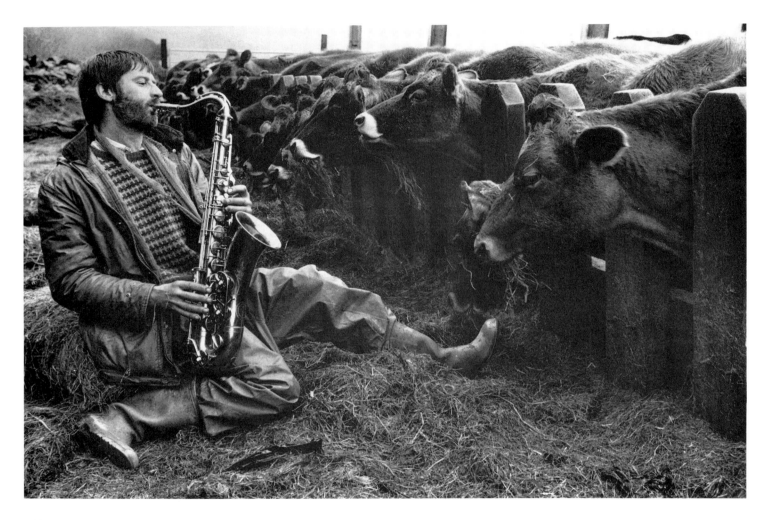

● *Above*

Easy-listening tunes, as all dairymen know, induce udder relaxation. Indeed, Mark Purdey, an English farmer, discovered that his bovines dug the blues. So he made them an offer that blew them away: You provide the cow juice, I'll provide the sax appeal.

Photographer:

John Redman

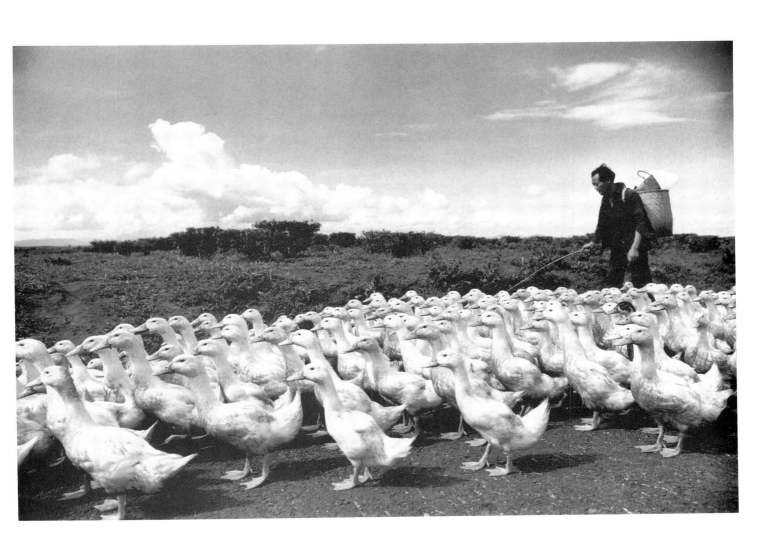

● *Above*

A Vietnamese peasant herds a
highly cooperative bunch of
ducks down a dirt road.

Photographer:

Geoffrey Clifford

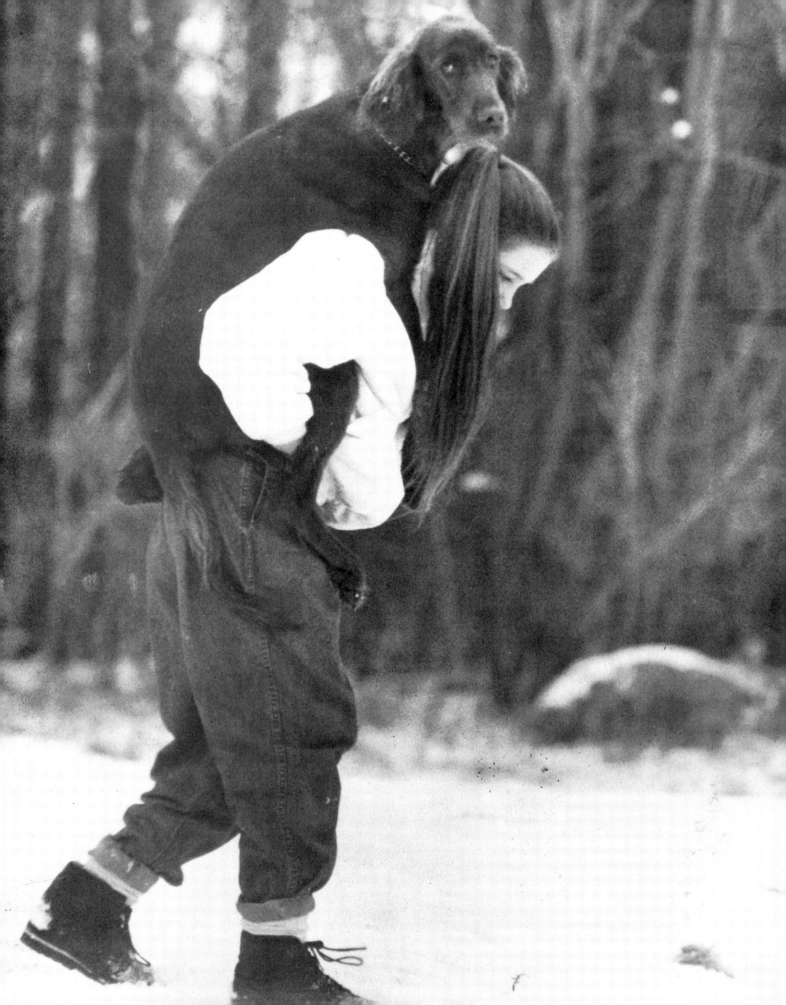

A Special Kind of Love

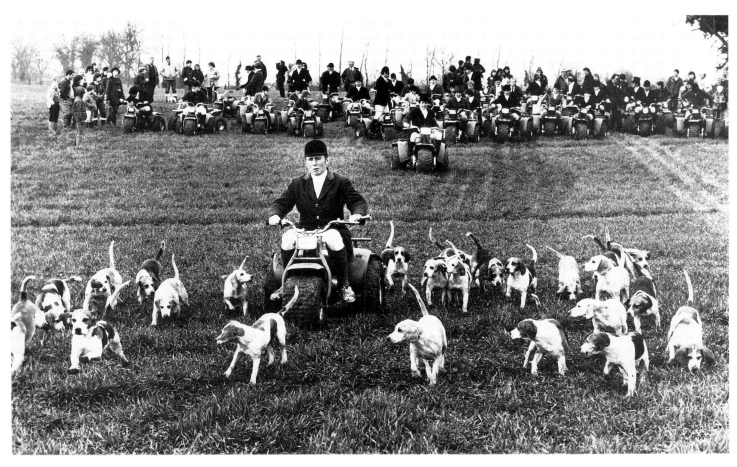

● *Left*

When this Canadian pair went for a walk, the Irish setter was determined not to get his feet wet—or maybe he was simply practicing to be a backpack.

Photographer:
Colin McConnell

● *Above*

In Buckingham, England, 45 members of the horsey set got aboard 45 Honda tricycles and roared off. It all started when a farmer suggested to the huntsmen that minitractors are cheaper to run than horses and cause less damage to fields. The joke snowballed into a charity event that raised money for handicapped children. Tally ho!

Photographer:
Paul Armiger

A Special Kind of Love

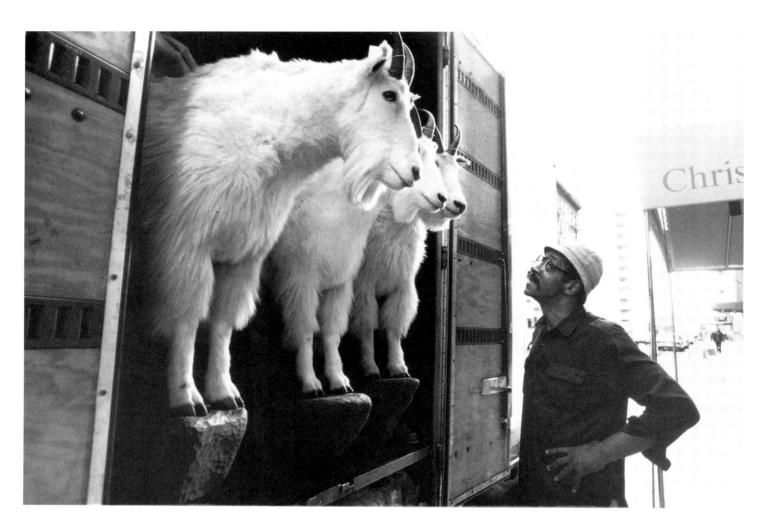

● *Above*

When a trio of stuffed Rocky Mountain goats from the collection of the late A.C. Gilbert, inventor of the Erector set, arrived at Christie's, the New York auction house, they looked happy enough. But what about later—when they brought only $300 each?

Photographer:

Wayne Sorce

● *Above*

When her mom, a nurse and single parent, was called up for the Persian Gulf war, this girl was left behind with a neighbor. Lucky for her, the neighbor also had a horse.

Photographer:

Joe McNally

A Special Kind of Love

In a Hamburg zoo, a camel
and its keeper rooted for the
home team.
Photographer:
Schwartzbach-Argus

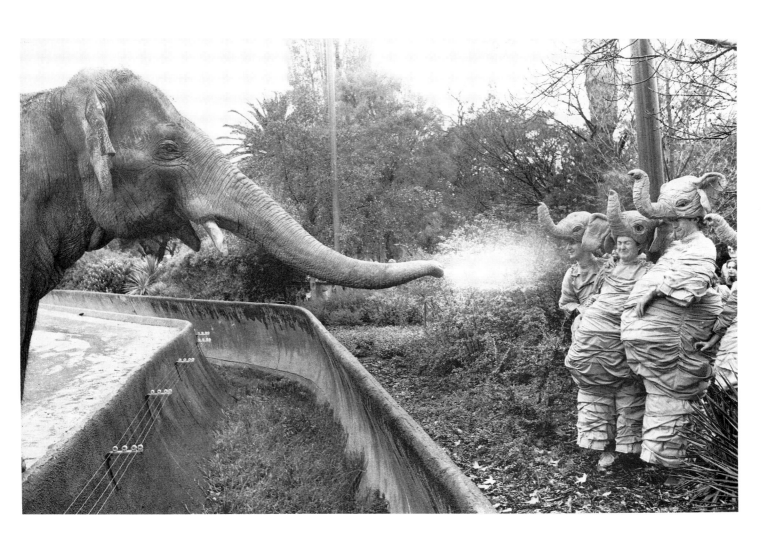

● *Above*

When cast members from *Babar the Elephant* showed up at a zoo to trumpet "Happy Birthday" to a 13-year-old soulmate, their plan boomeranged: The elephant's mate drowned them out with a burst of nasal spray.

Photographer:

John Lamb

A Special Kind of Love

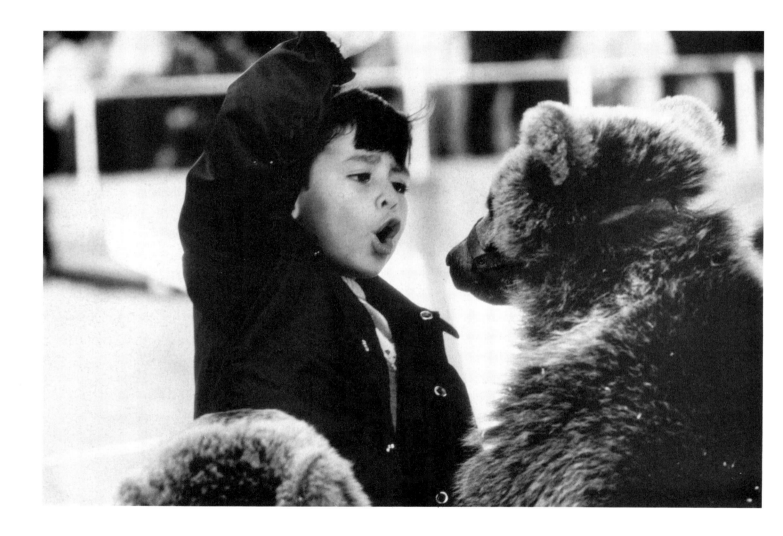

● *Above*

When you're a circus kid, you learn early on who has to be in charge, particularly when you're dealing with a Syrian bear named Piggy.

Photographer:

Co Rentmeester

● *Right*

This California sea lion, who answers to the name of Seamore, can stand, bark and even nuzzle.

Photographer:

Uli Rose

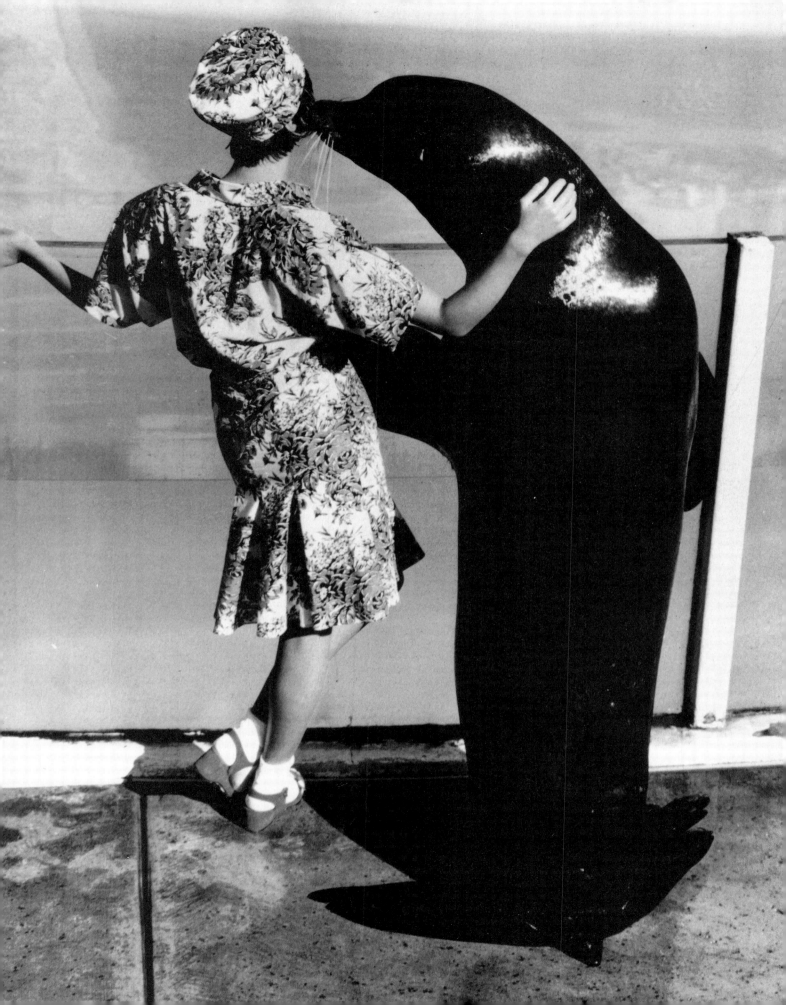

A Special Kind of Love

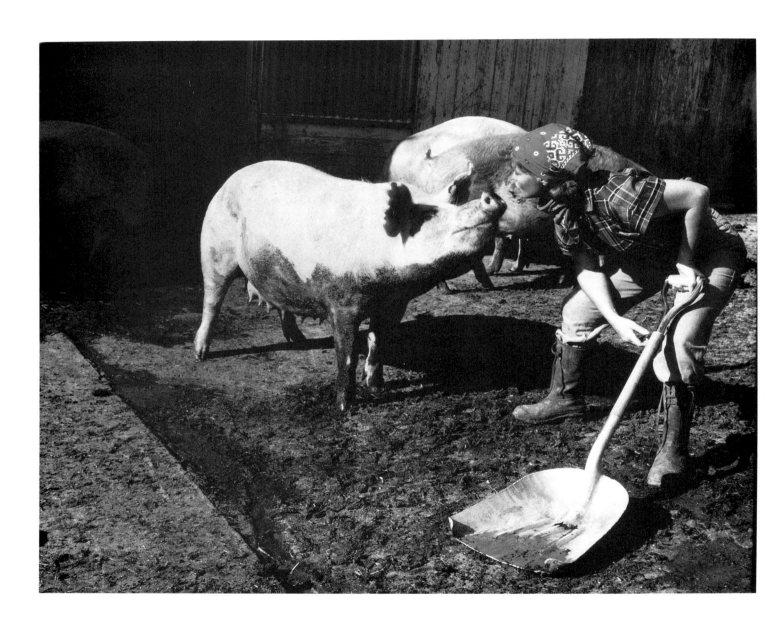

●*Above*

Love is where you find it.
And, then again, maybe not.

Photographer:

Arlene Gottfried

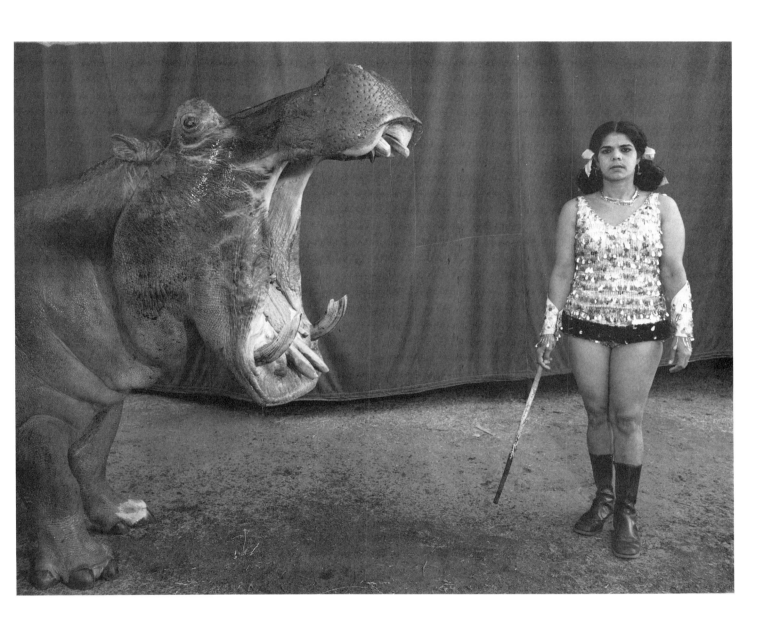

● *Above*

She's not his dentist, just his trainer.

Photographer:

Mary Ellen Mark

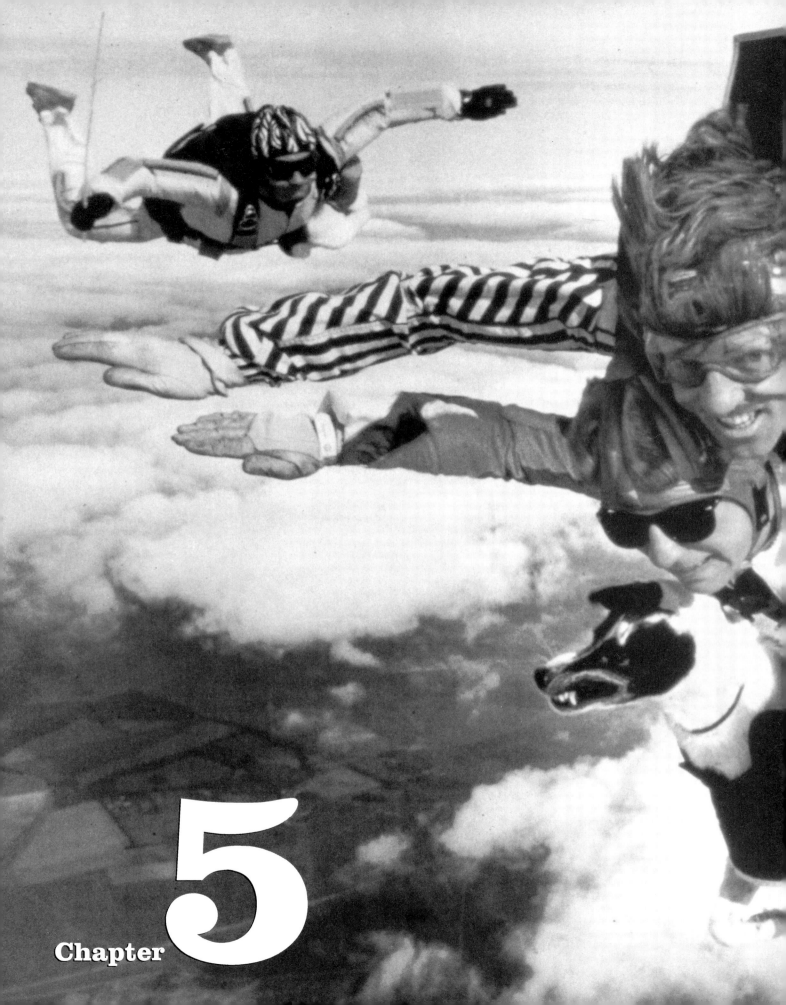

Chapter 5

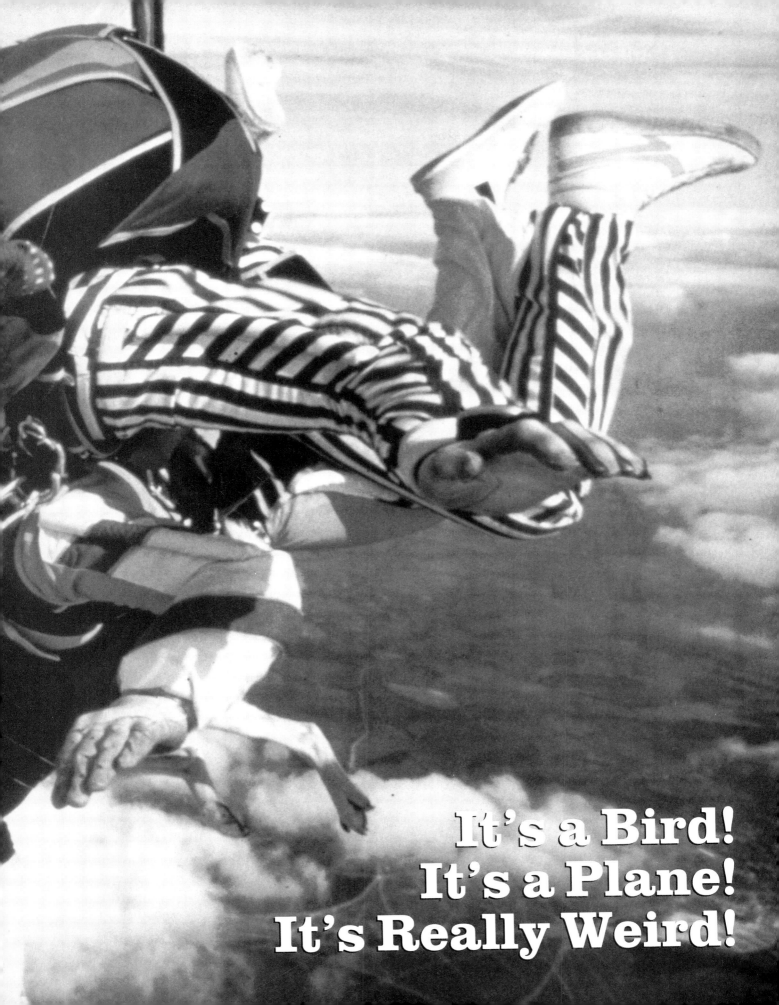

It's a Bird!
It's a Plane!
It's Really Weird!

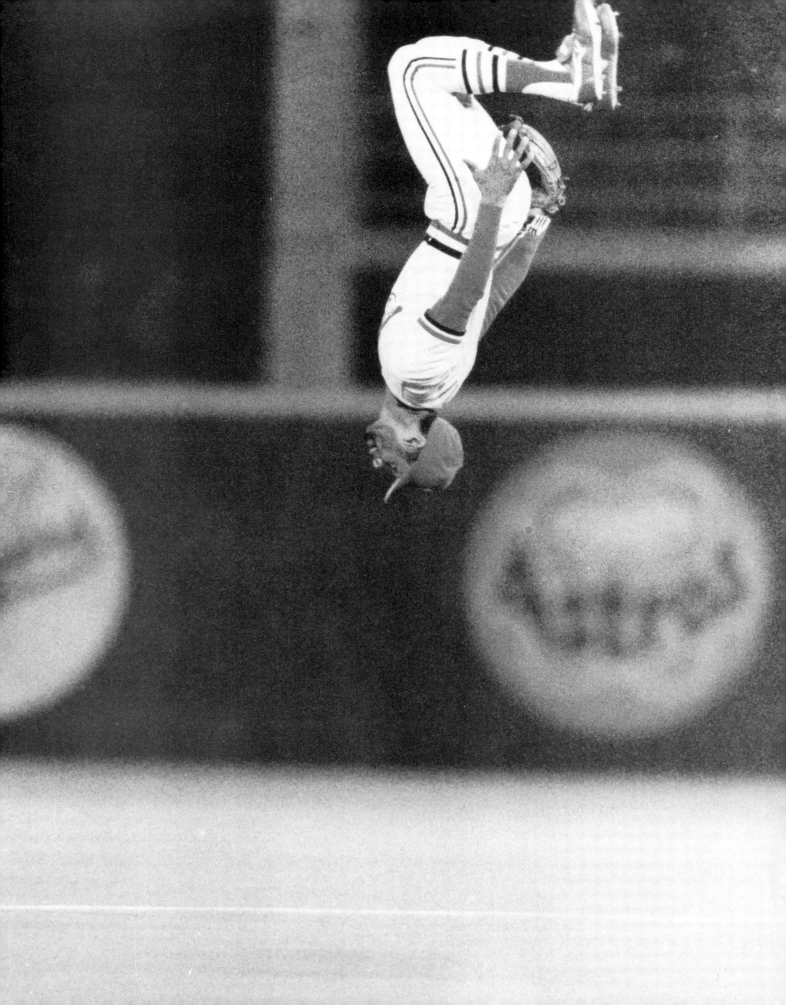

It's a Bird! It's a Plane! It's Really Weird!

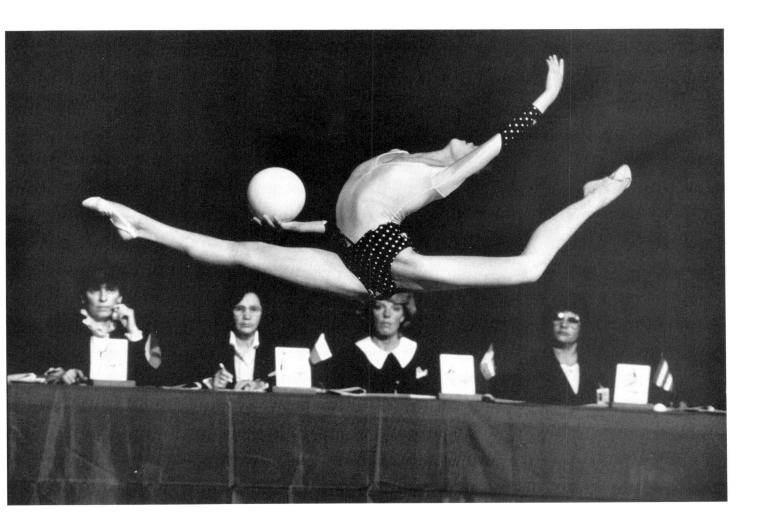

● *Previous page*

What's a best friend for, if not to share life's great experiences? When this mixed breed with a lot of heart landed safely, she wagged her tail and barked incessantly. If only her owner could have joined her.

Photographer:

Dickinson

● *Left*

It was 1985, the Cardinals would go on to win the pennant, and Ozzie Smith, the Wizard of Ahs, turned flipping into a favorite pregame ritual.

Photographer:

Peter Southwick

● *Above*

This gymnast's split-legged leap may look like a perfect 10. But the earthbound judges ranked her eighth in a field of eight.

Photographer:

Gerard Vandystadt

It's a Bird! It's a Plane! It's Really Weird!

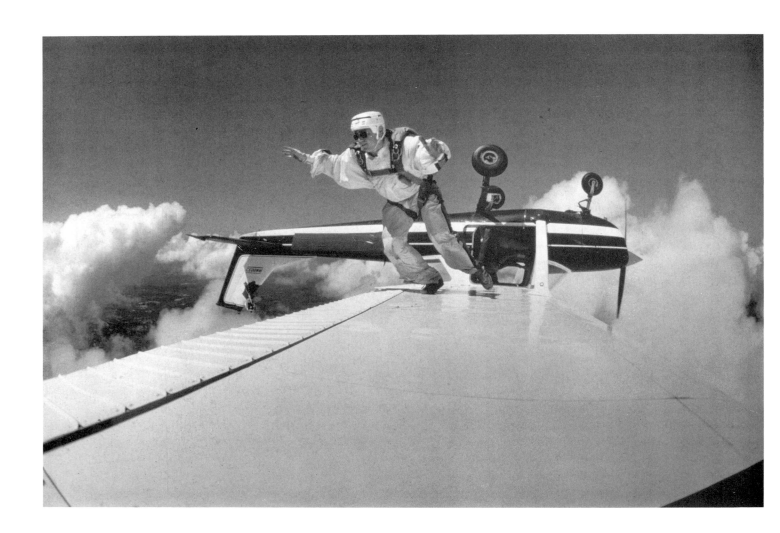

●*Above*

Excuse me, please: Is this the
way to the bathroom?
Actually, the sky diver
tripped a remote-controlled
camera mounted on the
plane's wing tip just before
plunging down toward
South Carolina.

Photographer:

Andy Keech

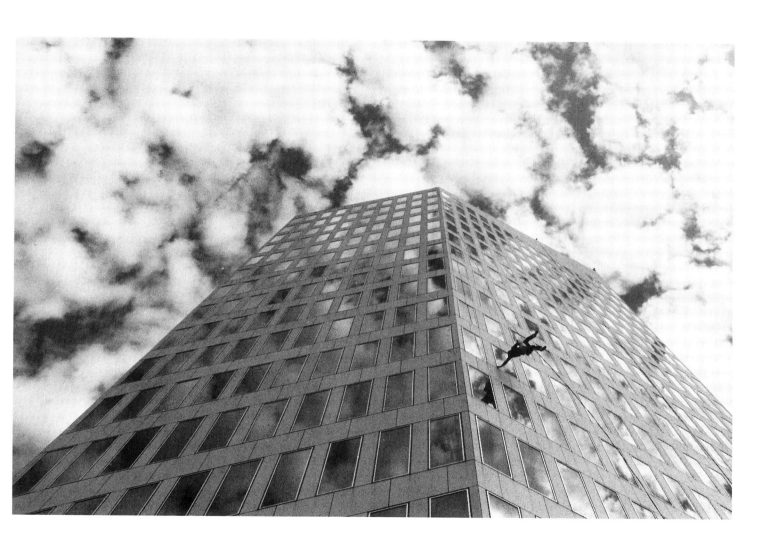

Tethered to an 18-story skyscraper in 15-mph winds, a Dallas window washer proved his stuff. The hard part, he explained, was squeegeeing the windows: "Then I have to let go."

Photographer:

Louis Deluca

It's a Bird! It's a Plane! It's Really Weird!

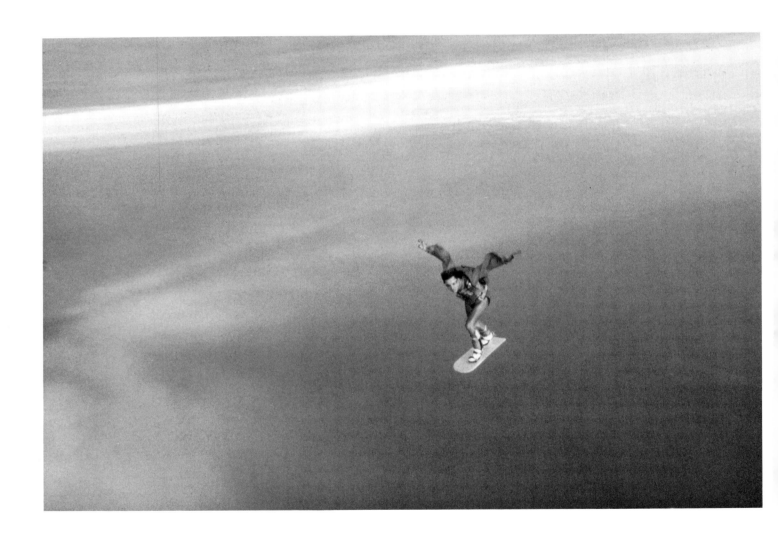

● *Above*

After jumping from a plane
with only a parachute and
a four-foot board, the
sky surfer rode a wave of
clouds 13,000 feet above
the countryside.

Photographer:

Dider Klein

● *Right*

With a final flurry of flippers,
a present-day naiad
disappeared inside a giant
barrel sponge.

Photographer:

David Doubilet

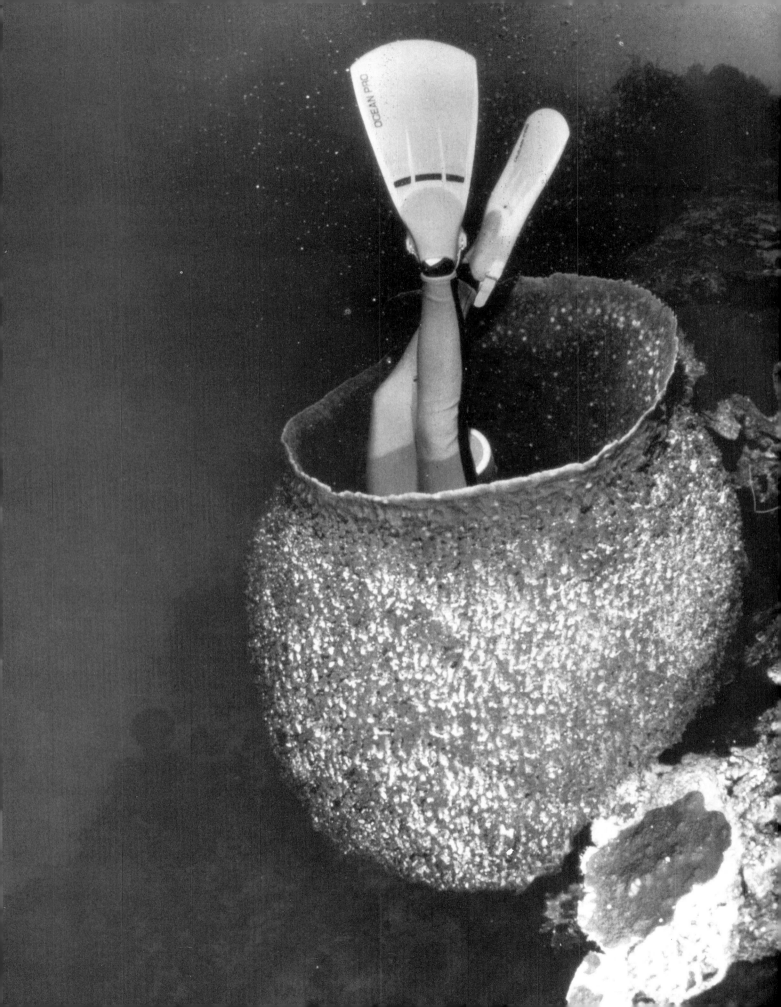

Chapter

6

Water, Water
Everywhere . . .

Water, Water Everywhere . . .

● *Previous page*

Sneak attack!

Photographer:

Dion Johnson

● *Above*

Say "Cheese."

Photographer:

Alex Webb

● *Right*

No, it's not a 12-inch diver. It's a 28-foot chair. The 1.8-ton piece of furniture was floated onto Switzerland's Lake Constance and positioned on an underwater scaffolding. And you thought Switzerland only had tall mountains.

Photographer:

Otto Kasper

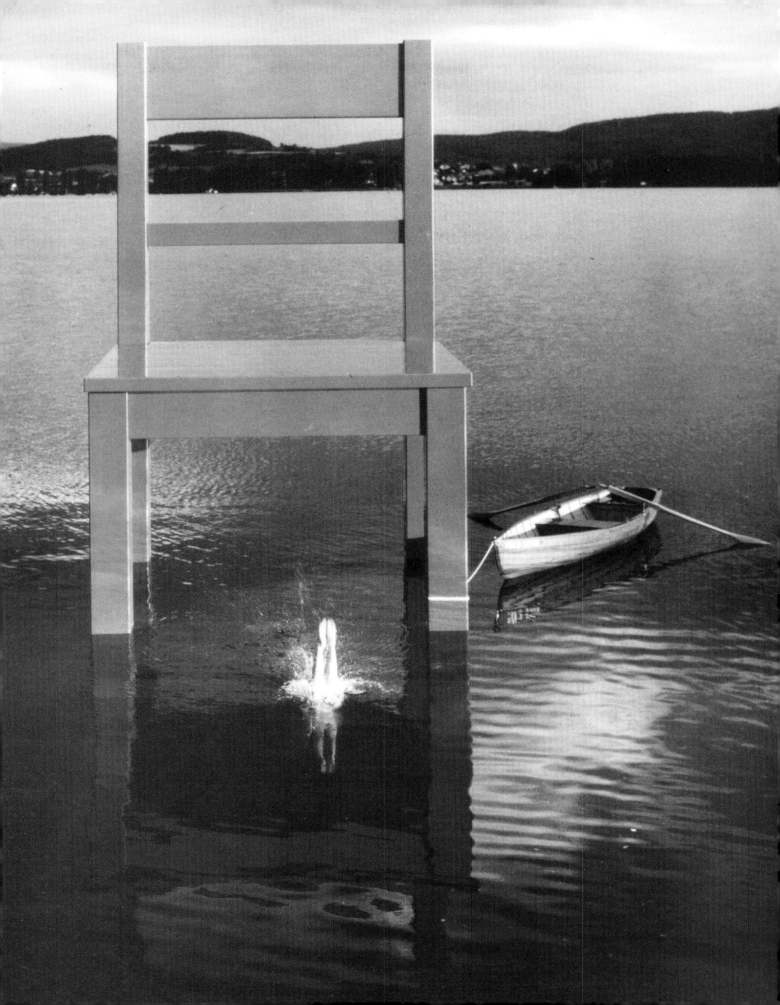

Water, Water Everywhere . . .

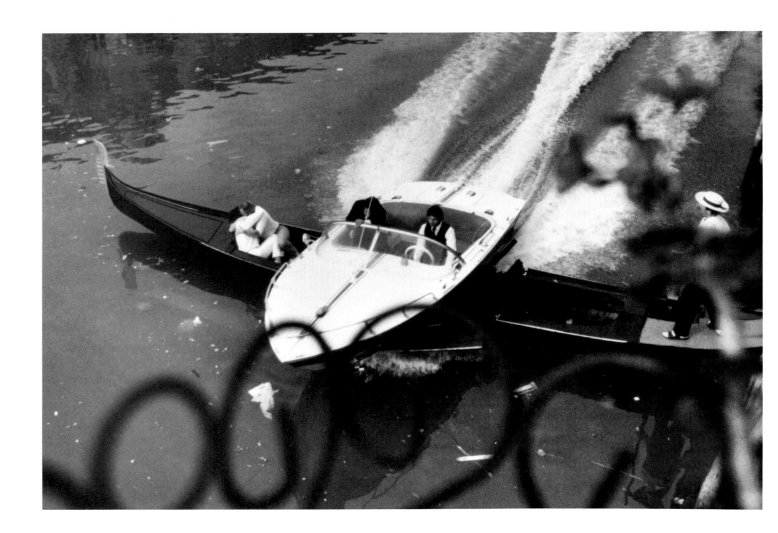

● *Above*

All in a day's work: During the filming of one of the 007 classics, *Moonraker*, a couple of thugs in hot pursuit of the elusive spy drove their speedboat straight through a passing gondola.

Photographer:

Co Rentmeester

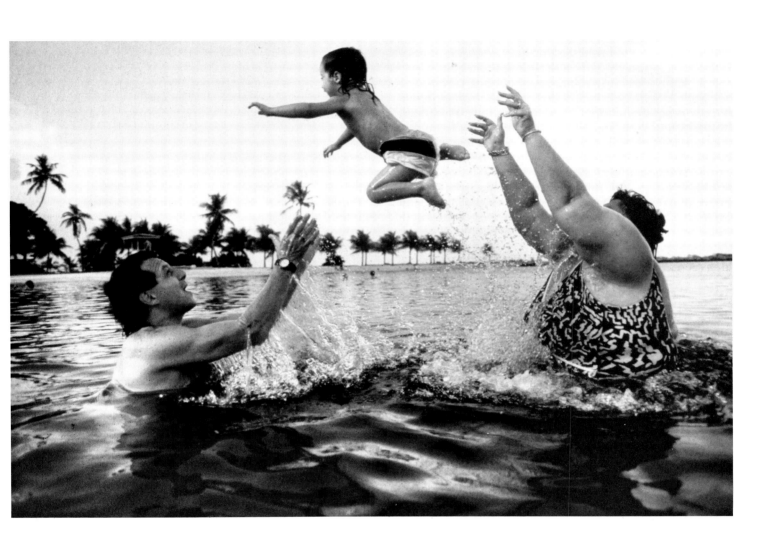

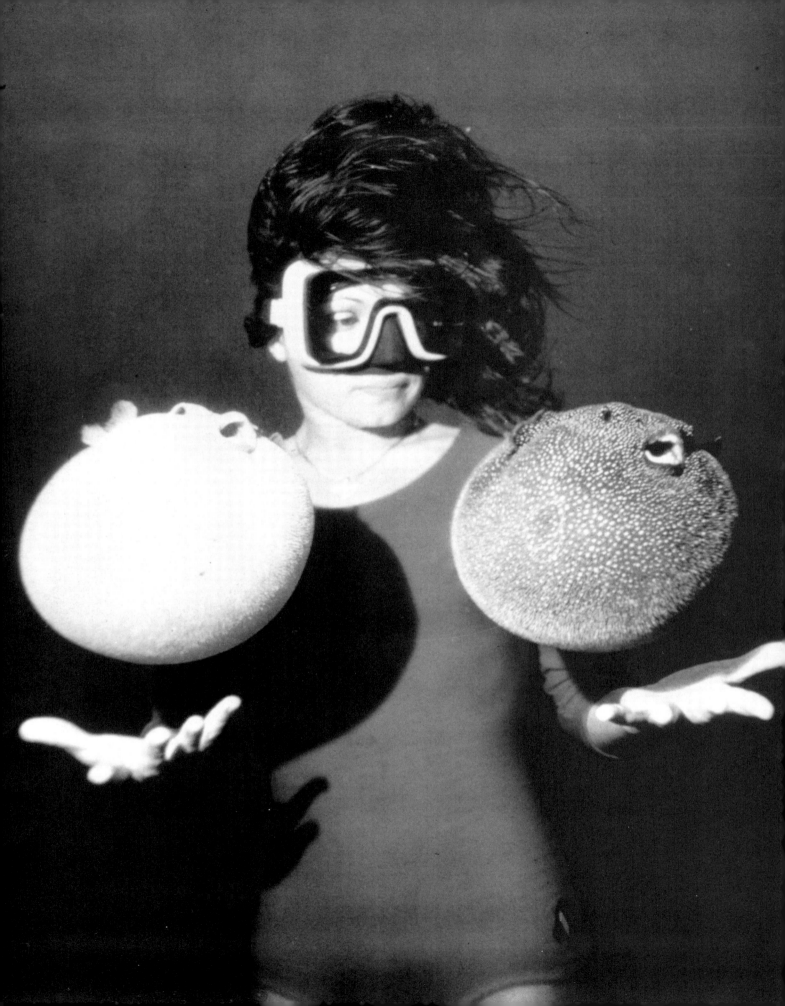

Water, Water Everywhere . . .

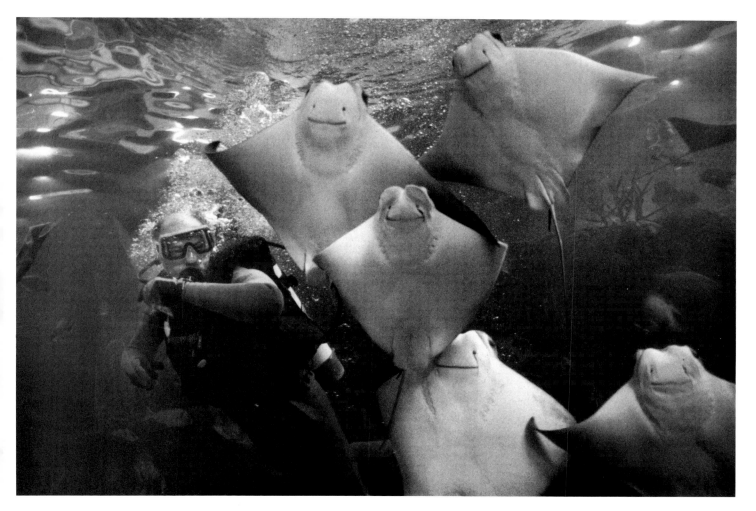

● *Left*

Juggling takes on new meaning 20 meters below the surface of the Indian Ocean— particularly when one's dealing with some agitated blowfish.

Photographer:
Agentur Binanzer

● *Above*

In their native Caribbean water, cow-nose rays can, when aggravated, deliver a venomous sting. But in the New Orleans Aquarium of the Americas they prefer to eat out of their keeper's hand and please the crowd with their angelic smiles.

Photographer:
Alexander Barkoff

Water, Water Everywhere . . .

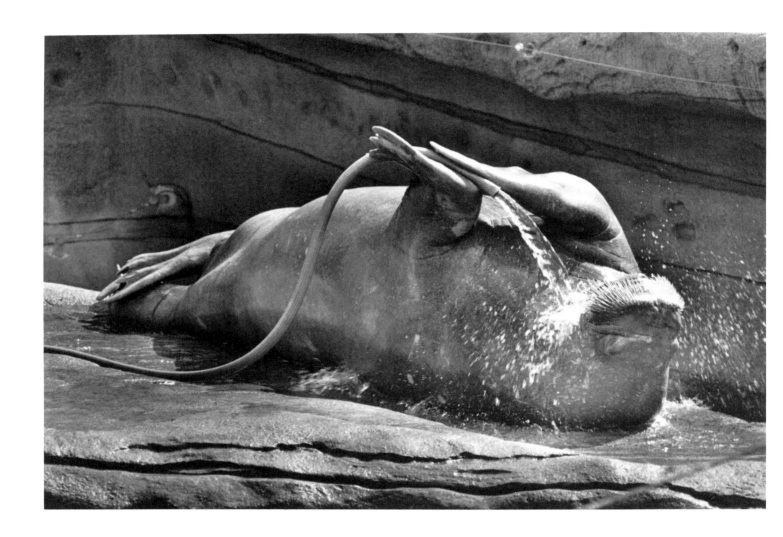

● *Above*

After a hard day of flipping out visitors to the Cincinnati Zoo, Aituk, something of a show-off, gives the crowd her best shot, neat—she wets her whiskers, takes a slug and spritzes the unsuspecting.

Photographer:

Rob Burns

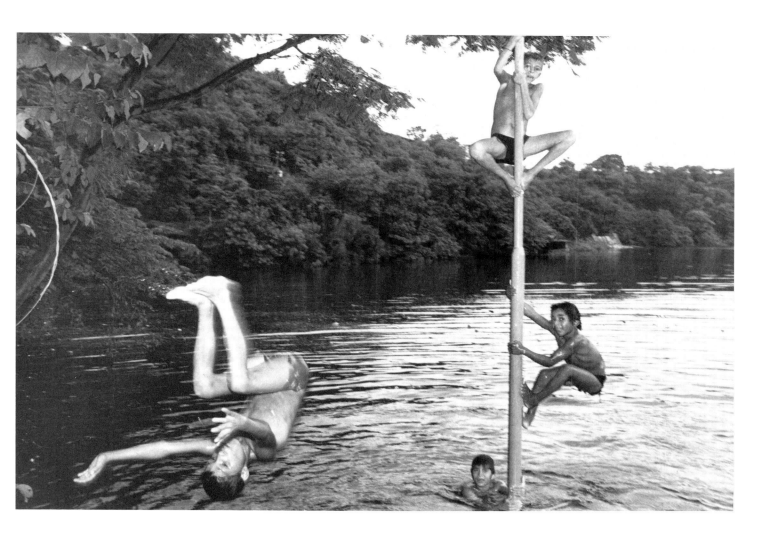

● *Above*

In Nicaragua, kids know
how—and where—to have
fun. Take for instance a
volcanic lagoon in the center
of Managua: It's perfect for
that perfect back flip.
Photographer:
Diego Goldberg

109

Water, Water Everywhere . . .

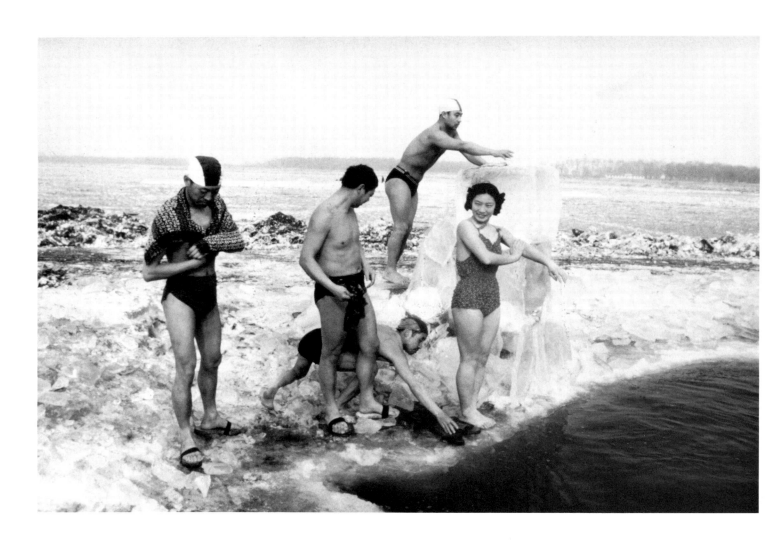

● *Above*

During winter in
Heilonqjiang, the
northeasternmost province of
China, fitness buffs took time
during their lunch hour for a
couple of one- to two-minute
dips in the Songhua River.
The water is about 32° F but
the air is -32°.

Photographer:

Hiroji Kubota

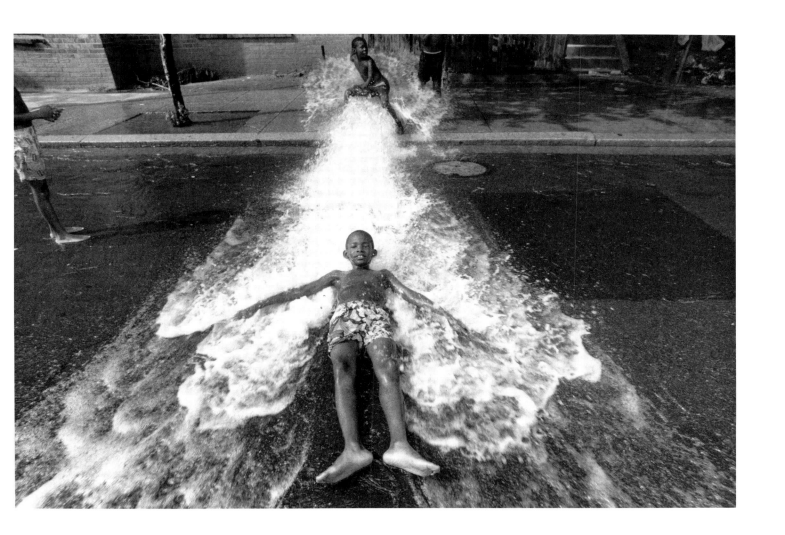

●*Above*

On a hot day in Washington, D.C., it took a kid to know how to make a waterfall.

Photographer:
Eugene Richards

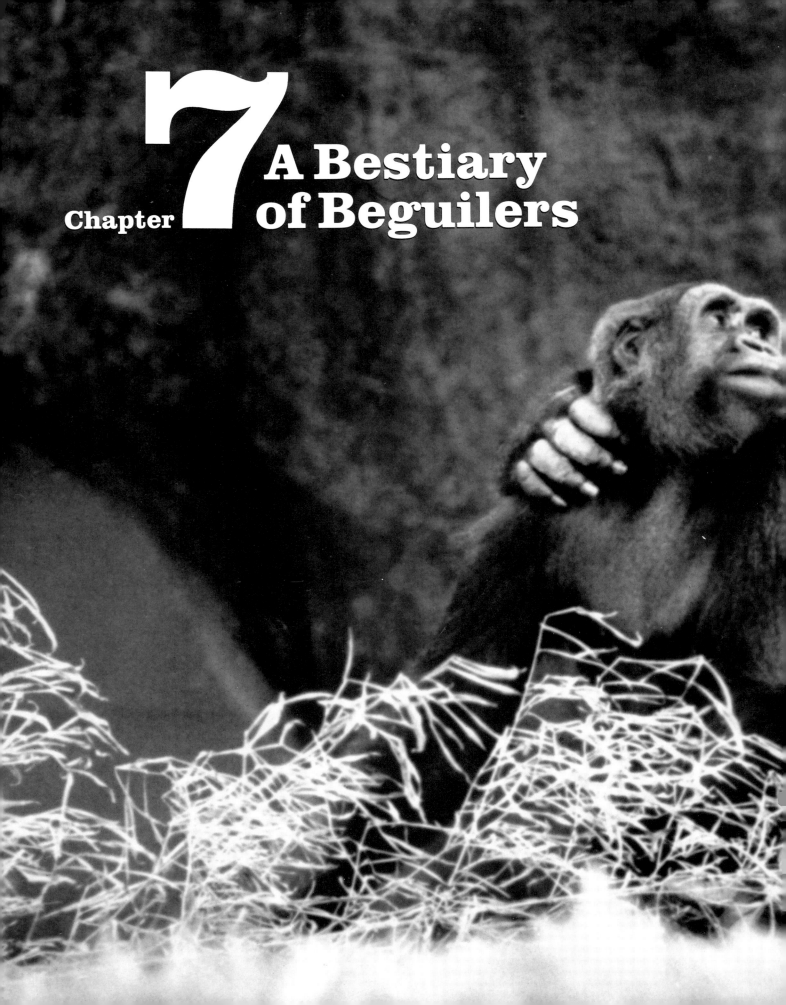

Chapter **7** **A Bestiary of Beguilers**

A Bestiary of Beguilers

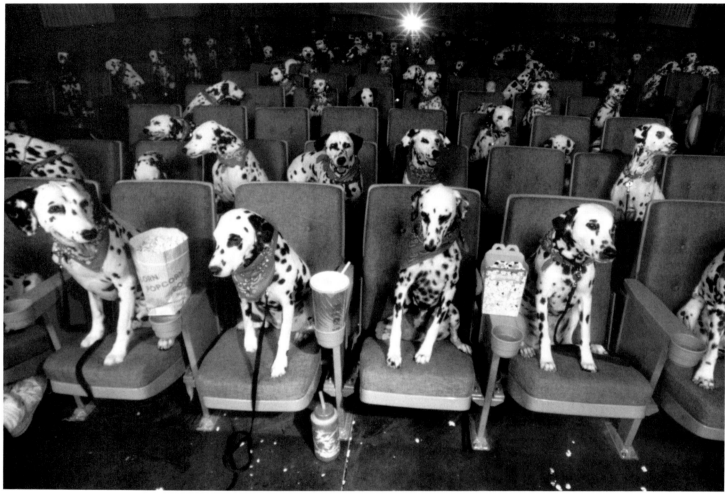

● *Previous page*

Willie B. had spent over three decades in celibate confinement until Zoo Atlanta enlarged its primate collection and built an outdoor habitat. When the gorilla first consorted with the ladies, he was immediately slapped by an adult female. Kinyani, six and a half here, softened up the big guy with chase and wrestling games. And, well, the rest is history.

Photographer:

Rich Mahan

● *Above*

A theater in Scottsdale, Ariz., put on the dog when it invited a pack of snappish critics to a screening of *101 Dalmatians.* Management thought better of serving hot dogs, but the popcorn was a hit. And when villainess Cruella De Vil appeared . . . well, it was a good thing that an owner was crouching behind every seat, restraining his leashed beast.

Photographer:

Melanie Rook D'Anna

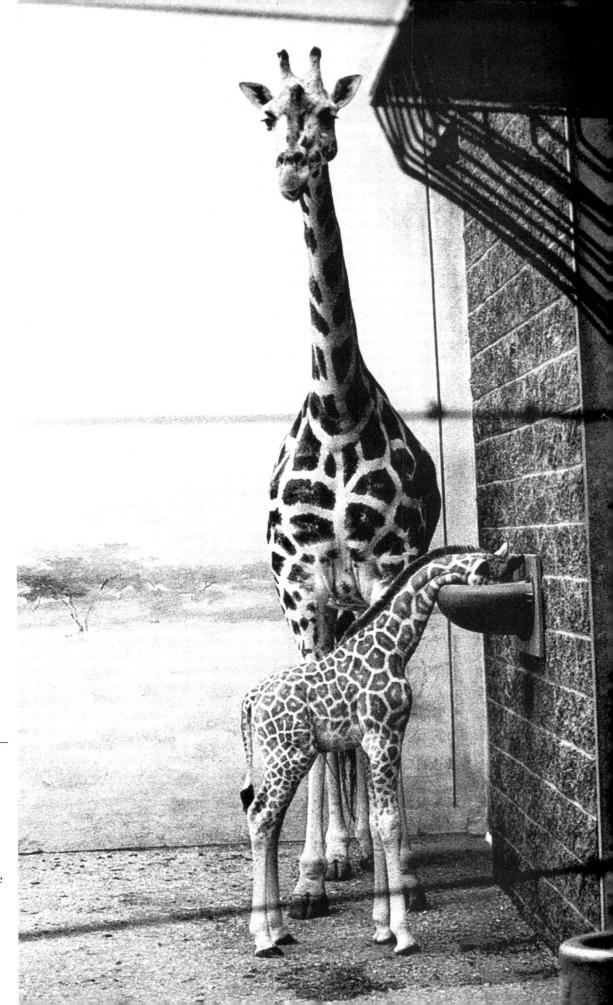

● *Right*

Even at birth, Mama Clara's baby Margaret was a long drink of water. Though the Baringo giraffe was born far from her species' native Kenya and Uganda, she's perfectly at home in New York City's Bronx Zoo. All the modern conveniences are within reach—especially if you're willing to stick your neck out.

Photographer:
Gerald Herbert

A Bestiary of Beguilers

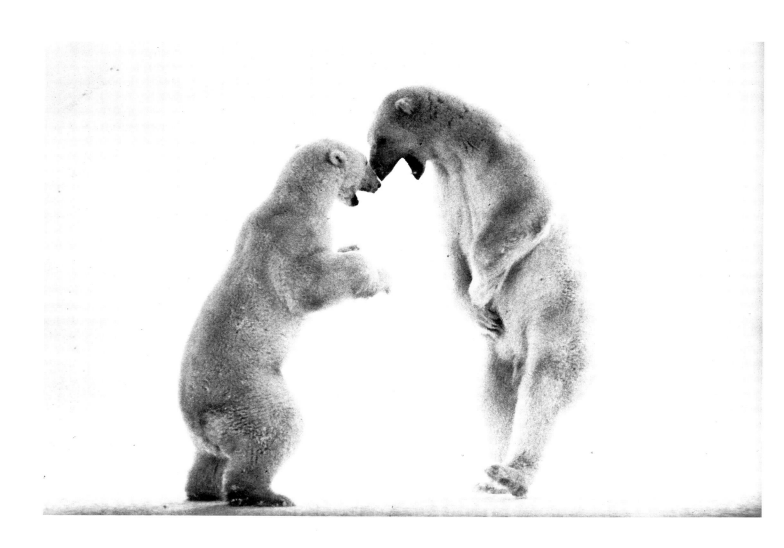

● *Above*

Just try and make me! . . .
Male polar bears mock-duel
on the shores of Hudson Bay.
Photographer:
Tom Ulrich

116

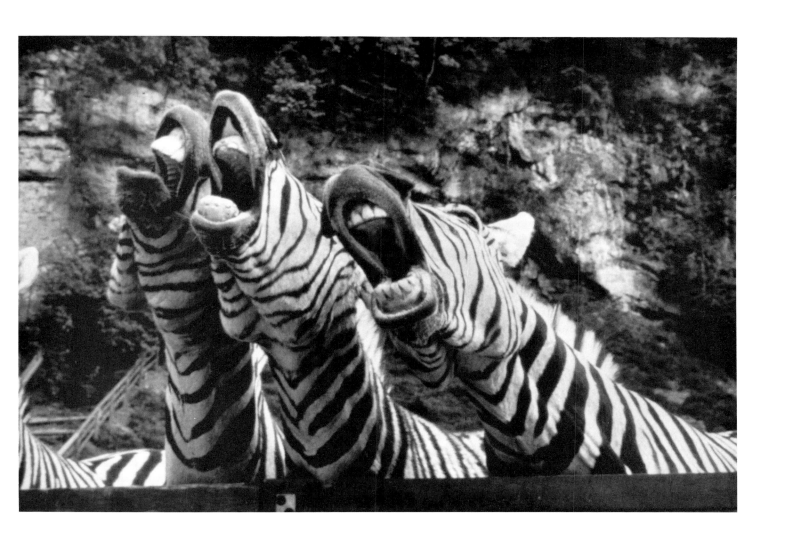

● *Above*

This zany trio of zigzag zebras zap passersby with a zingy serenade at the Salzburg, Austria, zoo. Complaints? Zilch.

Photographer:

Gerhard Kunze

A Bestiary of Beguilers

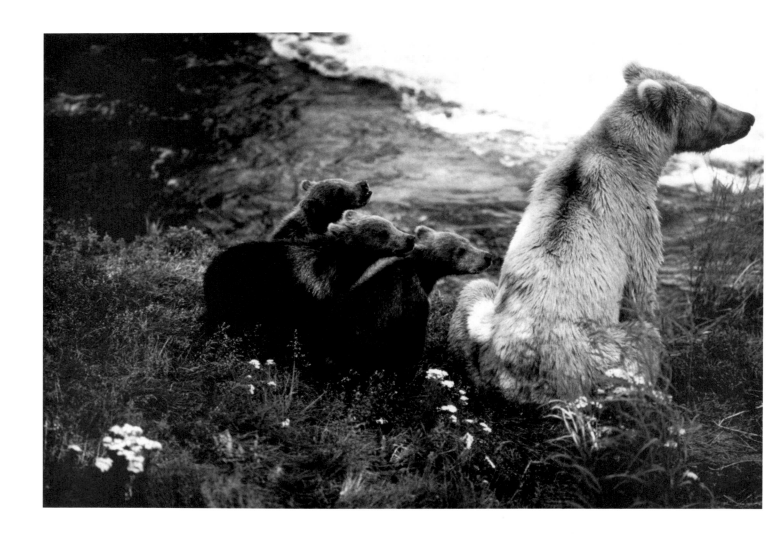

When you're little, you can sometimes learn best by watching—in this case the fishing techniques of some other, more seasoned bears nearby.

Photographer:
Fred Hirschmann

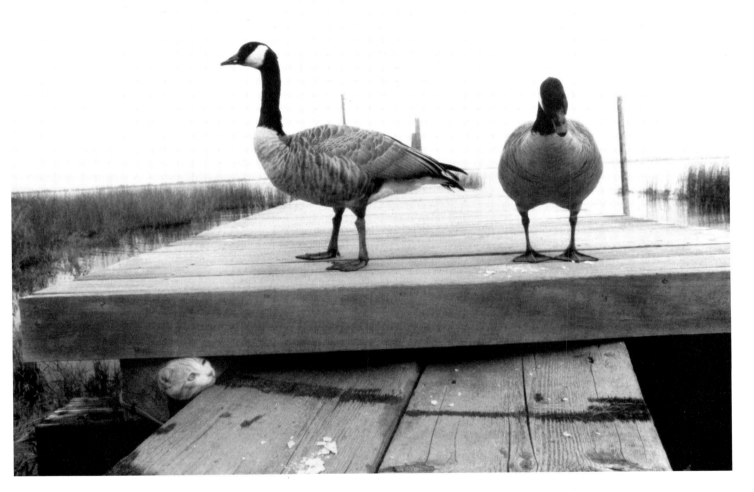

● *Above*

Ginger was used to ruling the roost around Elmira, Oreg., until the day two big Canada geese blew into town. One gander was enough to make Ginger suspect fowl play, so she decided to duck for cover. But the drifters, smelling a cat, quickly hightailed it out of there.
Photographer:
Brian Lanker

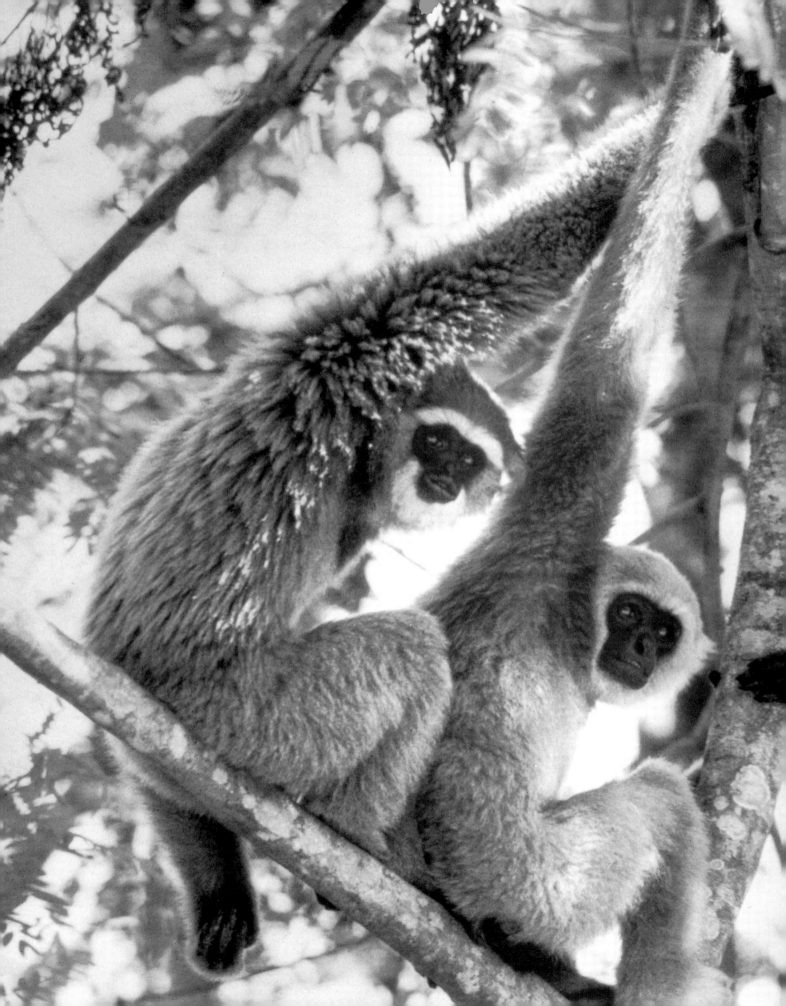

● *Left*

A pair of silvery gibbons,
also known as wau-waus,
perched at the edge of their
family territory.

Photographer:

Co Rentmeester

● *Above*

A broad-shouldered male seal
(*right*) kept watch over one of
his harem by the frigid
waves of the Bering Sea.

Photographer:

Michael O'Brien

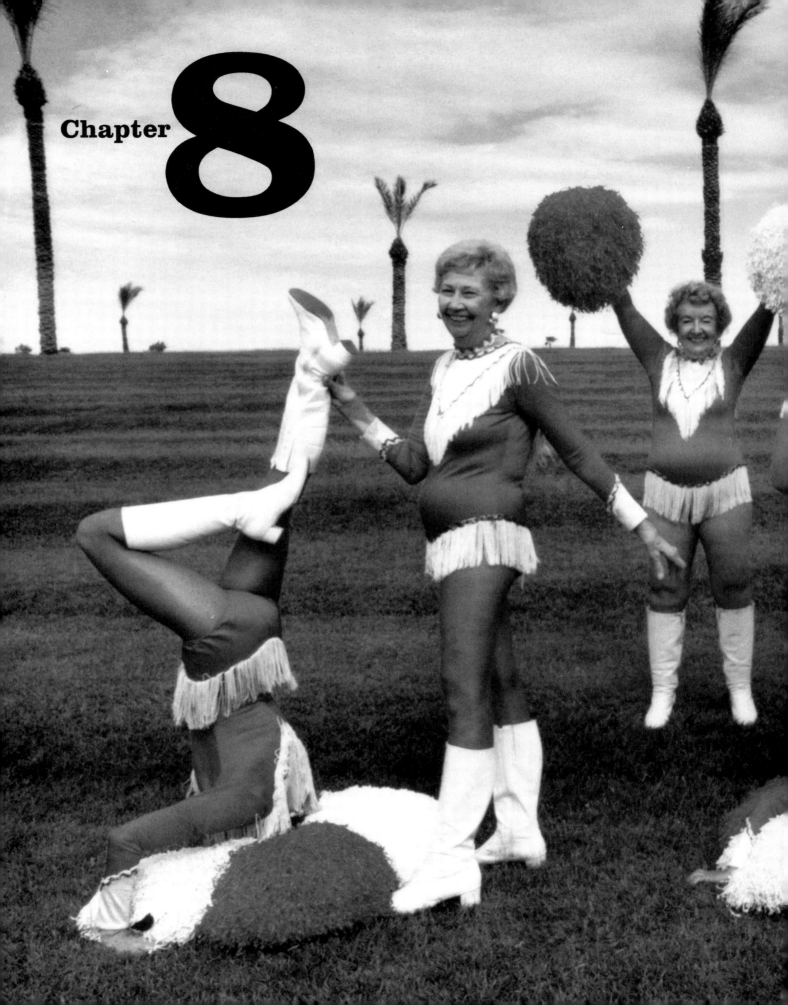

Chapter **8**

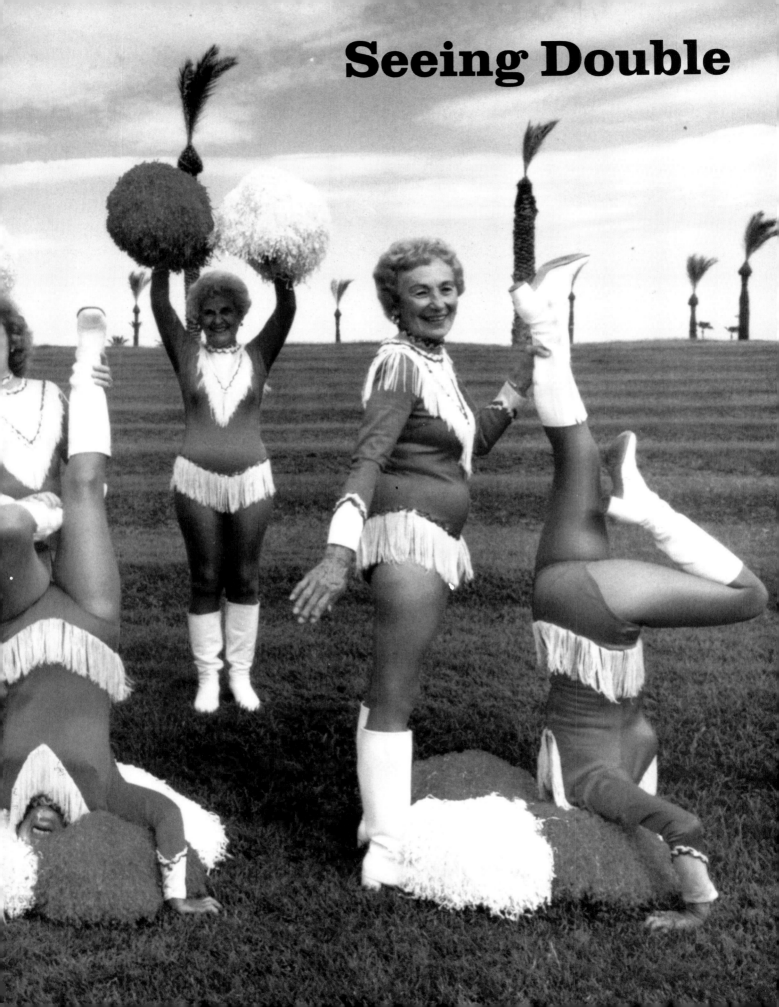

Seeing Double

Seeing Double

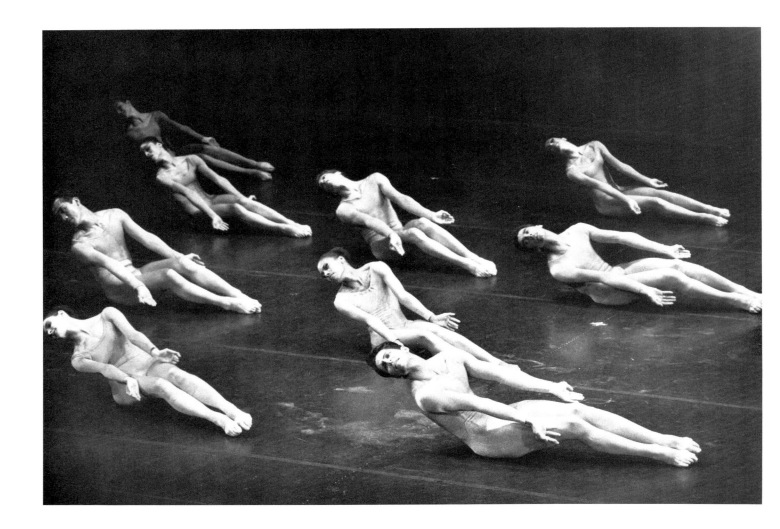

● *Previous page*

Gimme an "S" for septuagenarian: The Sun City Pom Poms, a group of cartwheeling Arizonans—average age? mind your own business—can still do some mean acrobatics.

Photographer:

Frank Fournier

● *Above*

At Martha Graham's 1991 memorial service in New York City, her company performed her *Acts of Light*—in a tribute she would have enjoyed.

Photographer:

Jim Wilson

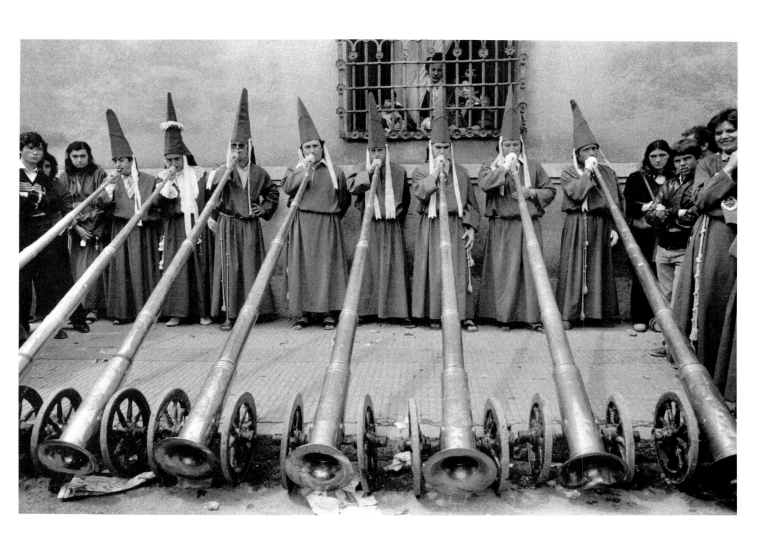

● *Above*

On Good Friday, in Murcia, Spain, the horrific din from the eight-foot-long *bocina* horns evokes Christ's suffering. It is also evidence of a certain anarchic humor.
Photographer:
Cristina Garcia Rodero

Seeing Double

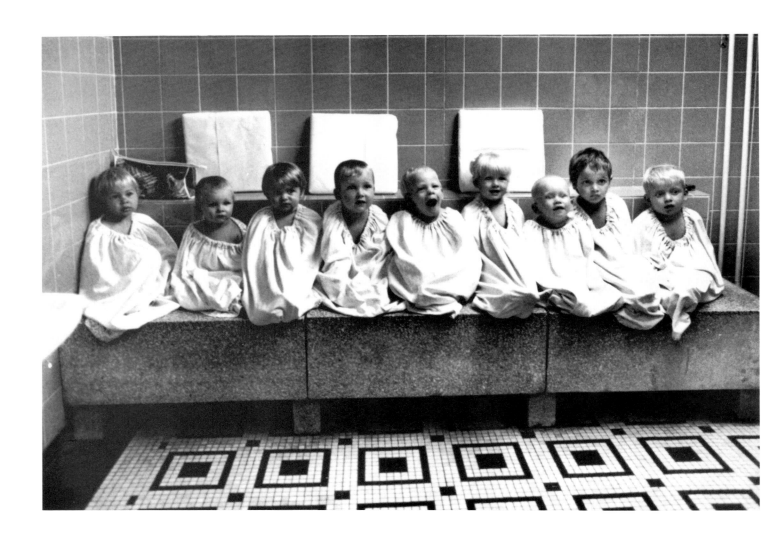

● *Above*

Day care, German-style: a
quick steam in a sauna.

Photographer:

Thomas Billhardt

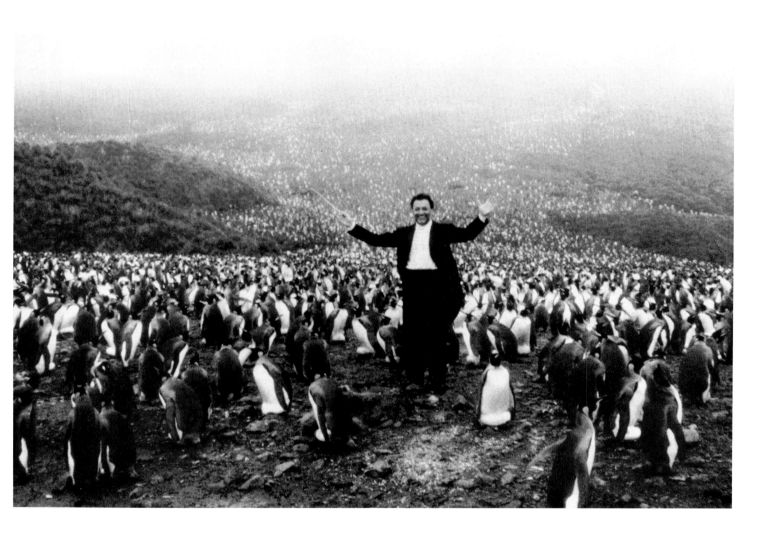

● *Above*

Symphony conductor Zubin Mehta, on a vacation cruise to Antarctica, looked right at home with this pickup chorus he found on the island of South Georgia.

Photographer:

Nancy Mehta

Seeing Double

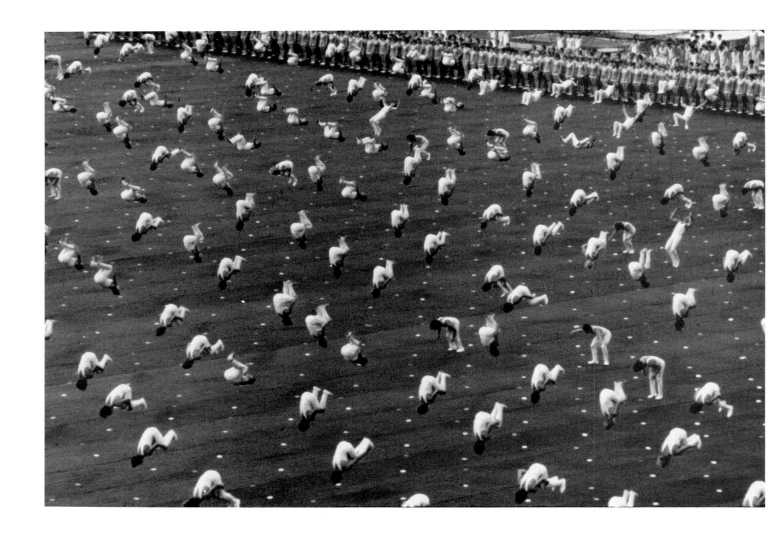

● *Above*

During the opening ceremonies of the 1980 Olympic Games in Moscow, the Soviet gymnasts did back flips—and a motorized camera caught the action.

Photographer:

Heinz Kluetmeier

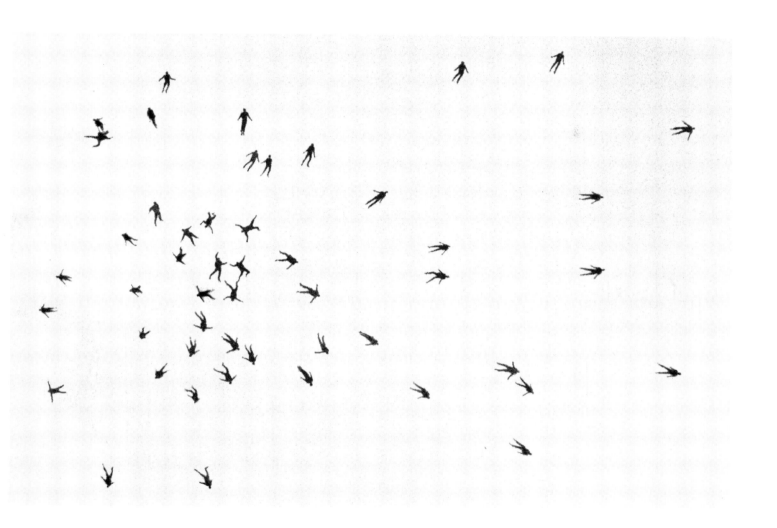

● *Above*

It was every man for himself as 55 sky divers failed to grope as a group. With less than 5,000 feet and 30 seconds left before becoming human pancakes, the divers had to separate to open their chutes.

Photographer:

Teri Harris

Seeing Double

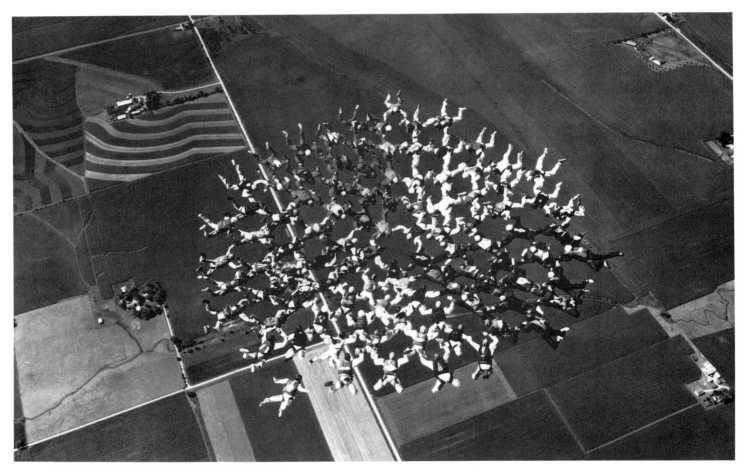

● *Above*

One hundred divers jumped at 18,000 feet from four DC-3's and then, over the next 70 seconds (with some of them free-falling at speeds of up to 200 mph), they maneuvered into place. They held the formation with 99 in place for 17 seconds, but the 100th man came in too low *(bottom left)* to complete the circle.

Photographer:

Robert Franzese

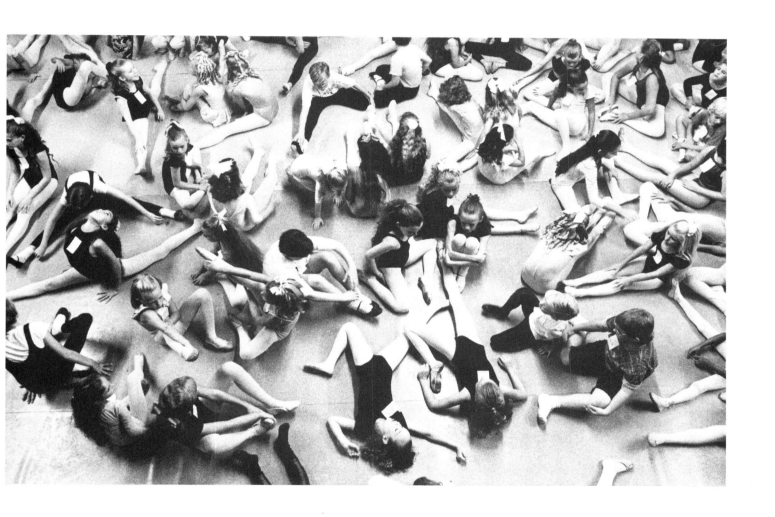

● *Above*

Every young balletomane
worth her sugarplums has
dreamed of dancing *The
Nutcracker.* When the
Southern Ballet Theatre in
Orlando, Fla., held an open
audition, hundreds tried
to appear calm before their
auditions.

Photographer:

Joe Burbank

Seeing Double

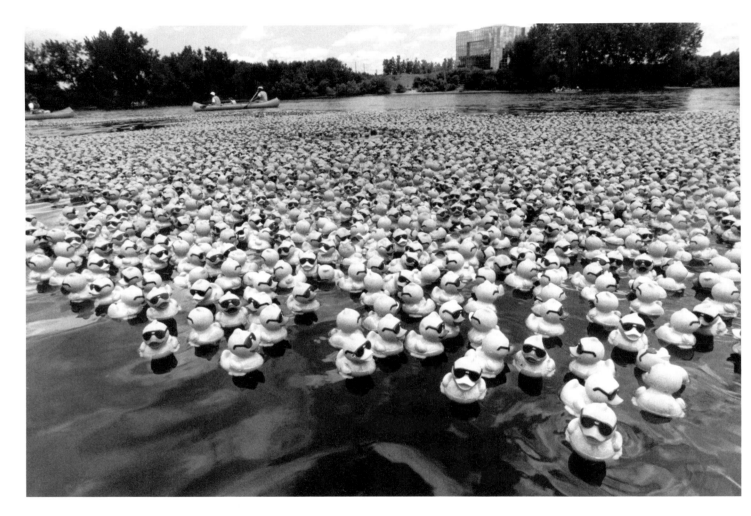

● *Above*

It worked like this: You
donated five dollars to a good
cause, and were assigned a
bar-coded vinyl duck. You
then watched 20,000 of them
float downstream and hoped
that your quacker would
win by a beak. As they say,
birds of a similar synthetic
substance flock together.

Photographer:

Cloe Poisson

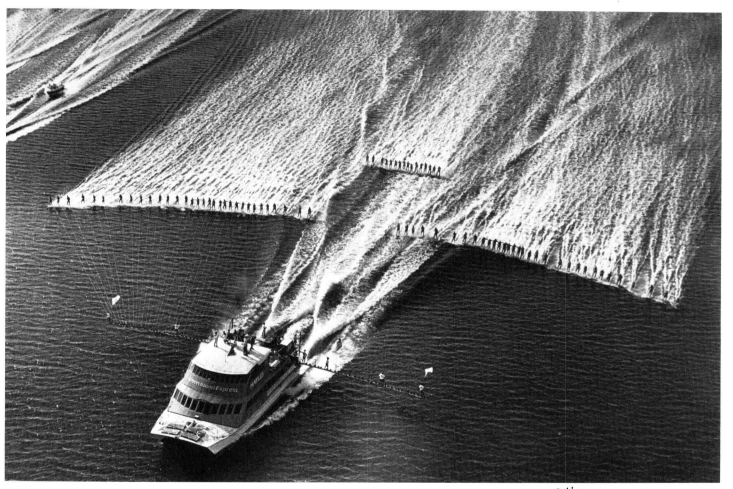

●*Above*

Tugged by a catamaran ferry, 80 members of a ski and powerboat club set a double-ski world record by remaining simultaneously perpendicular for one nautical mile. When 77 of the water-skiers were able to zip along for a second nautical mile, each balancing on a single ski, another world record was set.

Photographer:
Arthur Mostead

Seeing Double

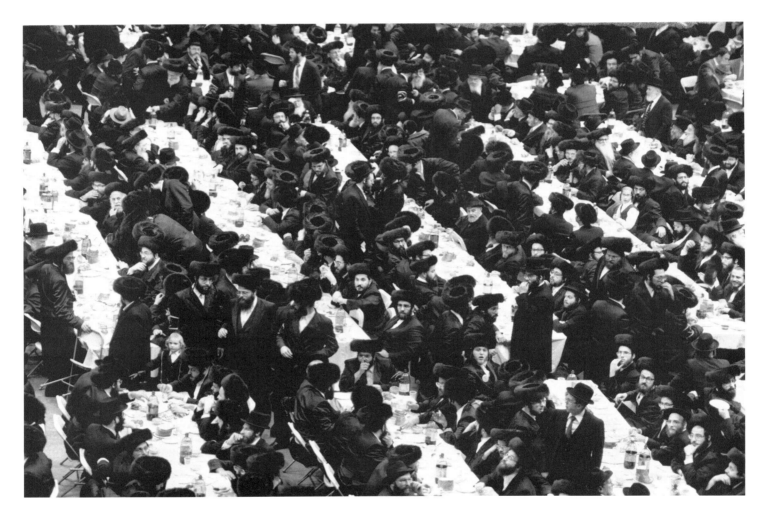

● *Above*

Have we got a wedding for you! There were 6,000 cantaloupes, 8,000 sandwiches, 3,500 chickens, 4,000 pounds of gefilte fish—and 20,000 guests at the wedding of two grandchildren of Grand Rabbi Moses Teitelbaum of Brooklyn.

Photographer:

Allan Tannenbaum

134

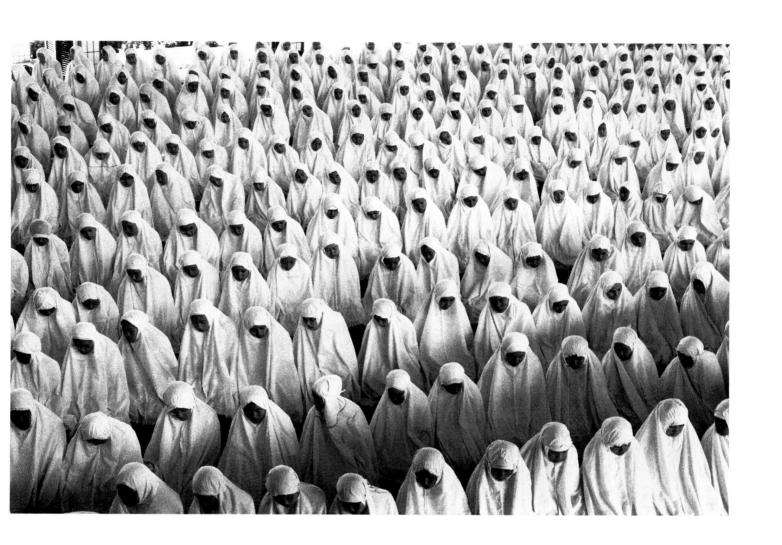

● *Above*

At al-Azhar college in Jakarta, Indonesia, young Muslim women wear their yards of pious veiling at Friday prayer.
Photographer:
Abbas

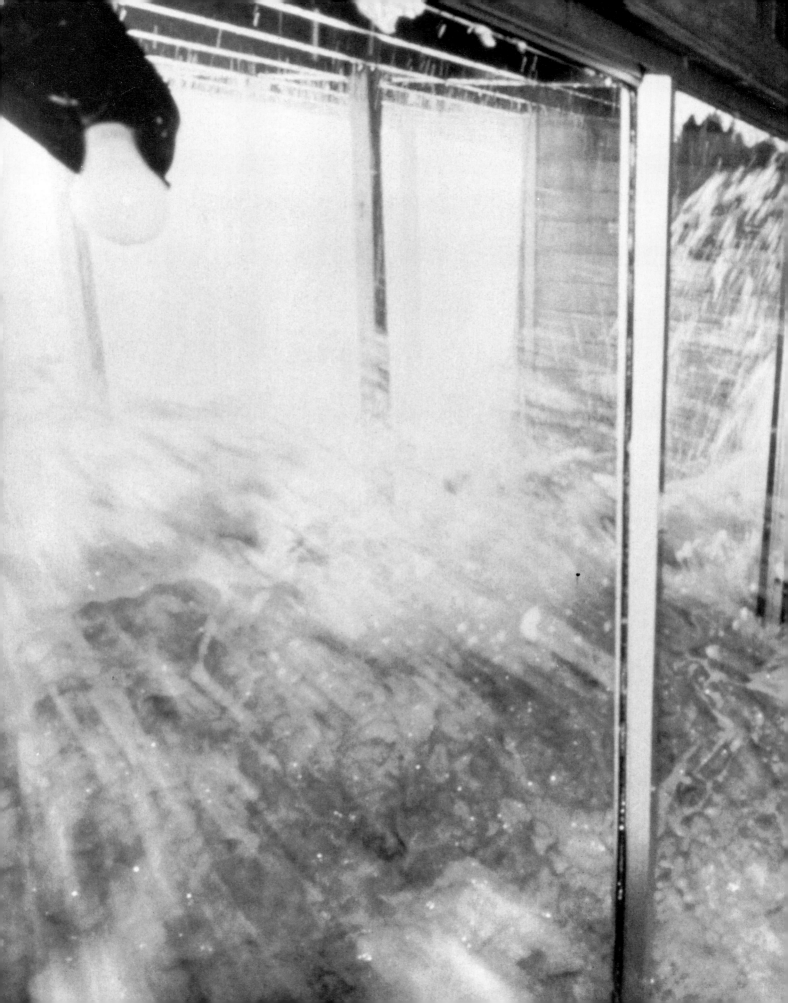

Chapter 9

The Weather Today Will Be . . . Unusual

The Weather Today Will Be . . . Unusual

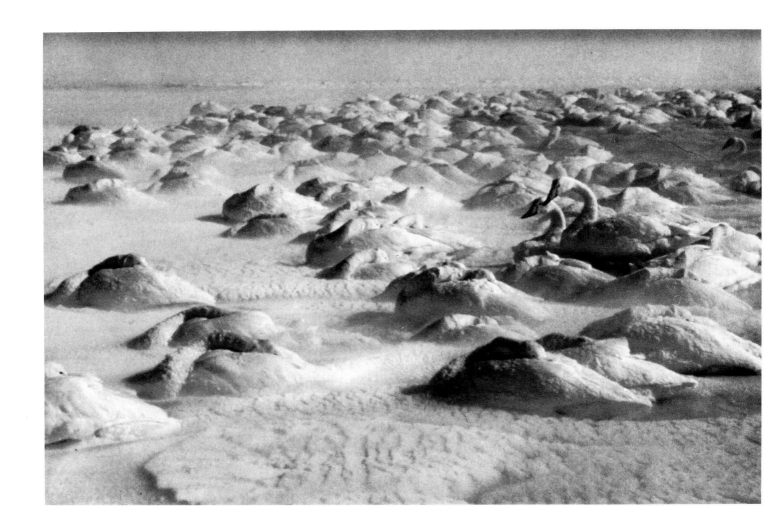

● *Previous page*

It was certainly a surprise when a surge from an October nor'easter crashed through plate-glass windows into a Florida living room.

Photographer:

David Lane

● *Above*

When migrating swans head north to their nesting grounds in Siberia, an overnight snowstorm can turn a bevy into a frozen swan lake.

Photographer:

Teiji Saga

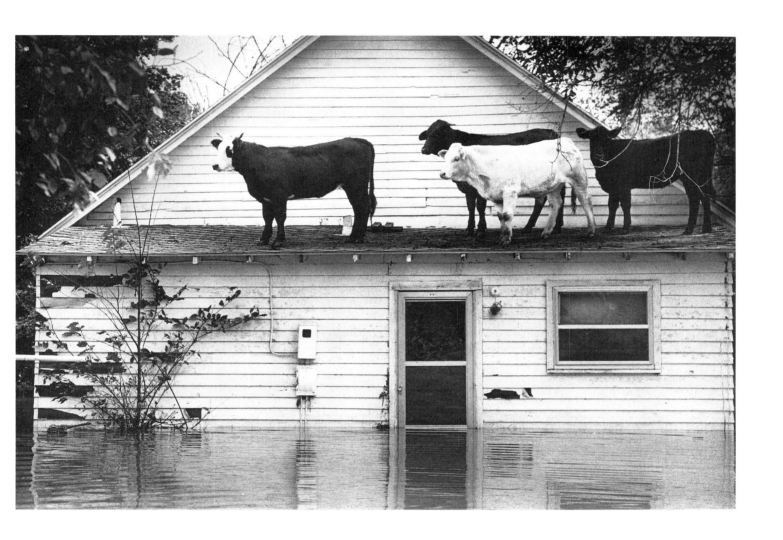

● *Above*

When a lower Missouri River tributary crested during five weeks of flooding, a quartet of cows took the high road.

Photographer:
Gary Dunkin

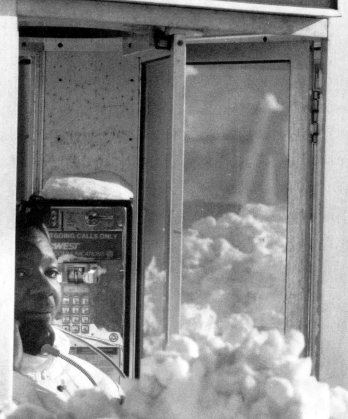

The Weather Today Will Be . . . Unusual

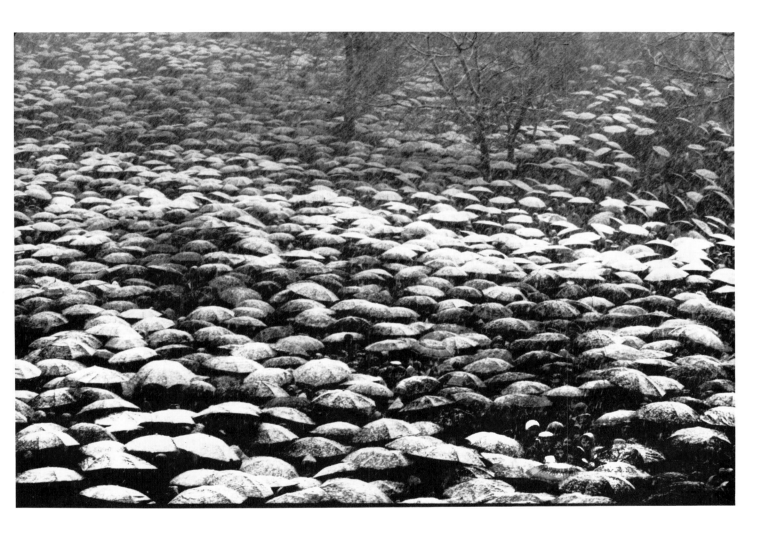

● *Left*

Minnesota's Twin Cities are
best known for Mary Tyler
Moore and snow—an average
of 13 billion cubic feet a year.
That's a lot of white stuff,
but not enough to keep a cool
operator off the telephone.
Photographer:
Chris Polydoroff

● *Above*

Daunted neither by
government opposition to the
Catholic Church nor by a
dusting of snow, Easter week
pilgrims in Poland huddled
under their umbrellas.
Photographer:
Bruno Barbey

The Weather Today Will Be . . . Unusual

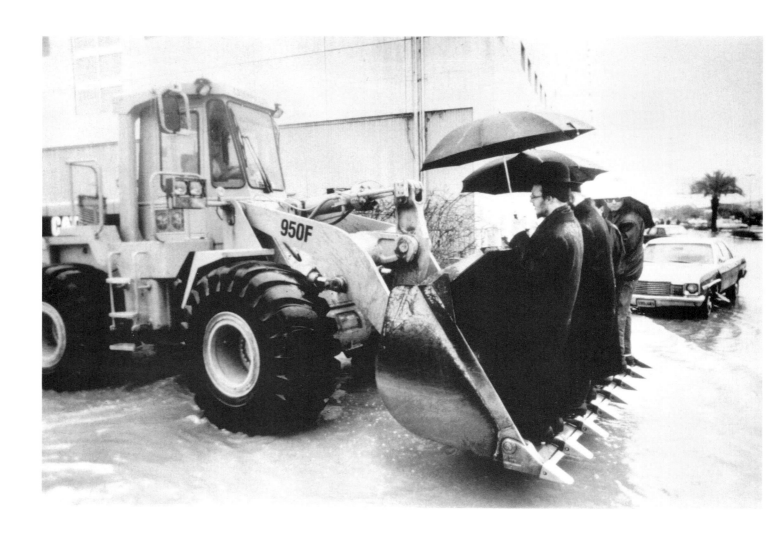

● *Above*

Israel is better prepared for Scud missiles than winter rain and snow. In Tel Aviv, earthmovers were commissioned to help residents part the waters.

Photographer:

Motti Kimhi

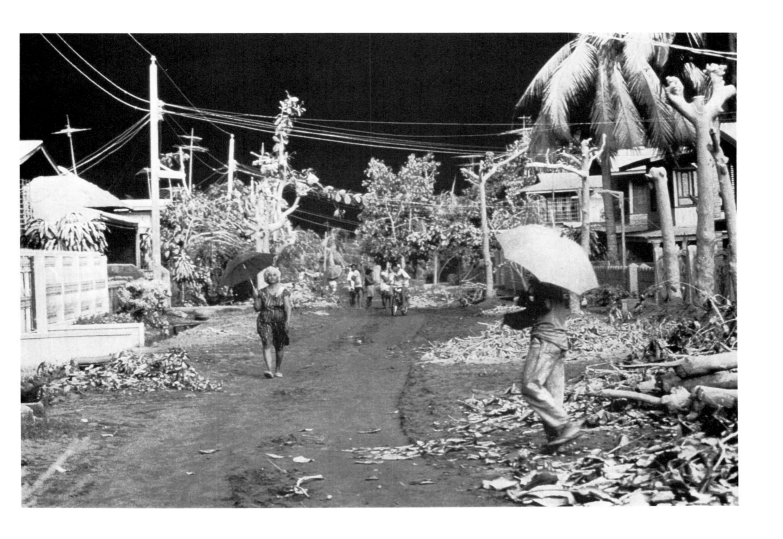

● *Above*

After Mount Pinatubo in
the Philippines launched
20 million tons of superhot
ash into the stratosphere,
villagers had to dig
out from under a
monochromatic blizzard.
Photographer:
Philippe Bourseiller

143

The Weather Today Will Be . . . Unusual

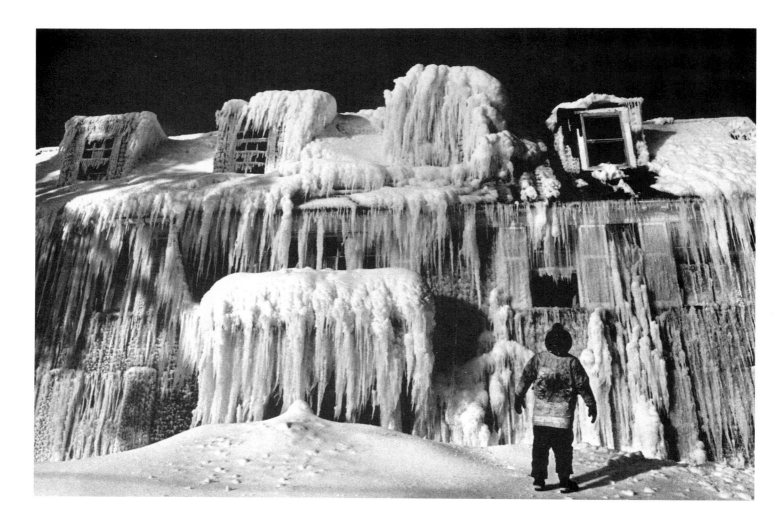

● *Above*

It looks beautiful now, but this ice house was an Iowa State frat house before a fire one frigid January.

Photographer:

John J. Gaps III

● *Right:*

When Hawaii's Royal Gardens Subdivision was built, no one planned on a rock garden. But after Kilauea erupted, many of the neighborhood's homes, including those at this intersection, were buried under lava.

Photographer:

Ron Dahlquist

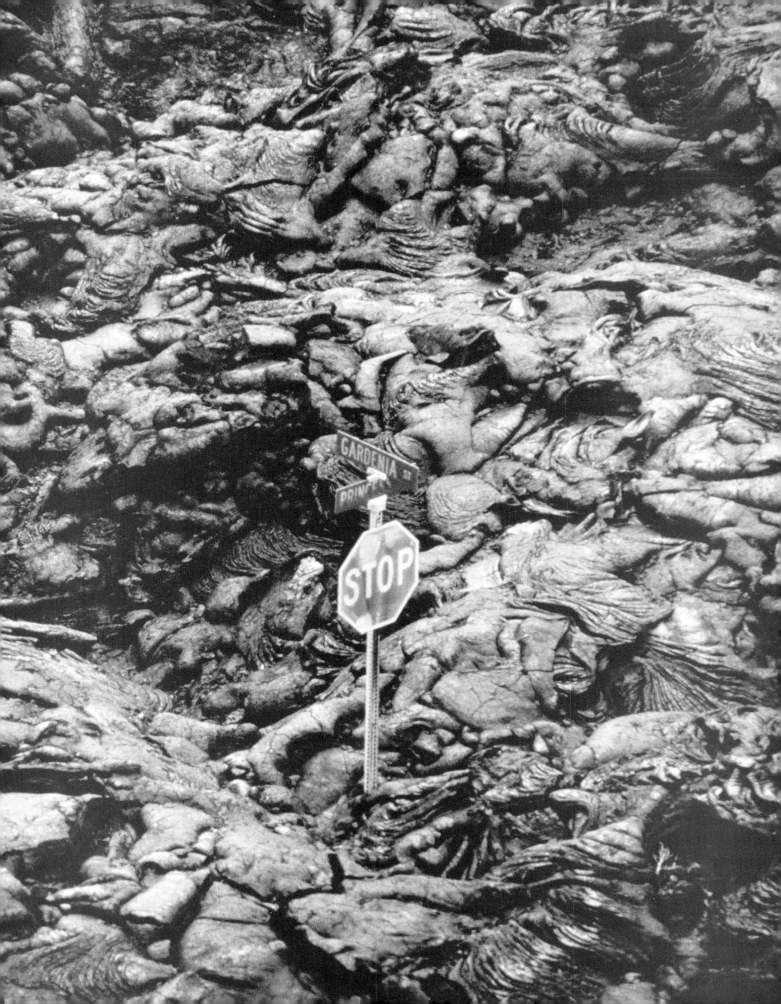

Chapter 10

Here's Looking at You

Here's Looking at You

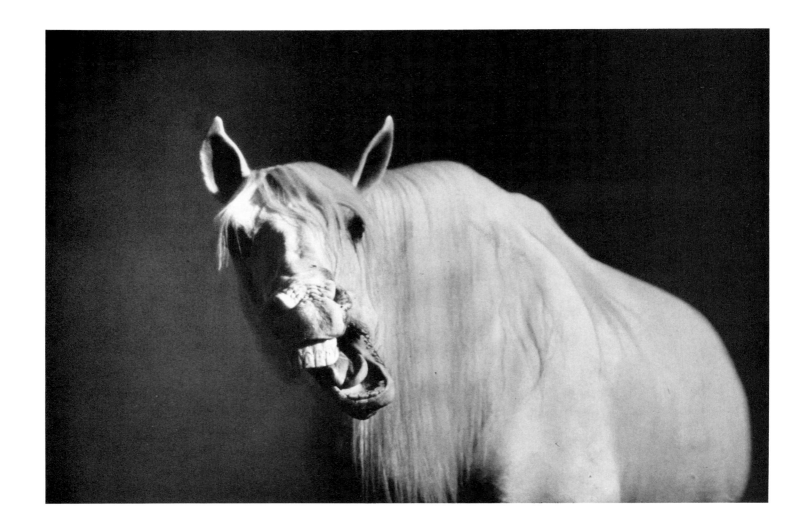

● *Previous page*

She's pretty, popular and, for all we know, smart, so why shouldn't this Persian beauty have felt like giving some lip?

Photographer:

Stephen Green-Armytage

● *Above*

This stallion wasn't chewing gum. He was thoroughly relaxed and just about to break into one colossal yawn.

Photographer:

Robert Vavra

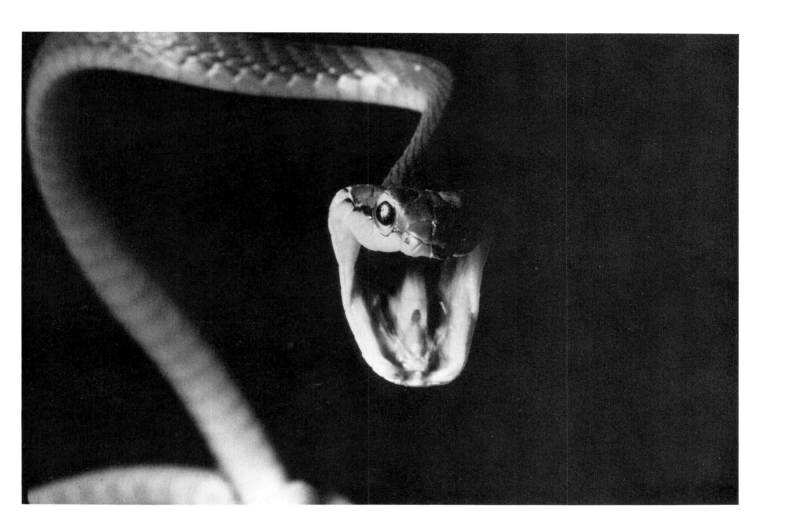

● *Above*

What a set of tonsils! This
green vine snake's advantage
is enhanced when the Costa
Rican jungle creature is
magnified to four times its
actual size.
Photographer:
Michael Melford

Here's Looking at You

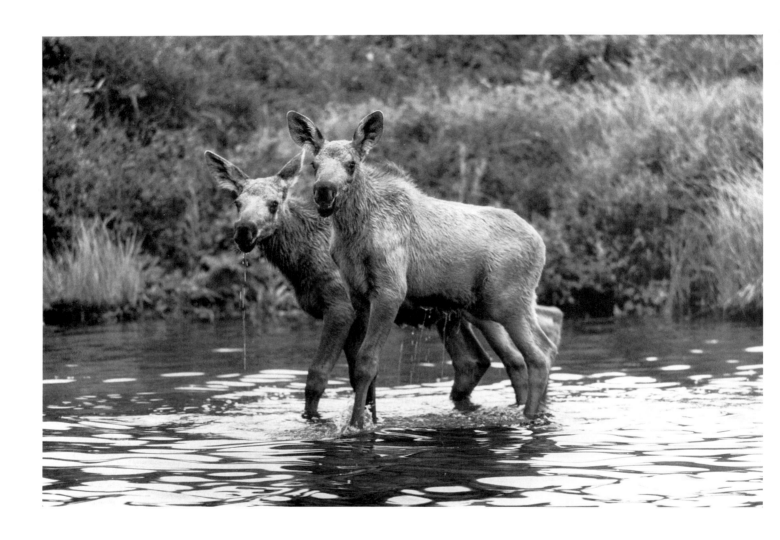

● *Above*

Northern Exposure may have made a celebrity of one Alaskan moose, but these two preferred the more rustic backwaters.

Photographer:

Art Wolfe

● *Right*

When winter comes, smart Japanese snow monkeys head south, to the moutains west of Tokyo. There, natural hot springs offer hedonistic delights—even in blizzards.

Photographer:

Co Rentmeester

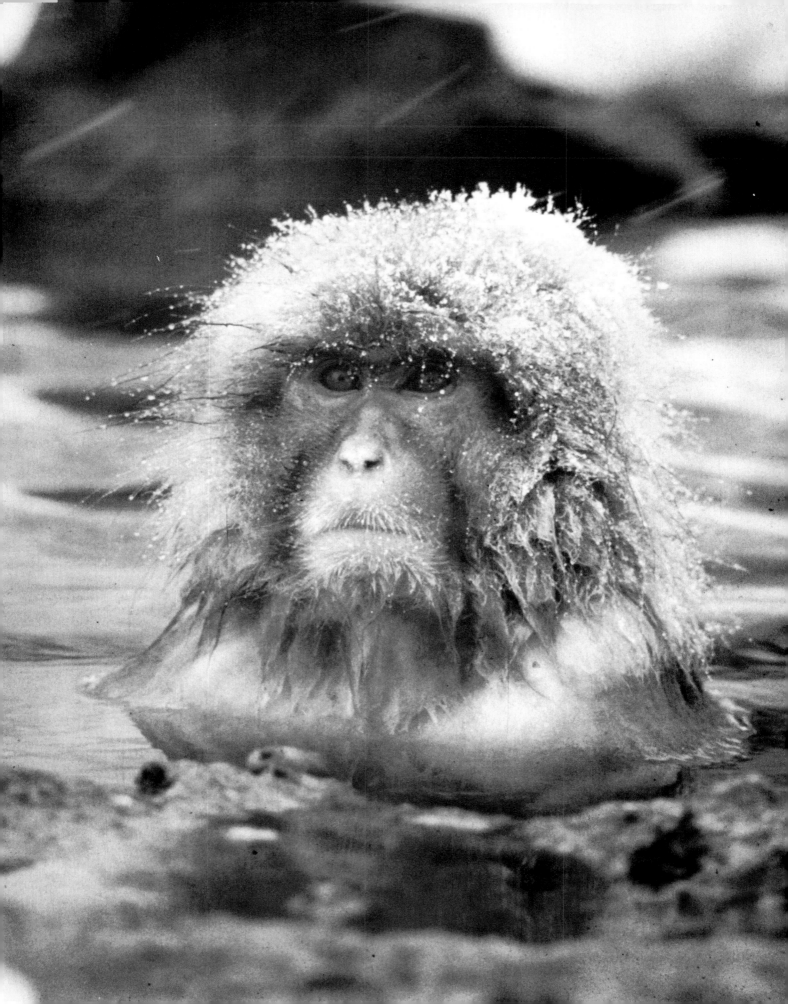

Here's Looking at You

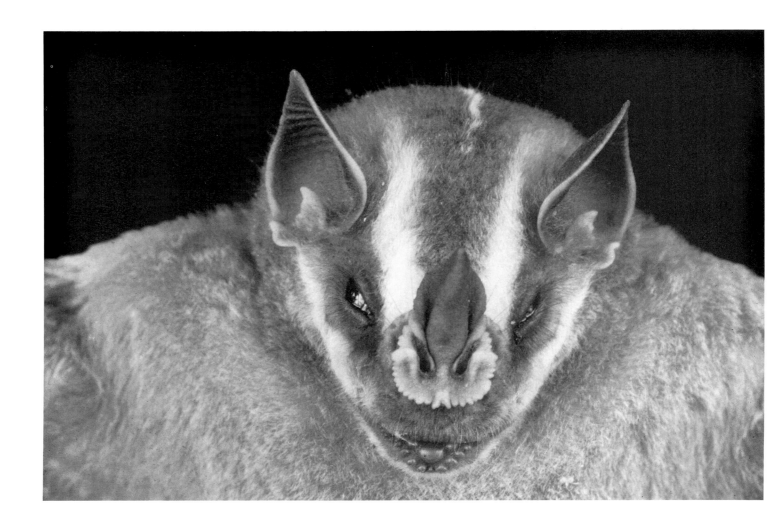

● *Above*

That's not a leaf on the end of
the face of this Heller's fruit
bat; it's the critter's nose—
greatly enlarged, we'll
admit—which it uses as a
radar dish.

Photographer:
Michael Melford

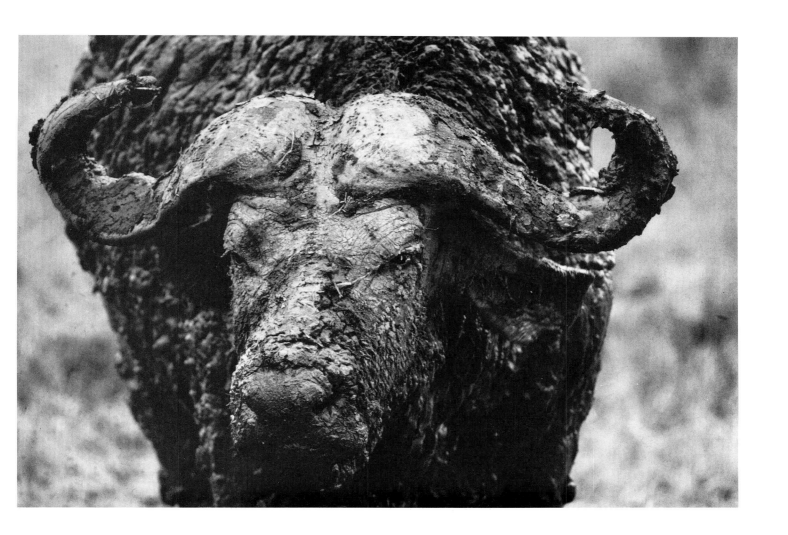

● *Above*

An old African water buffalo knows the tricks of the trade: A good wallow in muddy sludge makes a protective coating effective against flies and ticks. Or maybe the pests are just afraid of his prehistoric look.

Photographer:
Günter Ziesler

Here's Looking at You

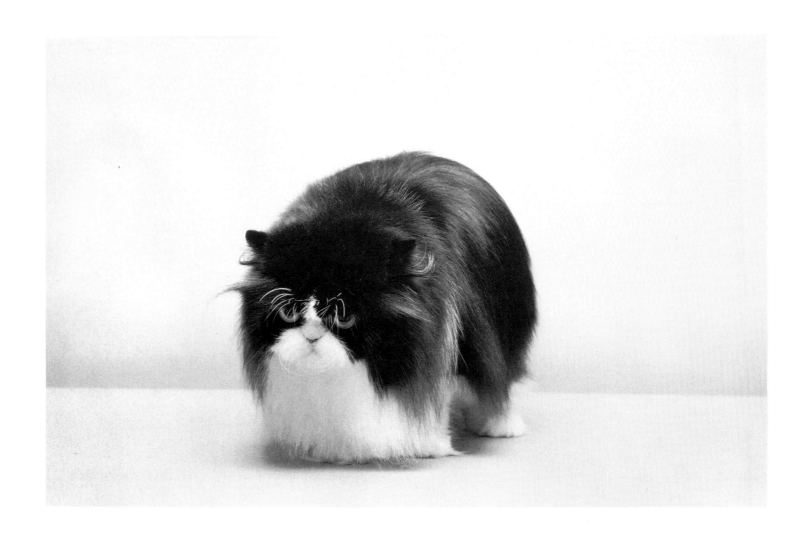

● *Above*

The spectators at cat shows
may get animated, but the
entrants can get bored. This
18-month-old Persian female,
who answers to the name of
Cheers, took the overall prize
and deserved extra mention in
the napping category.

Photographer:

Stephen Green-Armytage

154

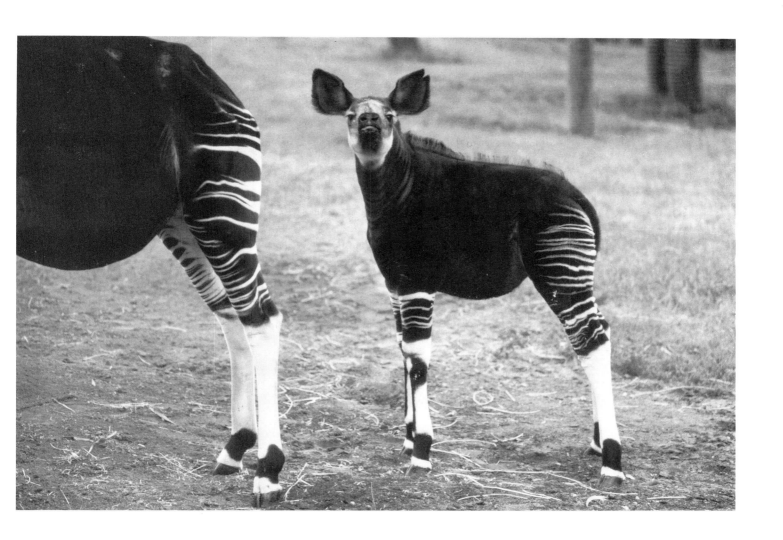

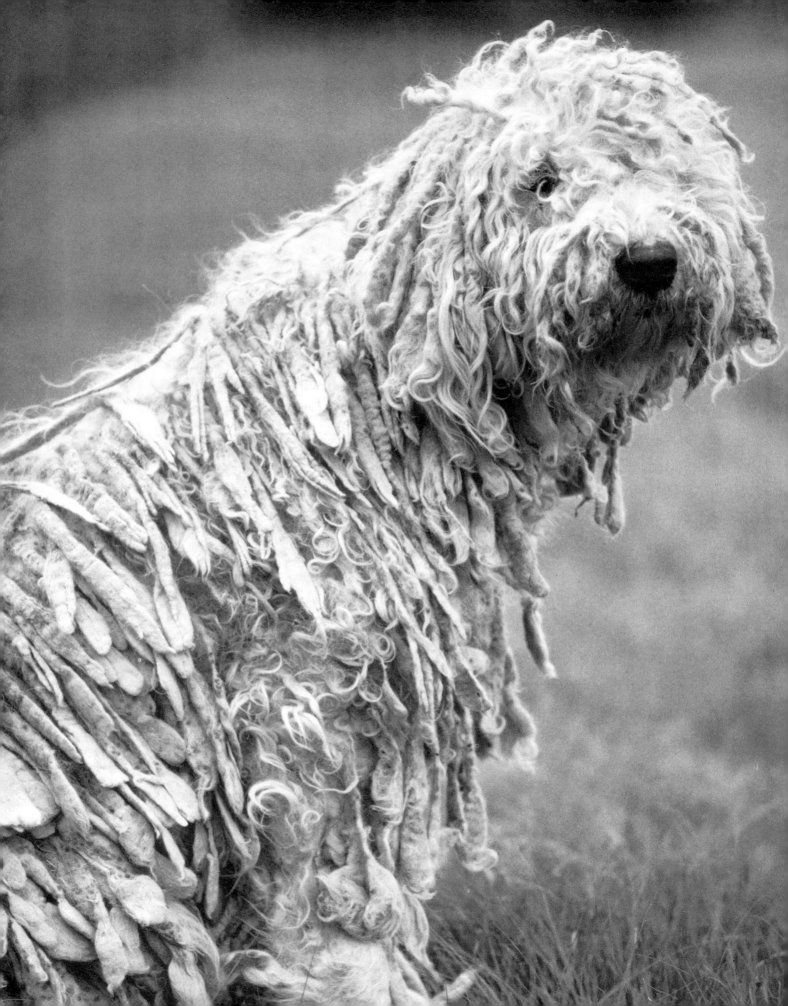

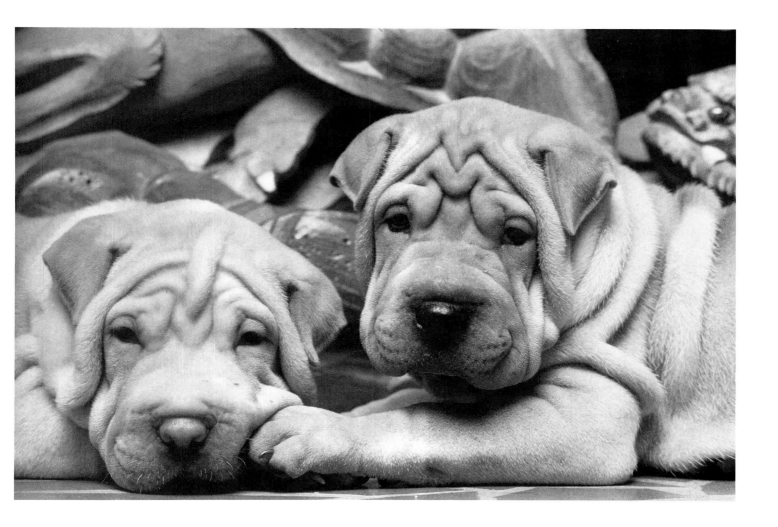

● *Left*

Cotton, a Komondor whose ancestors are traceable to ancient Asia and 13th-century Hungary, is a goat- and sheep-guarding dog on a Texas ranch. The herds seem to accept him as kin; could it be that coat he's wearing?

Photographer:

Stephen Green-Armytage

● *Above*

If you had skin loose enough to turn around in, you might look as tired as these Shar-Peis.

Photographer:

Stephen Green-Armytage

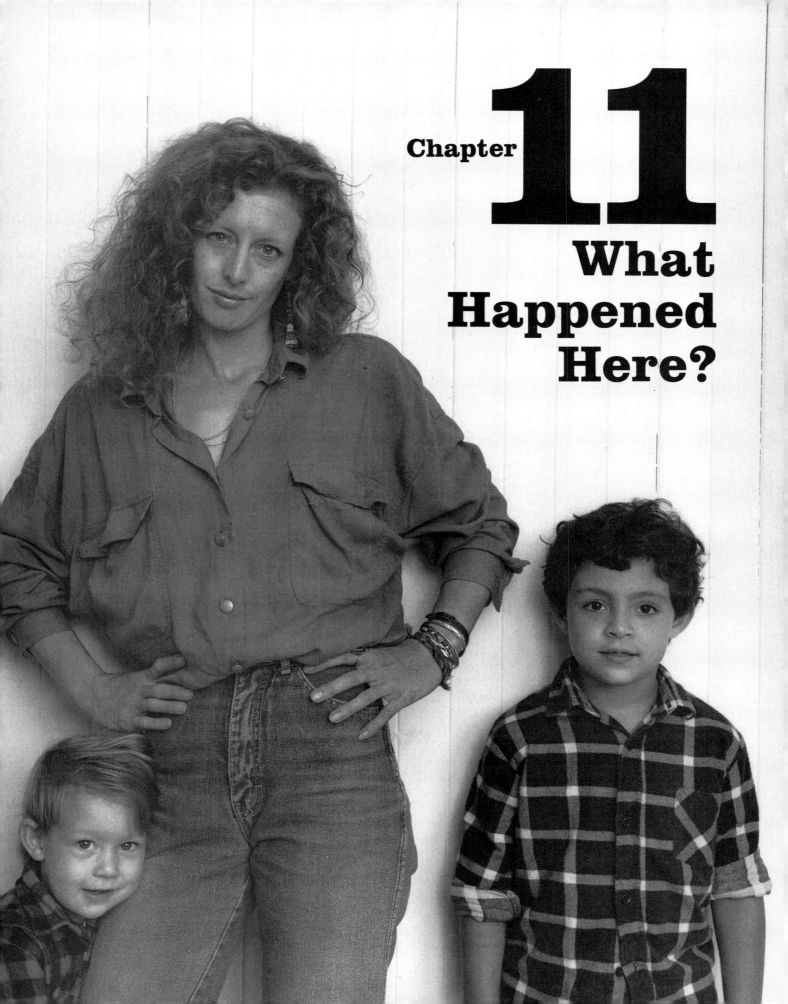

What Happened Here?

What Happened Here?

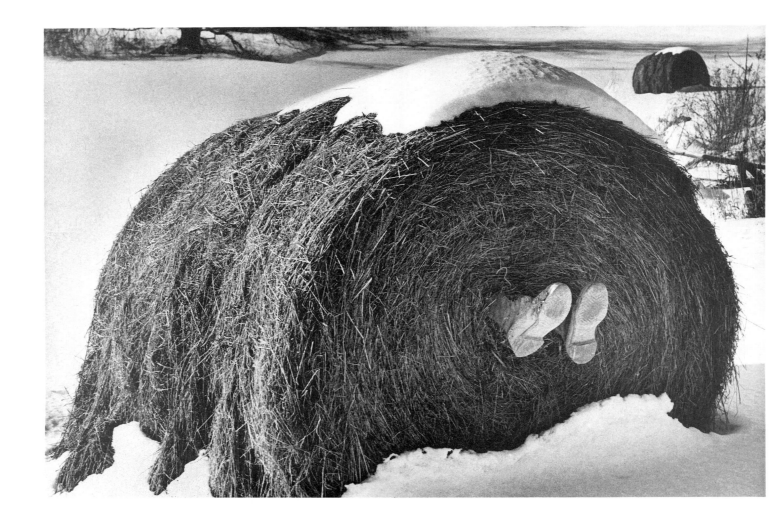

● *Previous page*

First there was Dani, in 1975. And then there was Dani with Justin and Jeremiah, in 1990.

Photographer:

Art Rogers

● *Above*

After motorists passing a New York farm noticed this victim of foul play, the authorities questioned the farmer. He finally admitted that he found a pair of old boots and simply wanted to have some fun. Bale denied.

Photographer:

Alan E. Solomon

● *Right*

You never know what's going on behind your back—even at your own wedding. In this case the best man, a heel if ever there was one, secretly appended an anguished footnote to the groom.

Photographer:

Tom Moran

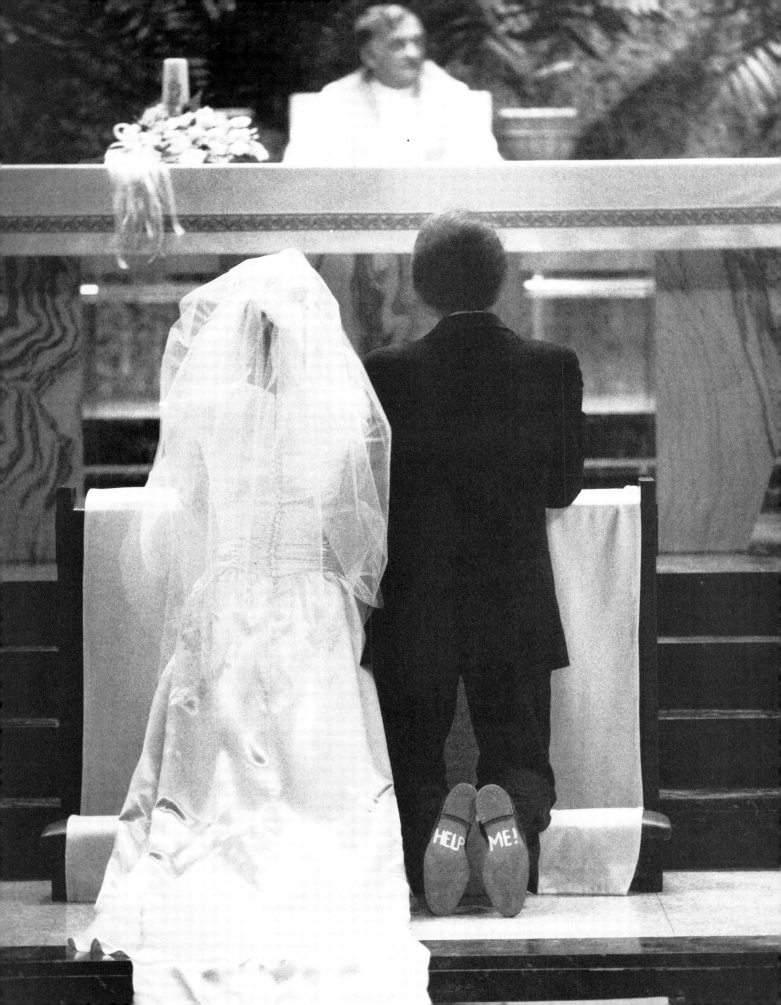

What Happened Here?

● *Above*

The days before Lent are
festive in the villages of
Spain—at least for the adults.

Photographer:

Cristina Garcia Rodero

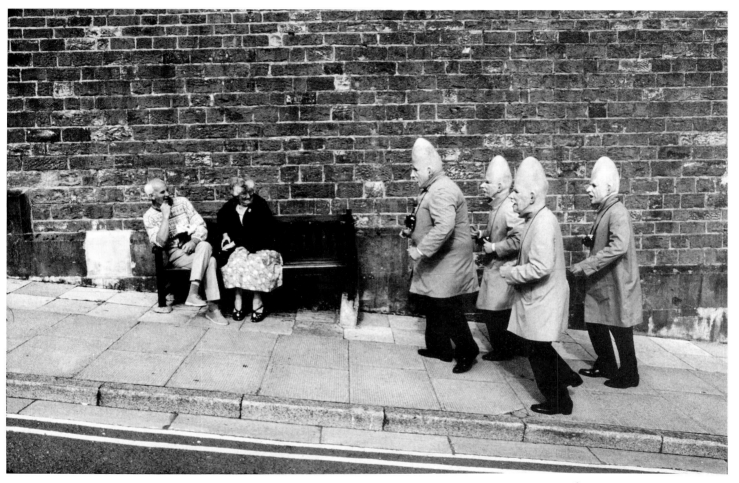

●*Above*

For more than two decades, Britain's Natural Theater Company has amused audiences with its "ambient theater"—street performances that involve passersby. In recent years this traveling skit, *The Coneheads*, has been most popular, even with people who don't seem to have a clue as to what's going on.

Photographer:

Richard Mildenhall

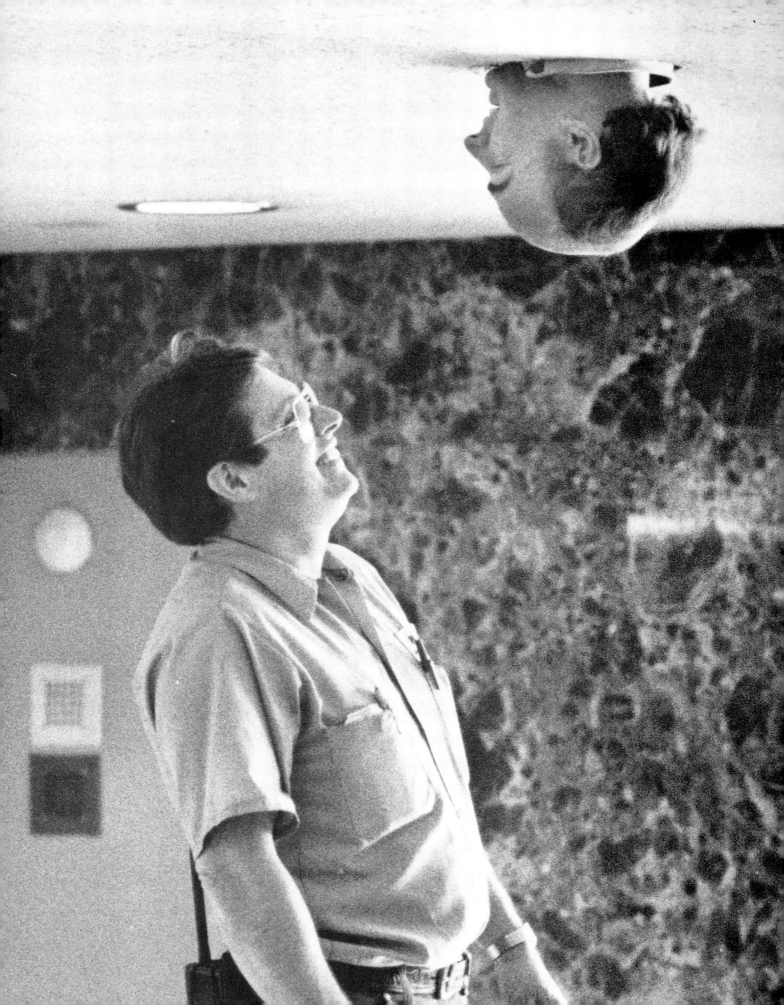

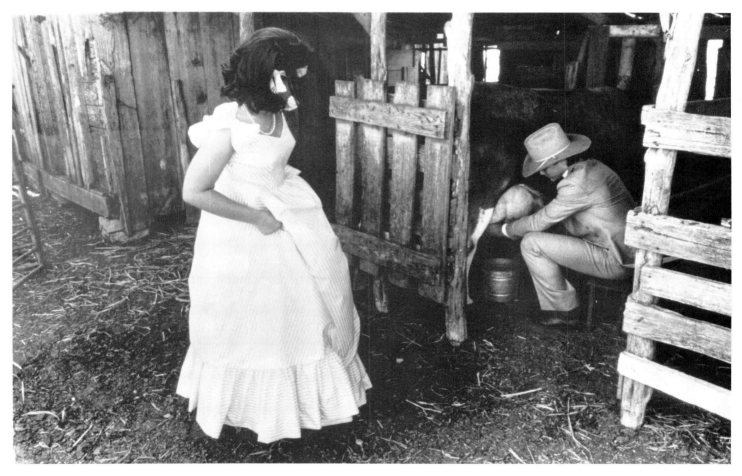

● *Left*

The people of Spokane, Wash., are not that interested in chandeliers, but this one in the lobby of a downtown office building drew a crowd. Maybe they thought the makers of a new futuristic guillotine were about to give a live demonstation. It turned out that the pate belonged to a guy helping install a light fixture.

Photographer:

Kit C. King

● *Above*

On prom night in Hamilton, Tex., one young farmer had to haul 650 bales of hay and milk a Jersey cow before moving from barnyard to ballroom.

Photographer:

David C. Turnley

What Happened Here?

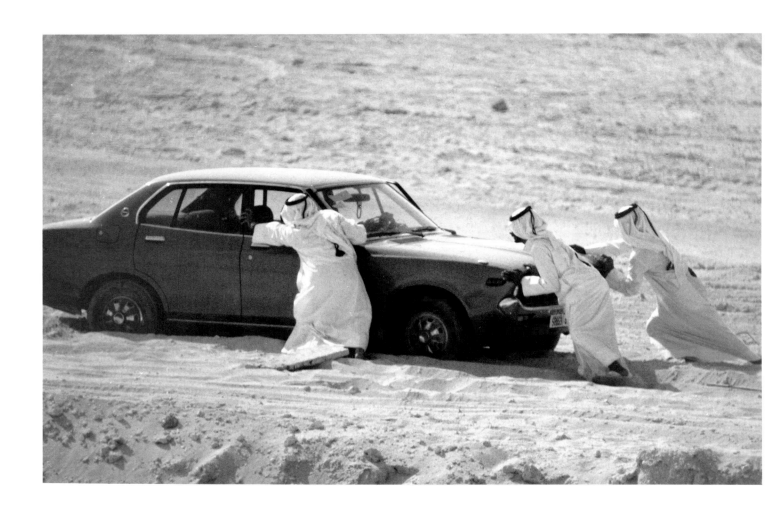

● *Above*

In this scene outside the city of Abu Dhabi, the vengeful fantasies of millions of gas-buying motorists finally came true. Could it be auto suggestion?

Photographer:
Donald Smetzer

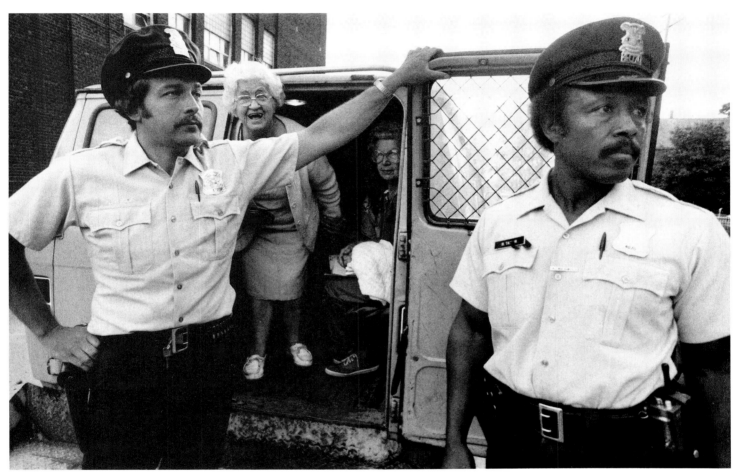

● *Above*

When Detroit condemned a part of the city known as Poletown, this 70-year-old lady and two dozen friends barricaded themselves in a church basement to protest the taking of their property. The police finally hauled everyone off to jail, but even a paddy wagon ride can't diminish some people's spirits.

Photographer:

Taro Yamasaki

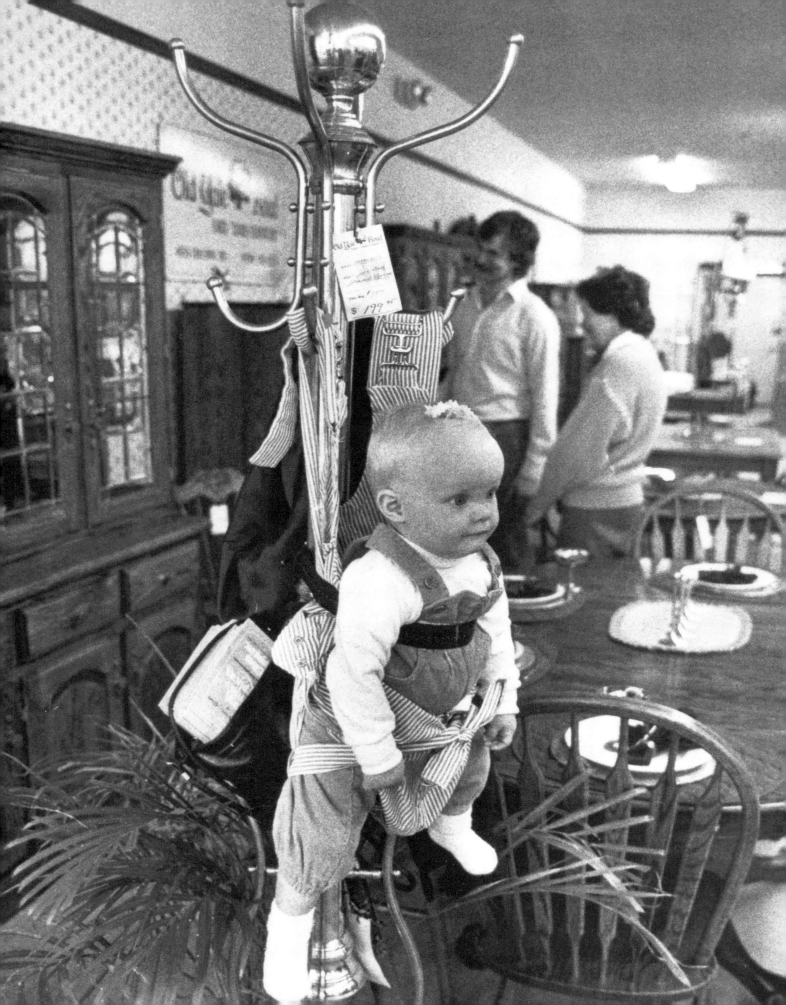

What Happened Here?

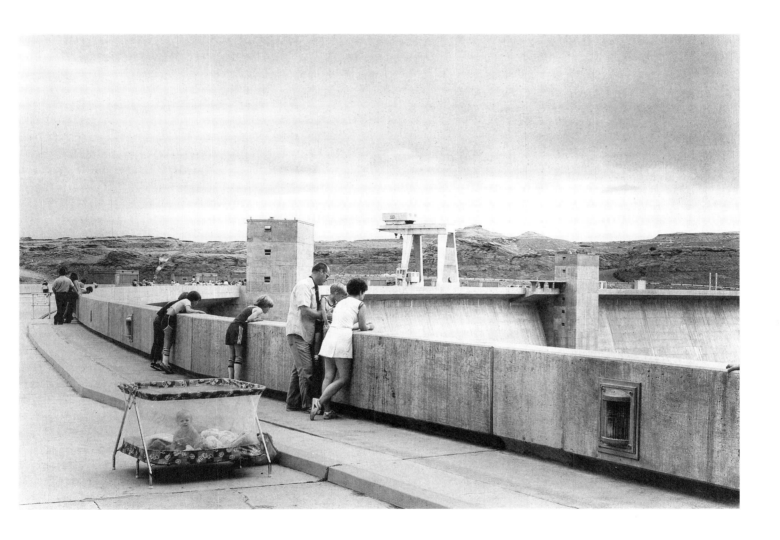

● *Left*

Rockaby baby in the clothes tree top. . . . While her grandmother browsed through a furniture store, the nine-month-old damsel, in no distress, captivated customers, who found her a bargain.

Photographer:
Ken Oakes

● *Above*

Some parents are so prepared they put the Boy Scouts to shame. Take, for instance, this family: They just happened to have a playpen handy when they wanted to look at Arizona's Glen Canyon Dam.

Photographer:
Joel Sternfeld

What Happened Here?

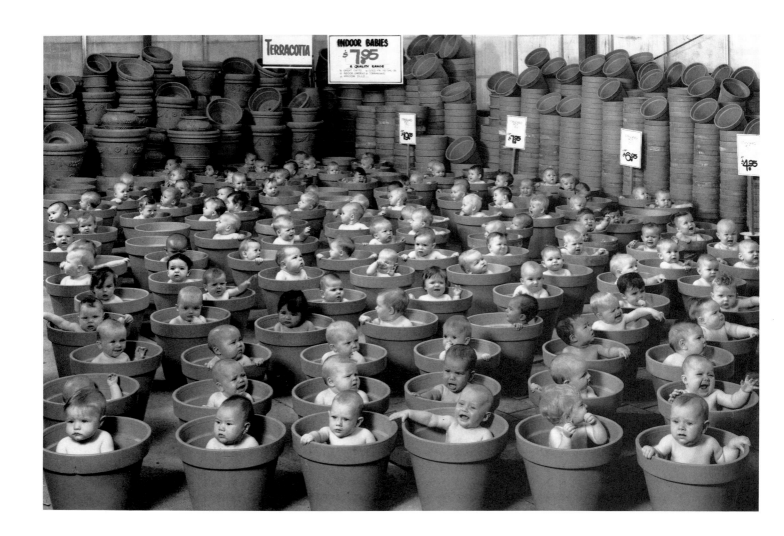

● *Above*

You'd expect to find youngsters sleeping in a nursery, but not this kind. One quick shot for a calendar and the 123 potted tots were uprooted by their waiting moms and dads.

Photographer:

Anne Geddes

● *Right*

It looks like torture, but it's really a platoon of Russian soldiers doing sit-ups in unison. Well, then again . . .

Photographer:

James Nachtwey

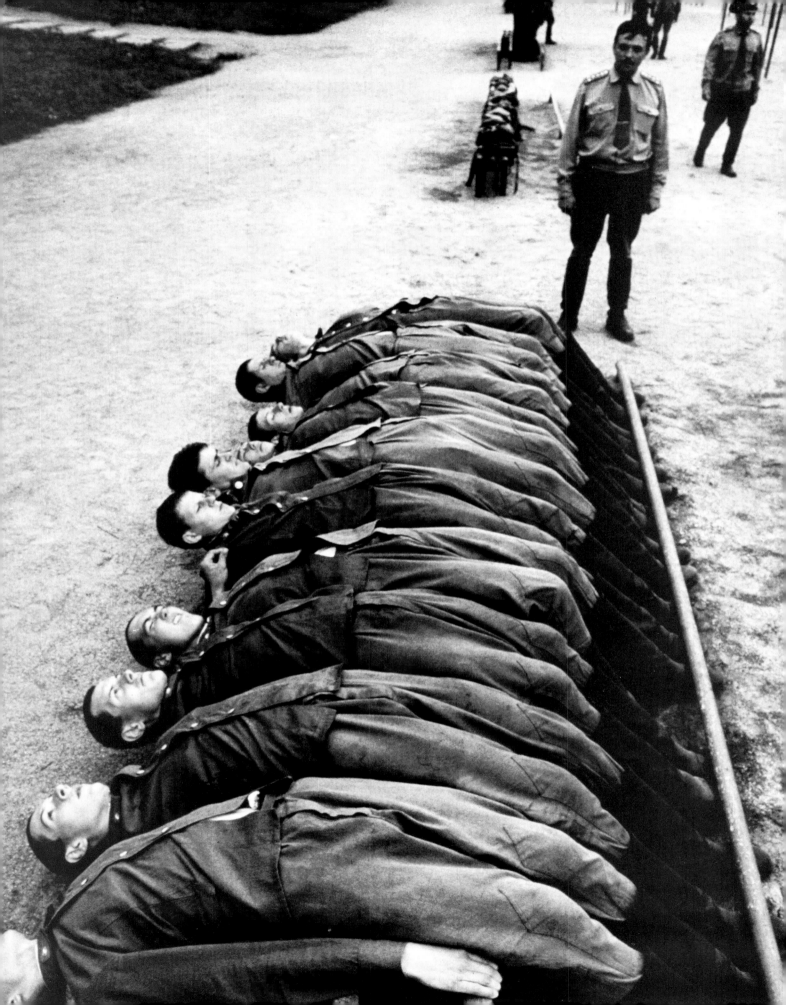

What Happened Here?

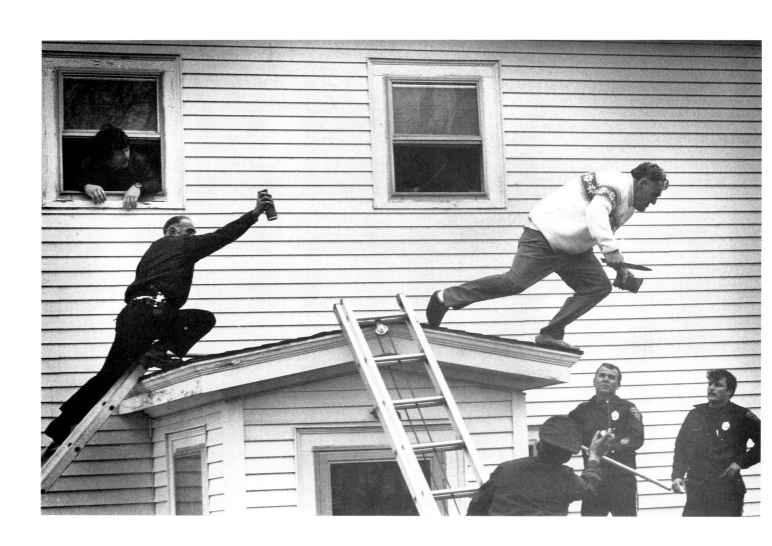

● *Above*

Sure, it was beyond the call of duty, but this was one suspect the police were clearly determined to grab.

Photographer:

Norman Sylvia

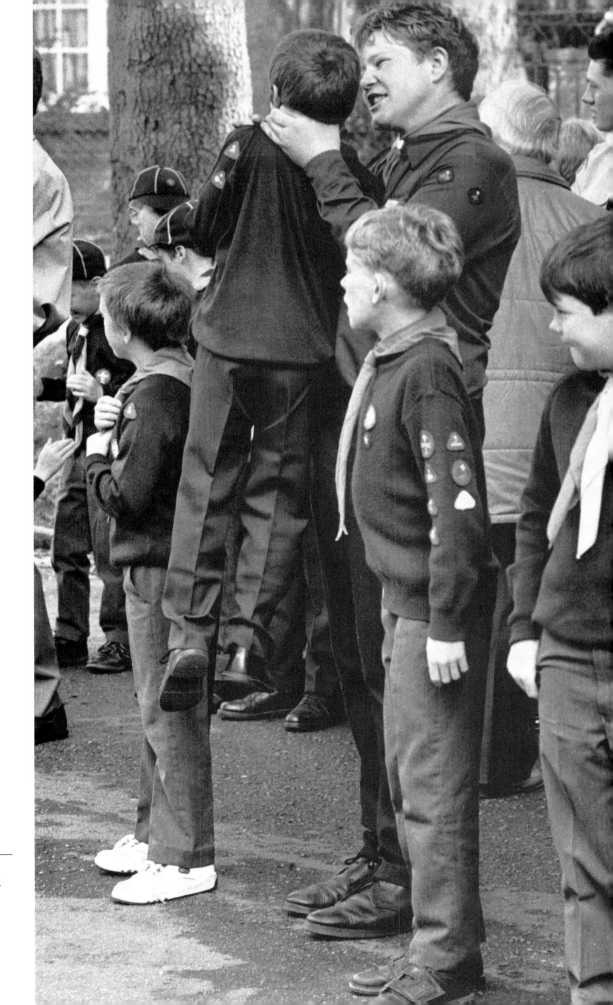

● *Right*

Scouts must be brave, kind,
loyal—and willing to hoist a
pip-squeak by the neck
when he's giving you lip.
Photographer:
Piers Morgan

What Happened Here?

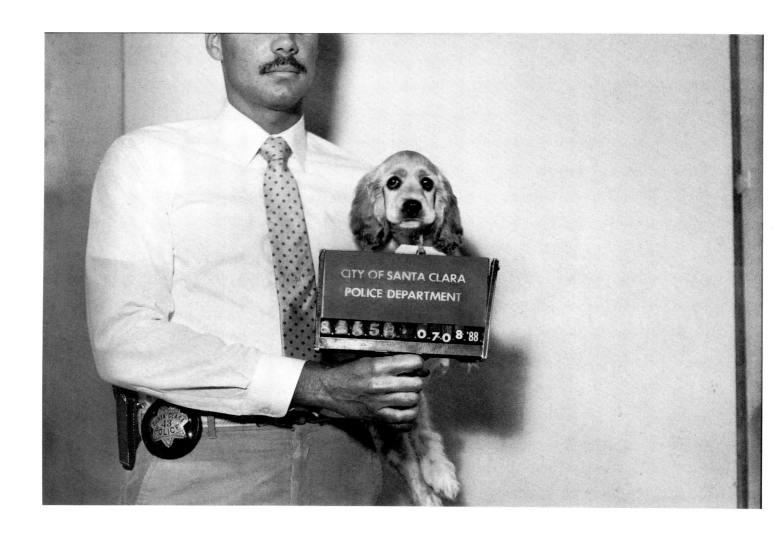

● *Above*

Now you tell me, are these the eyes of a criminal? Someone used a stolen credit card to take this pup from a pet shop, and the hot dog was booked as evidence.

Photographer:

Officer John Martin

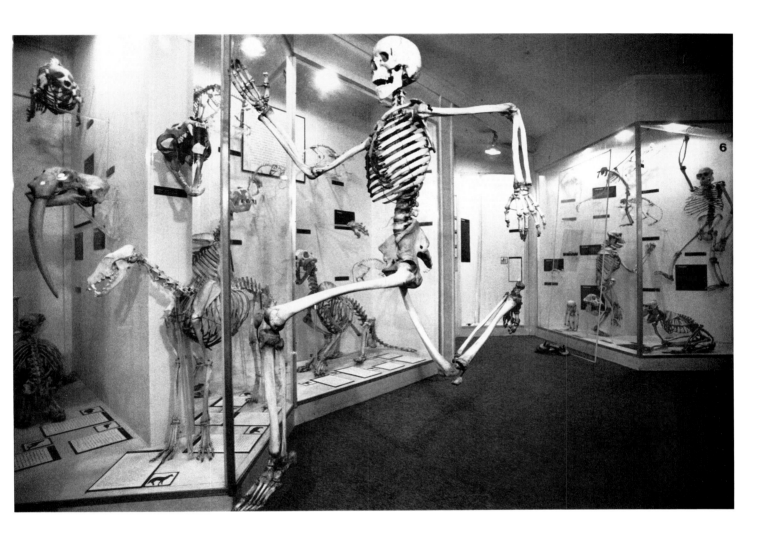

● *Above*

One hundred years ago, the records show, he was on his last legs, an arthritic Frenchman in his mid-20s. Now he's sprinting through the valley of a gallery of death, tickling museum patrons' funny bones.

Photographer:

Roger Bamber

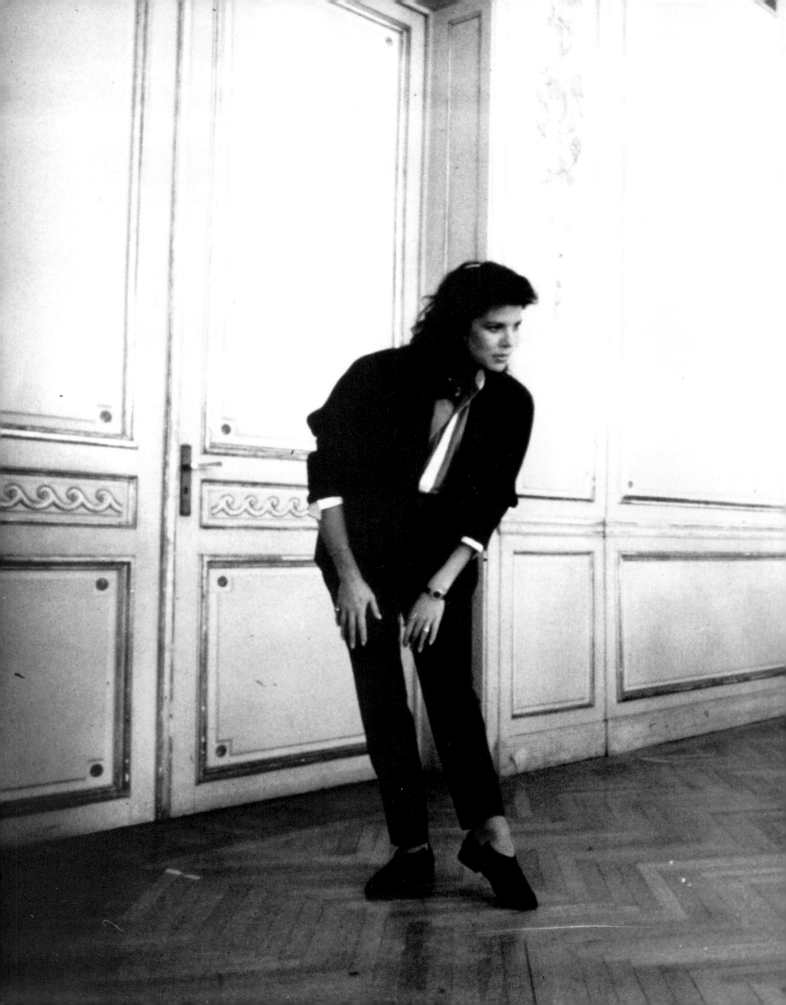

Chapter 12

Haven't I Seen You Somewhere Before?

Haven't I Seen You Somewhere Before?

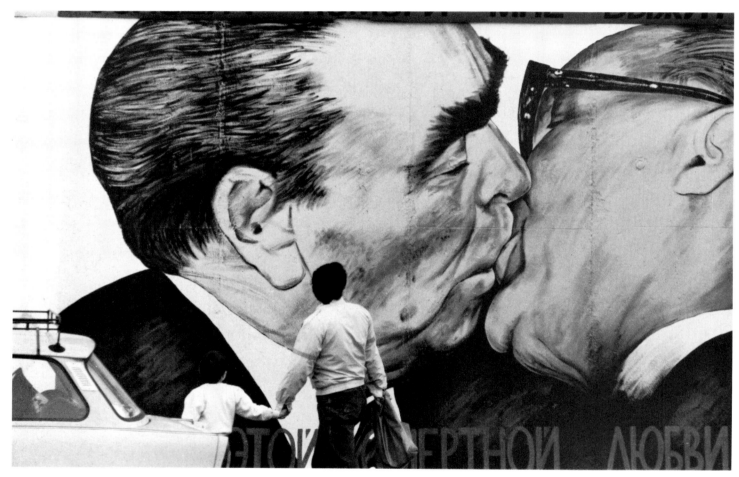

● *Previous page*

Having studied dance for 10 years, Princess Caroline of Monaco felt comfortable giving a class of aspiring ballerinas some royal pointers.

Photographer:

Harry Benson

● *Above*

Oh, what a love it was—a romance from hell that nearly strangled two nations. And when the grip relaxed—when Soviet leader Leonid Brezhnev and East Germany's Erich Honecker were gone—an artist decided to render their comradely ardor on a wall in East Berlin. Better to have loved and lost. Much better.

Photographer:

Juergen Schwarz

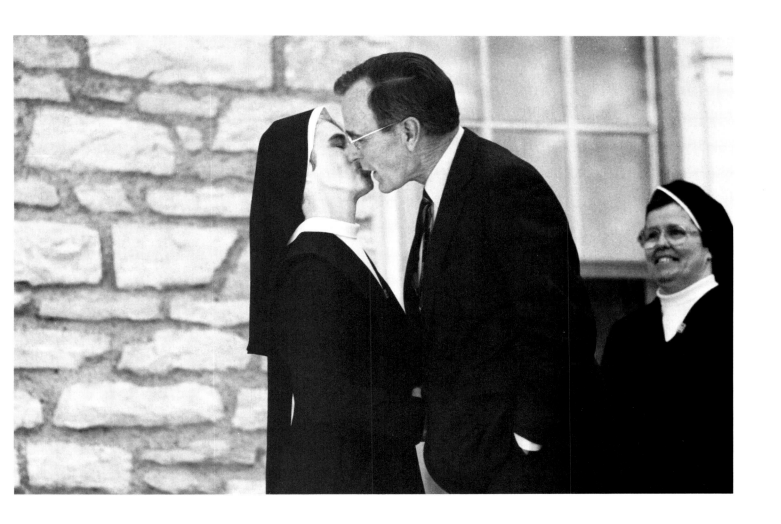

● *Above*

It was in the middle of one of those endless campaigns and George Bush was checking around for babies to be bussed. Finding none, he showed his catholic taste with an unexpected (but chaste) salute.

Photographer:

Mike Barber

Haven't I Seen You Somewhere Before?

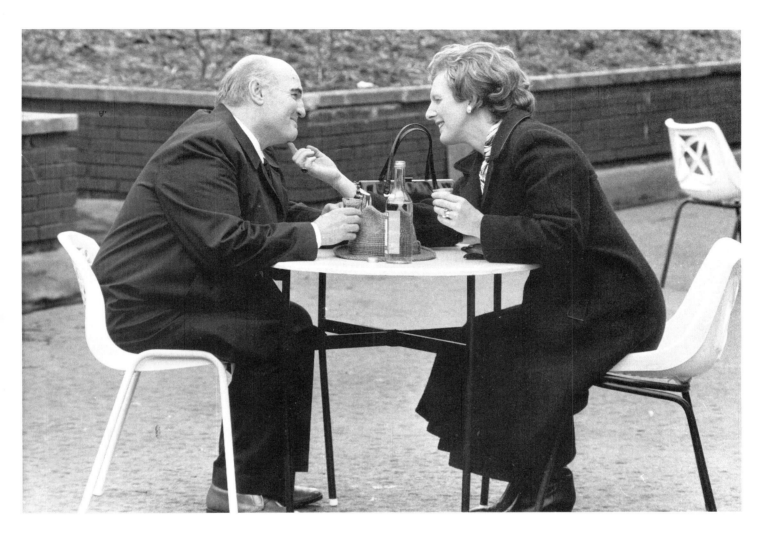

● *Left*

Fergie was never the model of a modern royal, but when Buckingham Palace reported the meltdown in the House of York, museum attendants made haste in dispensing with the dummy of their duchess. At last report, the museum's own Prince Andrew, not usually one to wax sentimental, could barely bring himself to wave a final goodbye.

Photographer:

The Press Agency Yorkshire, Ltd.

● *Above*

For a moment it seemed as if former British and Soviet leaders Margaret Thatcher and Mikhail Gorbachev were finding each other more disarming than disarmament. Actually, this imaginative peace initiative was acted by two look-alikes.

Photographer:

Syndication International

Haven't I Seen You Somewhere Before?

When Martina Navratilova
sized up Chris Evert's biceps,
she had a ball.
Photographer:
Michael O'Brien

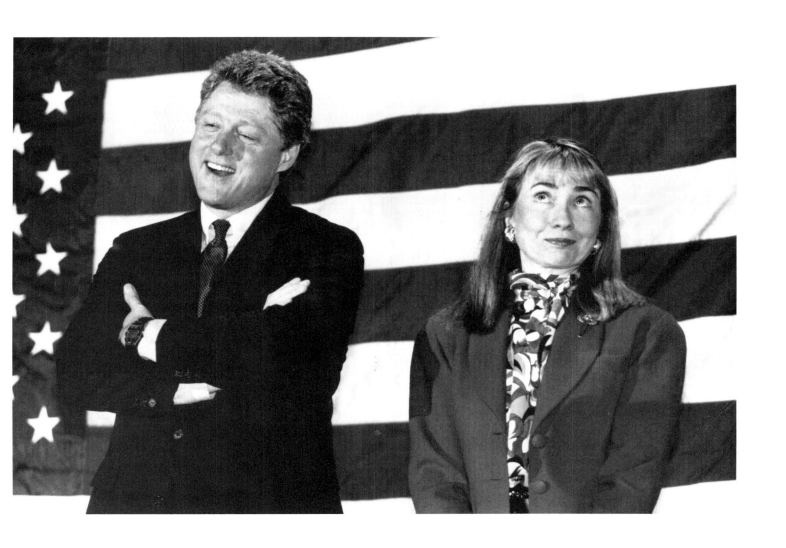

● *Above*

At the low point in Bill Clinton's campaign for the presidency, the governor and his wife, Hillary, were overwhelmed by a crowd of supporters.

Photographer:

Jim Bourg

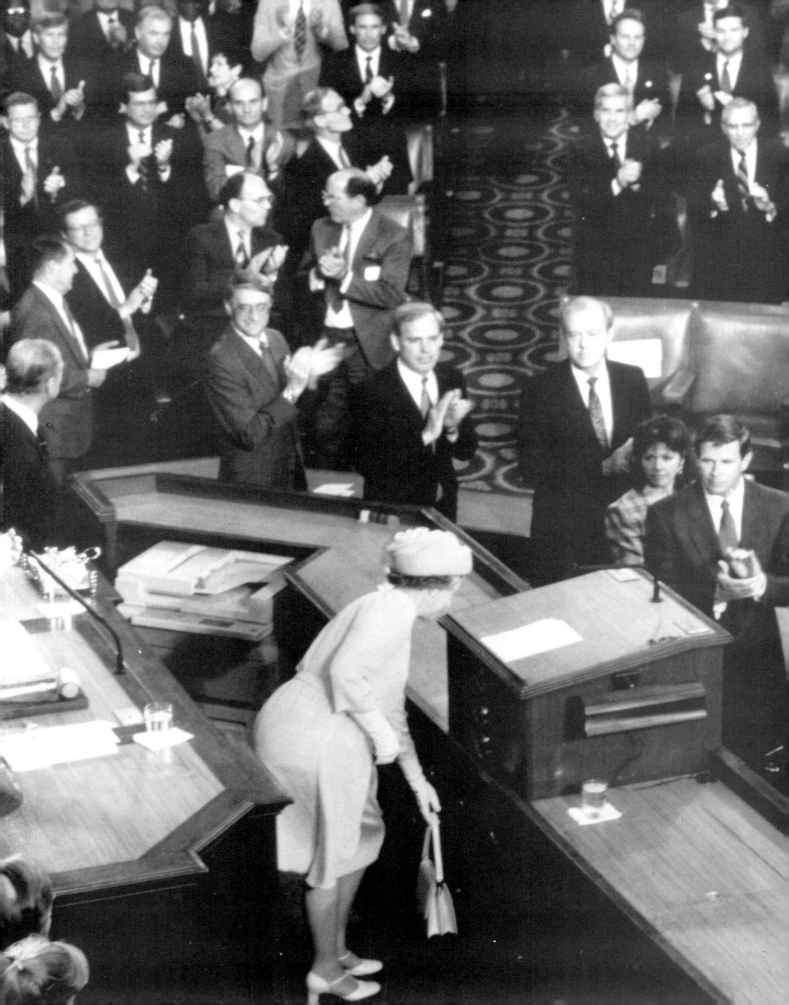

Haven't I Seen You Somewhere Before?

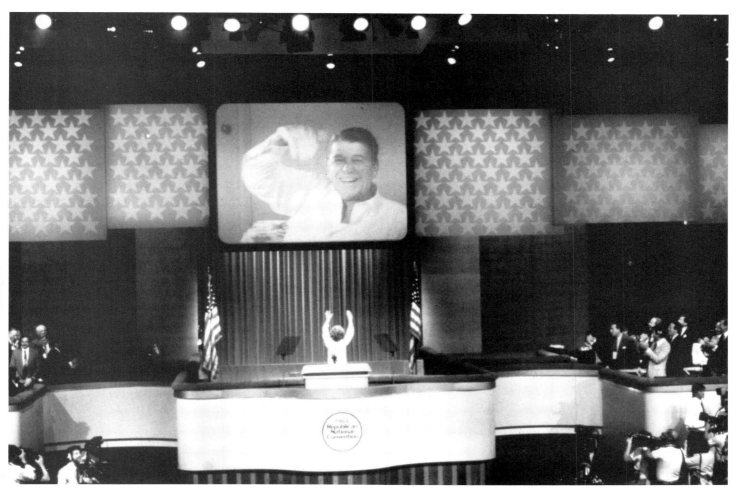

●*Left*

Purse snatchers, forget it. Britain's Queen Elizabeth and her proper whopper of a handbag are seldom parted, and royal-watchers never tire of guessing what's inside: A spare tiara? A small corgi? Even while addressing the U.S. Congress, Her Majesty kept the clunky thing safely by her side.

Photographer:

Mark Reinstein

●*Above*

When Nancy Reagan was through urging Republicans to "make it one more for the Gipper," she turned and waved at the then-President, who was watching her on TV in his hotel. A camera in his room caught his folksy reply.

Photographer:

Ben Weaver

Haven't I Seen You Somewhere Before?

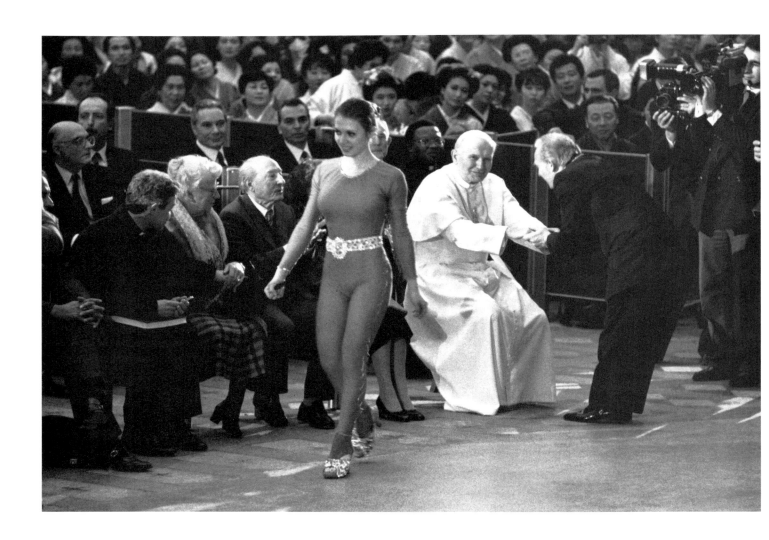

● *Above*

When Pope John Paul II was asked to bless a circus troupe that had just entertained him, he seemed to give a special benediction to the group's 20-year-old contortionist.

Photographer:

Reuters/Bettmann Newsphotos

● *Above*

During a photo session a week before his second birthday, Prince William inspected the equipment.

Photographer:

SIPA

Haven't I Seen You Somewhere Before?

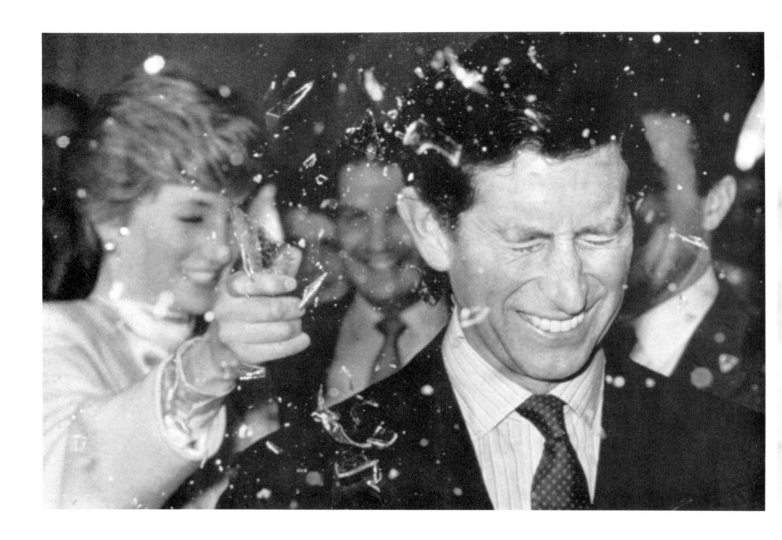

● *Above*

There was no harm done
when Diana whaled Wales
with a breakaway bottle.

Photographer:

George Whitear

● *Right*

Who can blame a pregnant
princess for dozing off during
yet another royal reception?

Photographer:

Tim Graham

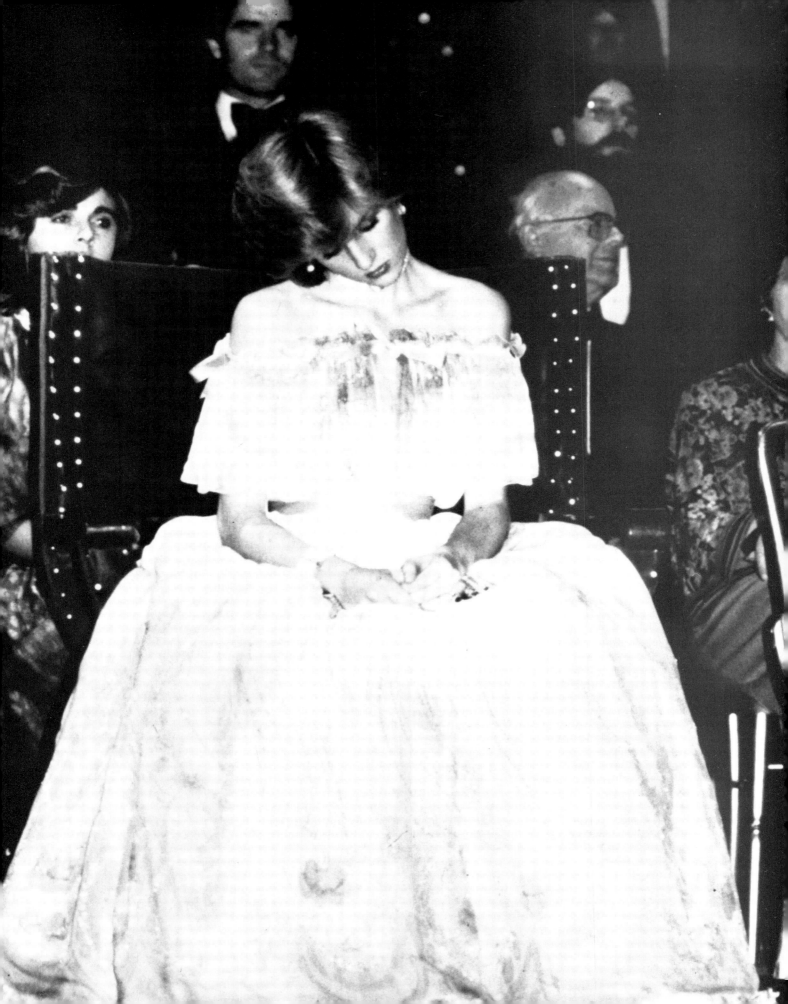

● *Right*

Edgar Bergen was more than Charlie McCarthy's voice and mind, he was his valet. At home in Los Angeles, Charlie had his own room; on the road, he had the plushest of traveling cases.

Photographer:
Mary Ellen Mark

190

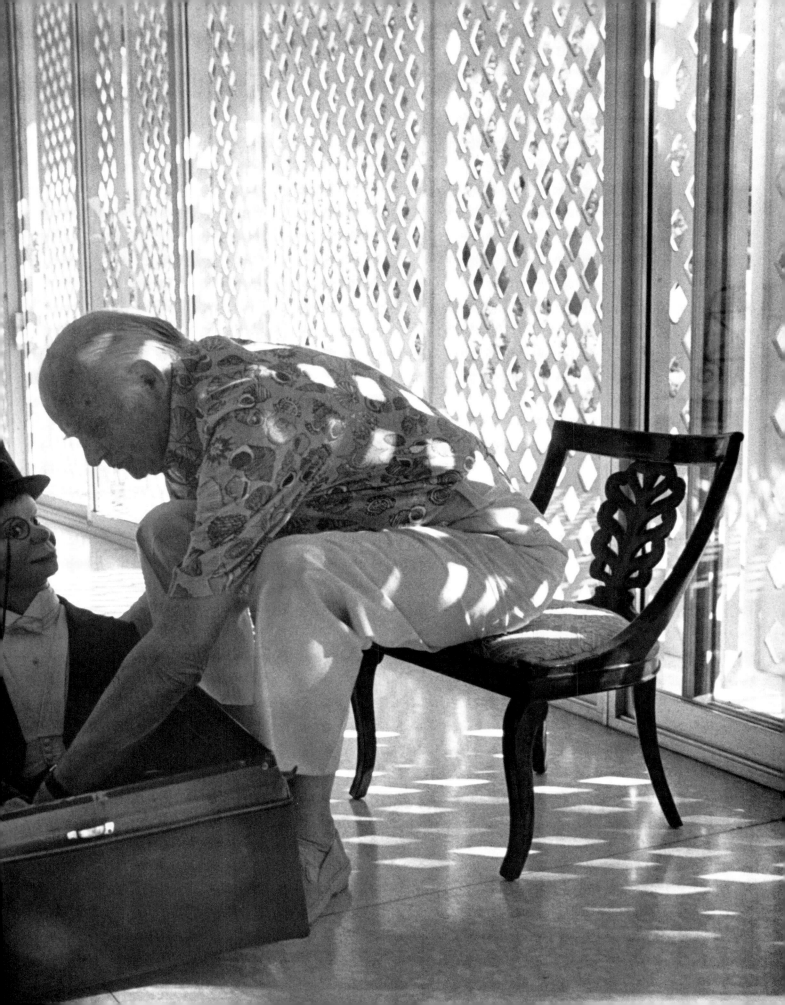

Picture Sources are listed by page. Introduction: Arthur Grace/Sygma. 16: Lionel Cironneau/AP. 18: G. Planchenault, T. Deketelaere, G. Vandystadt/Allsport USA. 20: Greig Reekie/The Toronto Sun. 21: Harley Soltes/The Register-Guard. 22: J. Ross Baughman/Visions. 24: Jim Koepnick/Oshkosh Daily Northwestern. 26: Manoocher/AFP. 27: James Meehan/Stern/Black Star. 28: Vince Mannino/UPI Bettmann Newsphotos. 31: Wes Wilson/Ottawa Herald-AP. 32-33: Glenn J. Asakawa/Rocky Mtn. News. 34: Jessica Norwood/Monroe Enquirer Journal. 36: David Steen/RDR Productions. 38-39, 40: April Saul/The Philadelphia Inquirer. 45: N. Durrell McKenna/Photo Researchers. 46: Daugherty/AP. 48: Janet Kelly/Reading-Eagle-Times. 49: Cloe Poisson/The Hartford Courant. 50: Stormi Greener/Minneapolis Star Tribune. 52: Michael Kienitz/Picture Group. 53: Roger Malloch/Magnum Photos. 54: Dennis Owen/Reuters–Bettmann Newsphotos. 57: Don Kohlbauer/The San Diego Union. 58: Nicholas Devore III/Photographers Aspen. 63: Lloyd Fox/The Baltimore Sun. 64: Carlo Chinca/Telegram. 65: Tom Jacobi/Stern/Black Star. 66: David Molnar/The Union News. 67: Jack Smith/AP. 68: Barbara Tetreault/The Caledonian Record. 72: April Saul/The Philadelphia Inquirer. 73: Nancy Richmond/Asbury Park Press. 74-75: Norbert Rosing/World Press. 77: Jan Du Sing/Pressens Bild-Photoreporters. 78: Christian Petit/Vandystadt. 79: Veronica Henri/The Toronto Sun. 82: Colin McConnell/The Toronto Star. 83: Paul Armiger/Daily Telegraph, London. 86: Schwartzback-Argus/Stern/Black Star. 87: John Lamb/The Melbourne Age. 92-93: Dickinson/SIPA. 94: Peter Southwick/AP. 96: From Skies Call, © '82 Andy Keech/London Express. 97: Louis DeLuca/The Dallas Morning News. 98: Dider Klein/Allsport U.S.A.–Vandystadt. 102: Alex Webb/Magnum Photos. 103: Otto Kasper/Sipa. 108: Rob Burns/The Middletown Journal. 109: Diego Goldberg/Sygma. 110: Hiroji Kubota/Magnum Photos. 111: Eugene Richards/Magnum Photos. 112-113: Rich Mahan/Atlanta Journal–Constitution. 114: Melanie Rook D'Anna/Tribune Newspapers. 115: Gerald Herbert/NY Daily News. 124: Jim Wilson/NYT Pictures. 125: Cristina Garcia Rodero/Agence "Vu," Paris. 129: Teri Harris/Seattle Times. 130: Robert Franzese/Aerial Dimensions. 131: Joe Burbank/The Orlando Sentinel. 132: Cloe Poisson/The Hartford Courant. 134: Allan Tannenbaum/Sygma. 135: Abbas/Magnum Photos. 136-137: David Lane/Palm Beach Post. 138: Teiji Saga/Pacific Press Service–Photo Researchers. 139: Gary Dunkin/AP. 140: Chris Polydoroff/St. Paul Pioneer Press. 141: Bruno Barbey/Magnum Photos. 142: Motti Kimhi/Hadashot. 153: Günter Ziesler/Bruce Coleman. 162: Cristina Garcia Rodero/Agence "Vu," Paris. 164: Kit C. King/Spokesman Review. 165: David C. Turnley/Black Star. 166: Donald Smetzer/Tony Stone Worldwide. 168: Ken Oakes/The Vancouver Sun. 169: Joel Sternfeld/Pace MacGill Gallery, NY. 171: James Nachtwey/Magnum Photos. 172: Norman Sylvia/Providence Journal. 174: Officer John Martin/Santa Clara Police Department. 178: Juergen Schwarz/Reuters–Bettmann. 179: Mike Barber/Suburban News Publications. 181: Syndication International/Photo Trends. 183: Jim Bourg/Gamma Liaison. 184: Mark Reinstein/Photoreporters. 188: George Whitear/©1987 Danjag, Inc. 189: Tim Graham/Sygma.